DATE DUE

MAY 1 0 2004			

DEMCO 38-297

LATIN AMERICAN WOMEN
ARTISTS OF THE UNITED STATES

Latin American Women Artists of the United States

THE WORKS OF 33 TWENTIETH-CENTURY WOMEN

by ROBERT HENKES

McFarland & Company, Inc., Publishers
Jefferson, North Carolina, and London

British Library Cataloguing-in-Publication data are available

Library of Congress Cataloguing-in-Publication Data

Henkes, Robert.
 Latin American women artists of the United States : the works of
33 twentieth-century women / by Robert Henkes.
 p. cm.
 Includes bibliographical references and index.
 ISBN 0-7864-0519-8 (library binding : 50# alkaline paper) ∞
 1. Hispanic American art. 2. Hispanic American women artists —
Psychology. 3. Art, Modern — 20th Century — United States.
I. Title.
N6538.H58H46 1999
704'.042'08968073 — dc21 98-43600
 CIP

Manufactured in the United States of America

McFarland & Company, Inc., Publishers
 Box 611, Jefferson, North Carolina 28640

Table of Contents

*Between pages 154 and 155
are 11 works of art in color*

Preface

Latin American art is frequently referred to as sacred art. The sanctuaries, shrines and altars are classified as contemporary installations. They are seldom objects of adoration but are suitable for contemplative purposes. The adoration of saints is a sacred practice for the Latino population. Many saints, particularly ones with baptismal names, are revered by Latin American families, and great celebrations occur on the feast days commemorating the saints.

The Roman Catholic environment that envelops the Latino population throughout South and Central America and Mexico is a strong stimulus for the creative process. To simply display the installation does not necessarily meet the demands of the creative process and the final art product. A complete compatibility between composition and idea must exist; neither should be overplayed.

The notions of childhood dreams and memories are valid stimuli for the Latino artist. Frequently their paintings and installations are forms of confession, personal repentance and atonement.

Murals are essential in the Latin American nations because of the public's need to know. Such public displays of propaganda, memorials and living tributes to governmental agencies serve the needs of the people.

Because of their widespread and profound religious beliefs, Latin Americans choose to couple their dogma with their art. This marriage of art and religion is ever present in one form or another, often hidden within a surreal context. Nonetheless, guilt often surfaces as a form of atonement when displayed on the painted canvas within the sculptured image or the installation.

Latin American women artists have led the nation in the use of saintly images and symbolic religious objects, thus adding an important element to American art.

Introduction

In order to become internationally recognized, the Latin American artist's cultural environment must be an essential aspect of his or her artistic expression. This work is an attempt to correlate native subject matter with personal insights and techniques. But more importantly this work focuses on Latin American women artists so that they might join their male counterparts in the art mainstream.

The works of art discussed in this book demonstrate that women's talents, although woefully neglected in the past, recently have gained remarkable recognition and are worthy of continual exposure within the international scene.

The choice of artists for inclusion was made by virtue of their various styles, themes and media, but not without valid artistic purpose. Latin American women have made a major contribution to the world of art, extending far beyond their respective nations.

The artists included in the text have lived or worked in the United States. Some retired to the United States, while others were American citizens by birth but of Latino heritage. Still others settled in the United States after working in Latin American countries. Each artist's career, education, solo exhibitions and group showings are discussed.

The language of visual art is universal. It is ironic that in order to enter the realm of international art, one must first be recognized in a regional sense. Yet, as a regional artist one is isolated from the world market.

The ethnic environments have been both a blessing and a hindrance to the success of the ethnic artist. To gain fame as a Latin American artist one generally gains success as a national artist, a recognized artist of one's own nation. African Americans and Native Americans are two major ethnic groups whose art has finally arrived on the international scene, due partly to European and Asian study and travel.

Thus, the use of contemporary styles coupled with national customs and symbolism has led to a greater number of successful ethnic artists. The difficulty of entering the mainstream of visual art lies in the need to adhere to cultural ancestries while blending in an international flavor. There are Latin American artists who will never be recognized beyond their respective nations' boundaries because of sheer competitive forces that are beyond the artists' control.

It seems essential to first isolate (in order to identify) Latin American art before expecting it to enter the mainstream of American art. The question as to what is "American" in American art continues to go unanswered. The Hudson

school of painting claimed the title, as did the art of the Depression and abstract expressionism. Then pop art gained the throne. Yet, all of these schools of thought ignored the art of African Americans, Native Americans and Latin Americans. This made it impossible to achieve a oneness, a blend of all cultures practiced by Americans.

This book is an attempt to identify some of the major Latin American women contributors to the visual art picture, so in a sense it is a process of isolation. By promoting them in a single volume it is hoped their work will be exposed to a wider audience and eventually accepted into the mainstream of American art.

The fight for women's rights and the feminist movement brought out an entirely new facet of talent and genius. The women artists discussed in this book are proven exponents of the creative process. In other words, American art was defined by technique rather than theme or culture. American art has to do with America.

Juana Alicia

One cannot ignore the vivid color, fluid brushwork and exciting interpenetration of form displayed in Juana Alicia's easel paintings and murals. Emotionally one is compelled to stare and respond to the colorful yet dramatic images on the canvas.

In a brochure of her work exhibited at the LaRaza Graphics Center in San Francisco, Alicia stated: "I am committed to having an impact on the visual vocabulary of my contemporaries, to work toward peace, and to preserve the environment. I want my work to contribute to the transformation of a violent world into a humane one, reflecting values of love, mutual respect, and awe at the beauty of nature."

To devote one's life to the creation of the divine and the notion of love for neighbor is revolutionary compared to the countless, meaningless abstracts that flood the market. Alicia's realistic style, coupled with an intermingling coverall, reflects an unusual interpenetration of two different cultures. As a muralist, Alicia shares her profound devotion to a peaceful world and nature's beauty.

Alicia's commitment to her artistic imagery is transmitted from the artist to the viewer in an absorbing panoramic view of humanity.

Born in 1953, Alicia has exhibited widely in the United States and Mexico, and the combination of the two cultures has furthered and deepened the relationship between her born citizenry and her cultural heritage.

Her fascinating mural painting *Alto al Fuego/Cease Fire* has an Easter Sunday flavor. The luminous star, radiating glowing streams of everlasting grace, enriches the Mexican landscape. The young male, confronted by a series of formidable firepower, smiles broadly as he reaches a clearing from the forested mountain.

Alicia's unusual composition contributes to a dual or three tier perspective. An original composition of tension between the young Latino boy and the rifles aimed at him is interrupted by a pair of strong hands that alter the total composition. The aggressors in Alicia's mural are left unidentified. The golden rays of color cast a yellowish green shroud over the entire panoramic view of the mountainous landscape.

There is hope beneath the dramatic confrontation. The yellow cast of light consumes the entire canvas and creates a controversial source of light that places highlights upon illogical objects and at argumentative locations. It becomes obvious that *Alto al Fuego/Cease Fire* has ignored the natural source of light or instead extended the source of light simultaneously from all four conceivable angles. It is initiated in a realistic vein and eventually transformed into a combination of realism

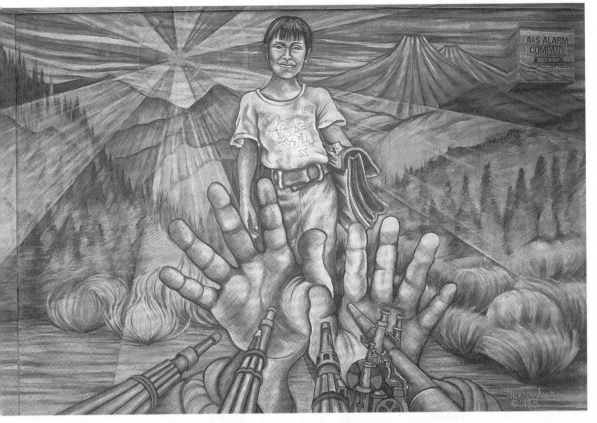

ALTO AL FUEGO / CEASE FIRE by Juana Alicia. 1988.
Courtesy of the artist.

and abstractionism. There is also a hint of surrealism. In many ways Alicia meets one's artistic as well as personal and social needs.

Two years after the 1988 execution of *Alto al Fuego/Cease Fire*, Alicia created the 1990 version of a political celebration called *Mission Street Manifesto*. The abstract nature of the composition blends the action with the location. The painting depicts a young lovely woman handing to a male celebrant a golden globe, which is the only realistic element. The woman occupies the foreground of a solo realist, while the male form is superimposed over the glamour of city life. The young male figure is superimposed onto an automotive image, creating an illusion of invisibility. In the sky resides a whirling dervish, a Ferris wheel of sorts in fiery red surrounded by an equally dramatic bluish environment.

The value of abstracting ideas is to allow several objects or images to coexist on a single surface. It permits the foreground and the background to exist in a space geared for a single unit. An abstract painter is able to increase or decrease the significance of an image. In *Mission Street Manifesto*, the young woman is given the more important position.

According to Margarita Luna Robles, poet-writer in residence at Platano Flats Jazz Conservatory in Iowa City, Iowa: "Color and form have attracted us to this

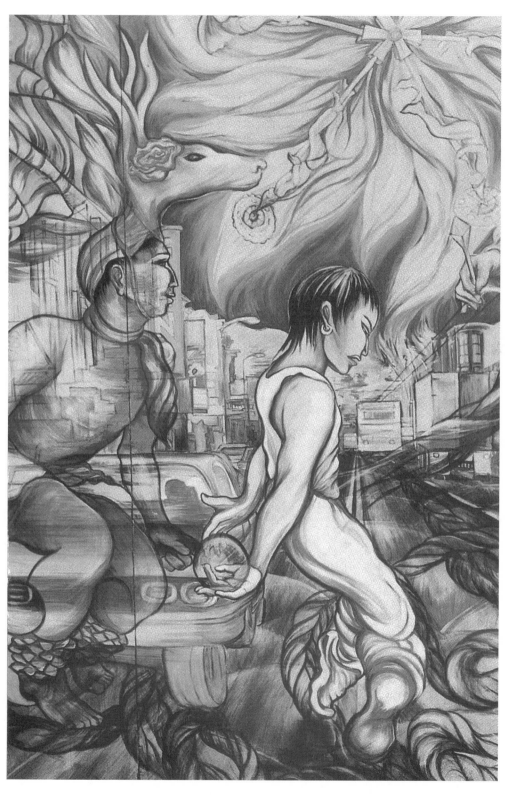

MISSION STREET MANIFESTO by Juana Alicia. 1990.
Courtesy of the artist.

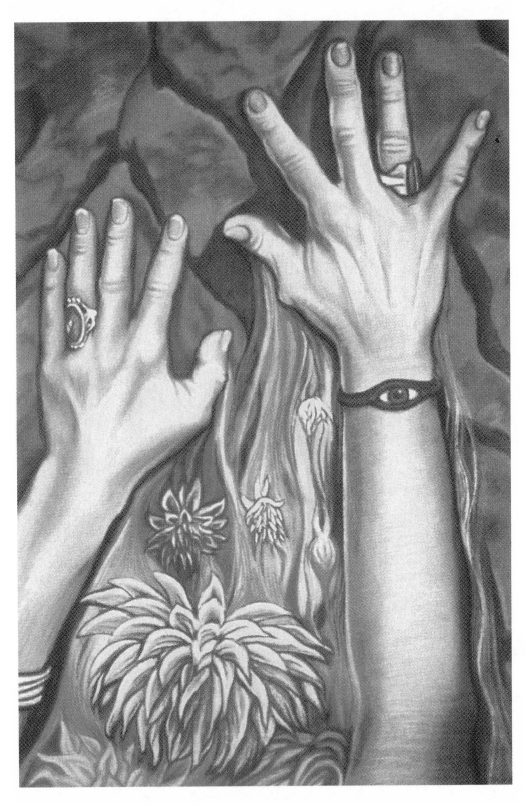

AUTO VISION by Juana Alicia. 1990. 19½ × 13 in.
Courtesy of the artist.

art, made us take a step forward to examine closely and pushed us back to see the totality of Juana Alicia's work. Taking the step back we can see symbols and themes of time, life, culture, gender, contemplation, death and the urgent struggle for survival. Woman as a character in Alicia's art becomes art metaphor for life and not just a portrayal of woman's condition. Juana Alicia's passion for life exudes onto her work, her concern for humanity urges us, the viewers, to reflect on our own personal quest for justice."

In spite of Juana Alicia's resolution for equal justice, love of neighbor, and appreciation of one's natural environment, her meanings are often difficult to grasp. In the case of *Auto Vision*, the viewer is faced with a pair of human arms and hands that reach desperately upward, grasping for unknown images. A ring adorns each hand, and the right arm sports a simple bracelet sheltering the image of a single eyeball. This is definitely an example of symbolism, but symbolism is often misinterpreted. Art is seldom what it seems, and the artist is not always accountable for his or her actions upon the canvas.

Although the upward movement creates a focus on the outstretched fingers, the viewer's attention is drawn downward to the two rings and single bracelet that form an invisible triangle. The flowing blossoms in the foreground actually detour one's vision, creating a textural contrast between the smoothly painted arms and hands and the textural design of the flowery foreground.

The personal imagery and the unusual arrangement make for a unique expression. *Auto Vision* could be a detail of a completed work or a small segment of a mural; the design of the background coincides with that of the subject's hands. There is an unusual subjectivity created by the closeness of the arms and hands to the viewer and by the almost total absorption of the canvas working surface.

Nature is a significant motivation for Juana Alicia, and the mural is the perfect medium to explore the various approaches. Usually the background consists of flowers, shrubs or trees, along with leaves, stems, roots and branches. In a detail of a mural featuring artists Frida Kahlo, Genny Lim and Maxine Hong Kingston titled *The Promise of Loma Prieta: Not to Repeat History*, Alicia reveals a sort of evangelism, a quest for peace and harmony through the mural medium. Since Alicia is motivated by her community when creating murals, each one serves as a unique sermon of sorts, which creates community togetherness and acts as a reminder of one's purpose in life. Juana Alicia is serving not only her community but the world as well.

The trio of female figures in *The Promise of Loma Prieta*, each protected by a strong forest, share a common cause. Frida Kahlo, fondling a pair of peace doves, is surrounded by a shroud partially invisible and yet suggestive of a saintly image. The middle figure, Genny Lim, represents a sense of belonging and a willingness for an establishment of an ethnic oneness. Finally, the smiling Maxine Hong Kingston beckons the viewer to participate in the cause. Alicia's color is intense, highly ornate and typically Latin American. The habitat is a background of gnarled trees that seem to dance to the brilliantly colored attire of the trio.

There is a formal balance that goes unnoticed because of the artist's technique of balancing objects after first setting them into an informal composition. The repetition eventually leads to a rather complex composition.

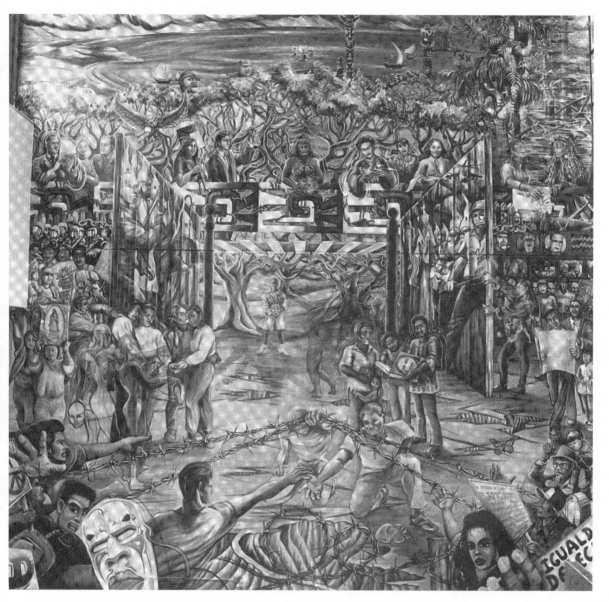

THE PROMISE OF LOMA PRIETA: NOT TO REPEAT HISTORY by Juana Alicia. 1992. Mural.
Courtesy of the artist.

 Not to Repeat History is an intricately complex composition of armed forces, protesters, peacemakers and activists. In spite of the several groupings, there are groups that are no longer identifiable. These groups mill about the nonviolent inhabitants. Remnants of war are everywhere. Gnarled trees — Alicia's favorite subject matter — resemble crucifixes. Strangers read the latest political news. Groups discuss the latest movements in the military and political atmosphere. Totem poles reign in the distance. Even the three sailing ships of Christopher Columbus set sail toward the New World. The *Pinta*, the *Niña* and the *Santa Maria* hold remote spots in the mural, but it is specifically because of the insignificant locations that the three

sailing boats become important. A soccer player waits patiently for the start of a new match.

Alicia utilizes barbed wire as a deterrent to violence between ethnic groups. *Not to Repeat History* is a masterful piece of workmanship: a beautiful panoramic view which extends in all directions. It is as if those nearest the top of the mural were also closest to heaven. There is also a surrealist flavor that compares notably with Philip Evergood and Ben Shahn.

A complex design and multiple groupings invite strong individualistic paintings. As many as 25 worthy compositions grace the interior of this painting. Juana Alicia has promoted several students to lofty positions in the art world, and she has also made them proud believers in the future of America.

Career Highlights

Born in 1953; San Francisco muralist; taught at Stanford University, Skyline College, World College West and California College of Arts and Crafts at New College of California.

EDUCATION
M.F.A., painting, San Francisco Art Institute, 1990; fifth year certificate in bilingual education, 1983; single subjects credential in art education, 1980; bilingual cross-cultural emphasis credential, U.C.S.C., 1979; B.A. in teaching aesthetic awareness from a cultural perspective, University of California at Santa Cruz, 1979.

SELECTED EXHIBITIONS
The Berkeley Art Center, Berkeley, California, 1995; The Red Mesa Gallery, Gallup, New Mexico, 1994; Pro Arts Gallery, Oakland, California, 1992; The Euphrat Gallery, DeAnza College, Cupertino, California, 1992; LaRaza Graphics Center, San Francisco, California, 1991; Mexican Museum of San Francisco, 1991; San Francisco Arts Commission Gallery, 1991; Channing Peake Gallery, Santa Barbara, California, 1991; Moss Gallery, San Francisco, California, 1991; University Art Gallery, Sonoma State University. California, 1990; Wight Art Gallery, U.C.L.A. International Tour, 1990; Fort Mason, San Francisco, 1990; Galería Posada, Sacramento, California, 1989; Mexican Fine Arts Center Museum, Chicago,

Illinois, 1989; Museo de la Estampa, Mexico City, 1989; Santa Rosa City Council, Santa Rosa, California, 1988; The Alternative Museum, New York, New York, 1988; Loteria Nacional, Mexico City, 1987; Berkeley Art Center, Berkeley, California, 1986; La Galería de la Raza, San Francisco, California, 1985; Evergreen Center for Peace and the Arts, Mill Valley, California, 1985.

MURALS
The Promise of Loma Prieta. University of California at Santa Cruz, Oakes College, 1992; *Regeneration.* San Jose Art Movement & Latin American Culture, 1991; *Silent Language of the Soul.* San Francisco Mission District, 1990; *Cease Fire.* Mission Street, San Francisco, California, 1988; *Bridge of Peace.* World College West. Petaluma, California, 1988; *Women of Fire.* Stanford University, 1988; *Earth Book.* Skyline College, San Bruno, California, 1988; *New World Tree of Life.* Mission Pool, San Francisco, California, 1988; *A Letter to the Future.* San Francisco's Good Samaritan Community Center, 1986; *For the Roses.* San Francisco Mime Troupe Building, 1985; *A Night in Veracruz.* Pablo's Restaurant, 1983; *The Women Lettuce Workers.* San Francisco Mission District, 1983; *A View of 20th Century.* Watsonville High School, Watsonville, California, 1983; *Birth Mural.* University of California, Santa Cruz, 1982.

Nela Arias-Misson

It has been said that the abstract expressionist style of painting is the most difficult of all techniques. Nela Arias-Misson, who was born in Havana, Cuba, in 1925, said in a statement to the author: "I refuse to analyze my painting. I cannot paint if I think. I cannot preconceive a painting. I cannot paint. I only know by intensities. Passion is the source of understanding. I absorb the world around me like a sponge — light, passions, personalities, smells. Before I can paint, I must empty myself totally, not thinking or imagining so that I can be used as an instrument, a channel. The purpose of my work is love."

An exquisite example of her style is her painting *Hombre Español*. It has all the earmarks of the Hans Hofmann school of painting. It is also childlike in its intuitive application of pigment. The huge head, dotted eye, spread legs and doodling effects are not unlike that of a child. The dramatic effects of the instinctive process are created by the direct, nonobjective approach. Errors are quickly and impulsively repainted. Areas are etched in by scraping off segments of paint and relying on instinct for furthering the process.

Hombre Español resembles total chaos, a flagrant use of the human figure. Upon close scrutiny, an image emerges from the seemingly disorganized environment. *Hombre Español* is a purely subjective expression. The entire working surface is utilized, thus sacrificing any negative space that appears to be surrounding the human subject. Strong vertical lines of dark pigment identify the human contours while simultaneously separating the subject from its environment. However, a similar textural application of pigment engulfs the figure, thus blending it with the background to form a completely subjective expression.

The notion is seldom identified during the process, nor is it preconceived. It is an intuitive process resulting in totally uninhibited responses to color, line and shape. Although *Hombre Español* is of the Hofmann and deKooning school, Nela Arias-Misson's other works follow the styles of such renowned expressionists as Franz Kline, Clifford Still, Mark Rothko and others. In the color field portrayals, the artist must deal with the placement of intuitive forces upon a working surface called the environment or habitat. Such forces take the form of geometric shapes that blend with a compatible composition, each one a complete unit equally intuitive of the surrounding areas. Receding and advancing colors create a sensation of three-dimensional space.

Nela Arias-Misson relies upon individual emotions; subjective reactions to life that hold no limits except for the physical confinement of the working surface

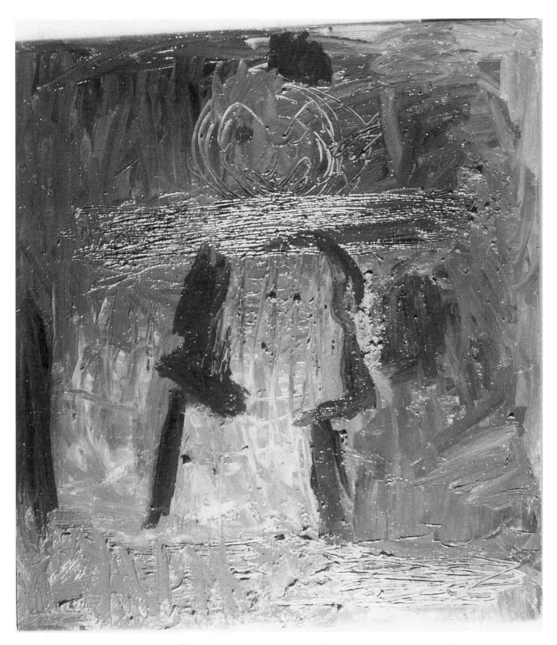

HOMBRE ESPAÑOL by Nela Arias-Misson. Oil on canvas. 1965. 30 × 60 in.
Courtesy of the artist.

(canvas). Apparent disorganization and irrational composition on the canvas are similar to human nature. Nature is neither methodical nor predictable, and it is this uncertainty that links Arias-Misson to the abstract expressionist school. Mechanical images, whether artistically expressed in the form of streamlined geometric, nonobjective paintings or in the form of subjective stimuli, are avoided in favor of personalized emotional statements.

Acutely aware of the dangers posed against mankind, Nela Arias-Misson

abolishes all traditional and acceptable premises and welcomes the instinctive, emotional, unprepared, and accidental — expressions that lay bare the inner guts of the oppressor, in this case the artist who bewails the ultra-organized, the surefire portrayal of visual identities.

Arias-Misson relies totally on intuitive responses, not necessarily to an idea but to the process itself. A brushstroke of color presupposes a countermeasure, and succeeding applications of paint, whether linear or solidified, progress toward an eventual conclusion. The process of painting becomes the product of painting. Its eventual outcome is uncertain just as each brushstroke becomes an adventure into the unknown.

In her painting *From the Arena*, Nela Arias-Misson introduces an informal balance of irregular shapes, which in a visual sense creates a psychological formality. It supports the statement that largeness is not necessarily better than smallness. Factors such as intensity of color, accent and surrounding hues determine its significance. Placement is also a factor.

The color-field approach is more disciplined and perhaps even more orderly than that of *Hombre Español*. There is an instinctive urgency in placement, even though controlled somewhat by the intellect. Each color and each shape has a life of its own. Life exists within life.

According to Arias-Misson, there are no dead areas in the universe, only in the artist's concept of space. In order to alter negative space surrounding a positive image into a positive space, the background is treated with a textural appearance so that the painting presents a oneness, a composition of complete and total unity.

In *From the Arena*, each image survives as a victim of its environment. The intensity or strength of the habitat determines the strength or weakness of the images. The overplay of an environment can weaken the translation of an image into important dialogue; such is not the case with *From the Arena*.

In her painting *Amor*, Arias-Misson has utilized warm colors that translate into an emotional image of love. Two black rectangular shapes atop the heated environment add to the fervor. Brushstrokes are full, creating a sense of gaiety and pleasure.

The bustling image of love occupying the frontal plane lies on a hard-edge background. The two techniques blend into a single unit because of the similarity of color between the habitat and the subject matter. The two opposing forces — intuitive and intellectual — combine to form an abstract version of the emotion of love. There is a cruciform suggested behind the mesh of heated colors that may or may not have been intended.

The placement of the dark rectangular shapes near the top of the canvas creates a three-dimensional spatial effect that defies Josef Albers' theory of recessive and advancing colors. *Amor*, a 1958 painting, was directly influenced by the Hans Hofmann school of painting and also reflects the influences of other abstract expressionists. The placement of the dark rectangular shapes is crucial to its successful composition. Dissimilarity in size and shape adds to the diversity of the design. The positioning of the shapes elsewhere would have created confusion and perhaps compositional destruction.

Frutas is a somewhat similar 1958 painting. Even though several irregular

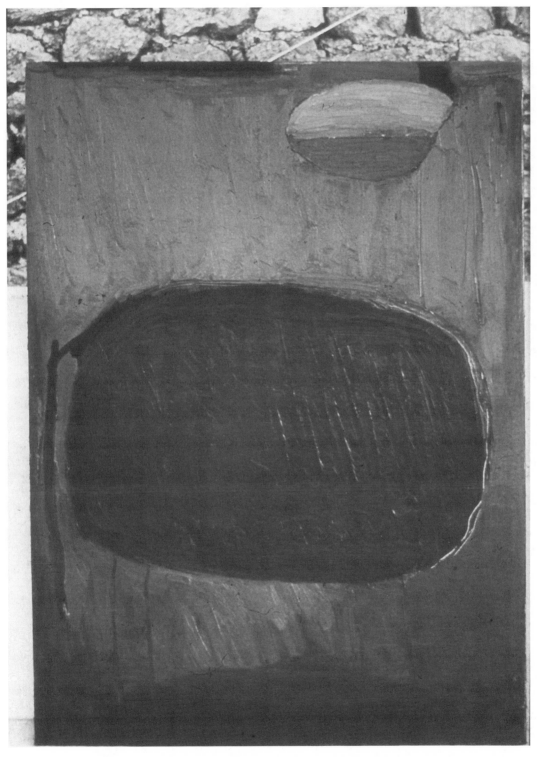

FROM THE *ARENA by Nela Arias-Misson. Oil on canvas. 1961. 38 × 51 in.*
Courtesy of the artist.

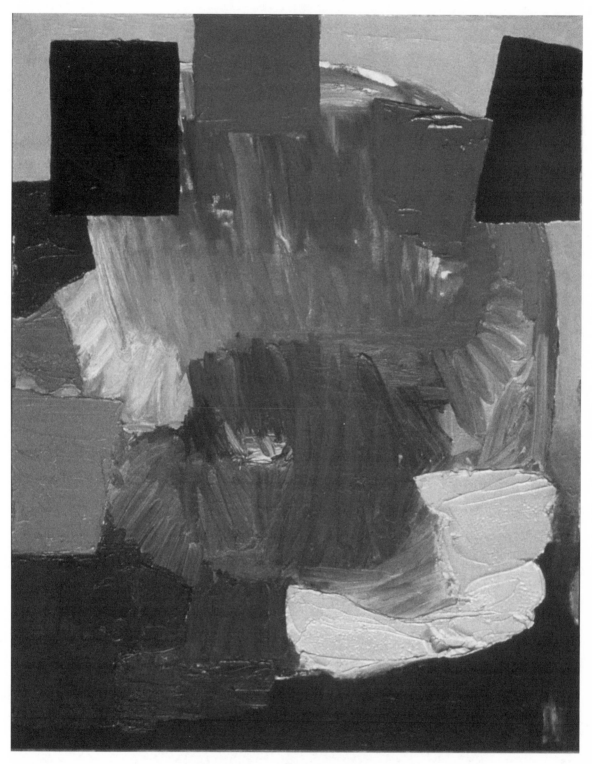

AMOR by Nela Arias-Misson. Oil on canvas. 1958. 40 × 50 in.
Courtesy of the artist.

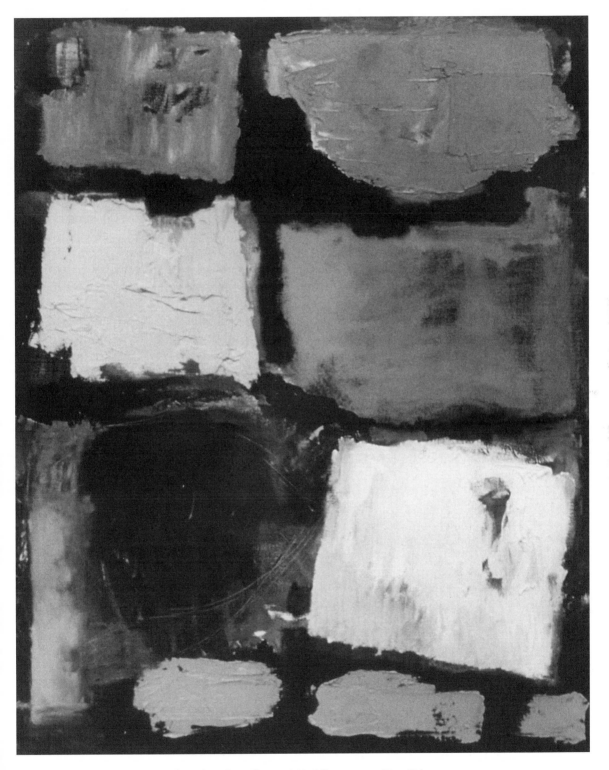

FRUTAS by Nela Arias-Misson. 1958. Oil on canvas. 50 × 40 in.
Courtesy of the artist.

shapes of color are laid upon a darkened environment, the spaces between the subject matter and the background serve as a positive element integrated into the whole. The subject matter of the painting is not portrayed realistically. Instead, one is introduced to several lush colors that correspond to the images of particular fruits. A light violet with a touch of red identifies the plums while other colors symbolize other aspects of nature.

However, because *Frutas* is an abstract painting, the viewer is free to interpret its contents according to individual training and insight. *Frutas* is a provocative work; images seem to float in space while simultaneously anchored to its environment. Nela Arias-Misson's abstract expressionist paintings were executed during the 1950s, the heyday of the movement.

Fig Trees from the Garden of Alameda was painted in 1988. It reveals images of five fig trees positioned in a horizontal line across the canvas. The images are purposely staggered to form an uneven anchoring and avoid monotony. The unusual purple tree trunks are topped with grape-like fruit images, each bunched in a slightly different manner. The environment is flat and divided by a single diagonal that serves as a receded baseline.

Nela Arias-Misson considered Hans Hofmann to be the master of the art universe. However, after a year in Spain she scanned the real life of the outdoors — the daily chores, duties and hardships. Such elementary behavior was merged with the Hofmann variety of expression. She reached a stage when outside stimuli coincided with corresponding inner feelings, allowing her freedom to express itself. Yet, she felt outside of life.

In 1975 she claimed to have entered reality. She no longer fled from this world, but became a part of it through a spiritual transfusion. *Fig Trees from the Garden of Alameda* is an example of her reawakening, her entrance into the world of reality.

Career Highlights

Born in Havana, Cuba, in 1925.

EDUCATION
Studied at Traphagens and Parsons in New York City; studied at the Hans Hofmann School in New York City.

SOLO EXHIBITIONS
Chapelle de Boondael, Brussels, Belgium, 1973; Centro di Arte, Sanielmo, Italy, 1972; American Cultural Center, Brussels, Belgium, 1971; Galería Cultari, Madrid, Spain, 1970; Circula de Arte, Cespedes, Cordoba, Spain, 1970; Galleri Dierick, Brussels, Belgium, 1970; University of Leicester, England, 1969; Vecu Gallerij, Antwerp, Belgium, 1969; Gardner Arts Centre, University of Sussex, Falmer, 1968; Charlottenborg Gallery, Copenhagen, Denmark, 1962; New Gallery, Provincetown, Massachusetts, 1957.

GROUP EXHIBITIONS
Merkin Concert Hall, New York, New York, 1986; Wiseman Gallery, Dallas, Texas, 1980; Women's Lib Exhibit, Passage 44, Brussels, Belgium, 1971; National Association of Women Artists, New York, 1959; Provincetown Art Association, New Gallery, Provincetown, Massachusetts, 1957.

Leonora Arye

A single photograph of sculpture has a visual disadvantage in that only one angle of view can be seen. However, Leonora Arye's photo of her alabaster sculpture *La Madre* reveals a three-quarter angle that displays both front and side views. Because of its compact composition, one envisions a life-size image, and yet it measures a mere 8½ by 12 by 10½ inches.

La Madre has little negative space to consider. Negative space refers to space outside of the sculptured form. Since sculpture should be attractive when viewed from all angles, negative space is conceived as less significant.

La Madre is a strong emotional piece. The love engendered by the buxom mother for her child is made even stronger by the gesture of caution and awareness of outside social forces. The crouched figure of the mother is distorted to amplify the devotion and love of her offspring.

In the rather expansive areas of smooth white alabaster, the artist has blended a subtle shade of gold that enhances not only the surface but allows for further study and appreciation. The smallness of the sculptured piece projects a strength that bolsters the importance of a mother and her child. The huge hands offer a safe haven and security for the young child.

Switching media is a difficult task, but Arye makes a successful transition in *Amigas,* which is made of chestnut wood with rosewood and maple inserts. It is a delightful theme and a satisfying piece. The theme is of friends in a warm semiembrace, a stalwart bodily couple. Both forms are finely chiseled and attached together appropriately. A profile view displays to advantage the warm friendship of the couple.

Although similarities exist between the two female figures, the inserts of rosewood and maple avoid the possibility of monotony. There is a bulkiness that is relieved by an opening between the lower torsos of the two forms.

The viewer may scan the entire sculpture, but eventually will focus upon the negative space between the eyes of the two friends. However, that empty space is filled by what can be thought of as unspoken words between the two. The looks of endearment are appropriately distanced. Were they further separated, the friendship would have been lessened.

The base anchoring the beloved couple seems unnecessary since the sculpture itself possesses a broad base. Removing the base would have lessened the heaviness attached to the piece. Nonetheless, *Amigas* is an attractive work developed from a difficult medium. The simplicity of form is not unlike the work of Jean Charlot.

El Rebozo, an engraved alabaster sculpture, displays strength and power equal

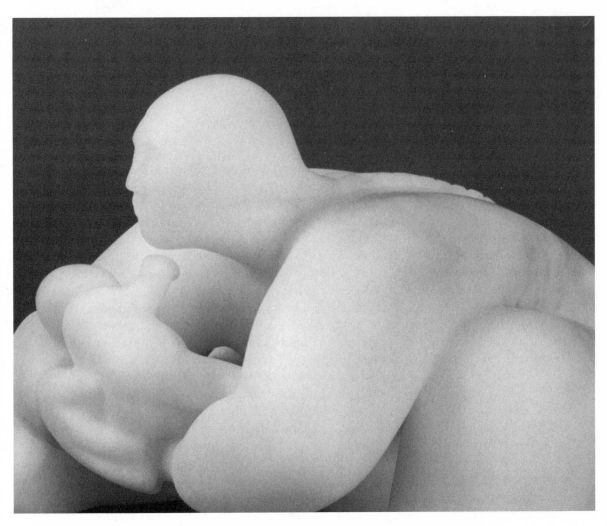

LA MADRE by Leonora Arye. Alabaster sculpture. 8½ × 12 × 10½ in.
Courtesy of the artist.

to its title. Regardless of the angle from which the piece is viewed, endurance and determination are obvious. Arye has managed to control power within a limited space. To sustain an explosive force and maintain its potential power is an amazing artistic feat. The massive unit is interrupted with deeply incised areas that flow naturally throughout the sculpture.

The strong facial expression is matched by a ponderous hairpiece. Distorted for the sake of the composition and to strengthen its message, the hair flows downward and diagonally, connecting with the child at the rear of the figure.

The Mayan cloth etched into the sculptured piece joins the textural grain of the alabaster. One is reminded of a prayer or petition for grace. Arye's sculpture retains a Latin American flavor while embracing the American scene. The two cultures are uniquely blended.

A detailed, delicately rendered decorative cape embraces the robust shoulders

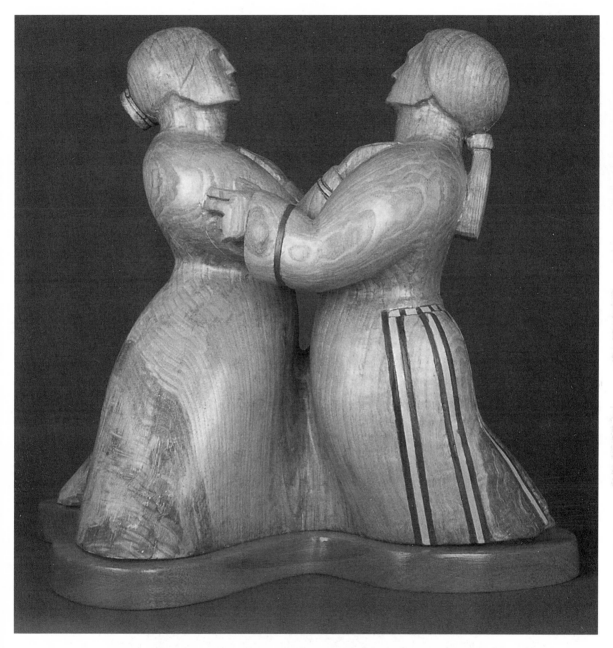

AMIGAS by Leonora Arye. Chestnut with rosewood and maple inserts.
Courtesy of the artist.

of the figure *Cosin Rosado*. The massive body with few but appropriate crevices identifies this piece with Arye's other works. The lower body segments are reminiscent of Botero's heavy set sculptures. The ornate shawl or serape draped over the subject's shoulders is balanced with the same design on the hem of the skirt. The front and side views are particularly compelling, while the rear view is intercepted by the decorative shawl to break any monotony.

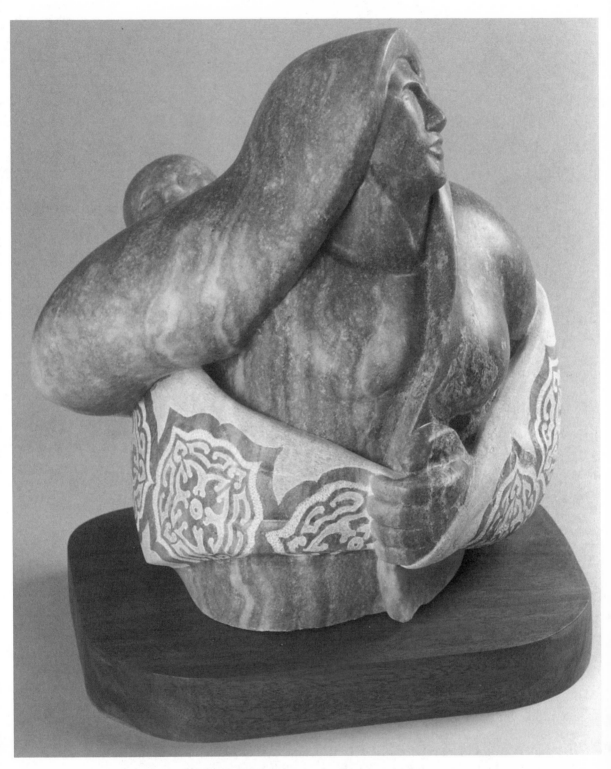

EL REBOZO by Leonora Arye. Engraved alabaster. 17 × 15 × 15 in.
Courtesy of the artist.

Again, the figure is glancing upward as if in a state of repentance. Hands are folded inward while feet are spread apart, creating a spiritual posture. The classic figure has a smooth exterior, with the shawl and skirt being the only textural surface. A religious atmosphere prevails. The three-dimensional structure is balanced by positive shapes and negative space. The entire body is made up of curved segments culminating in a compact work of art. The subject's head seems to emerge from the sharply defined shawl, producing a sense of rebirth. Again, the spiritual sense comes into being. The only visible flesh are the face, arms, hands and feet. All are exaggerated because of the strength and power of the figure.

Torciendo is a monumental limestone sculpture with an architectural concept. The two extreme points of contact are the elongated arms and their attached fingers that grip tightly to a horizontal base. A magnificent example of extreme distortion, *Torciendo* exhibits the power of womanhood.

The perfect blend of a positive shape and negative space, *Torciendo* is conceived as a truly three-dimensional structure, compelling from all four sides. The entire figure is without detail. The right leg of the figure extends into the frontal plane, inviting the viewer to interact with the sculptured form.

There is power in *Torciendo*, a strength that is domineering. Although both arms stretch and reach beyond normal limits, its span of space represents strength and determination. Arye has succeeded in creating a masterful sculpture that not only enters the mainstream of modern sculpture, but should make its mark among the nation's masterpieces.

Bolero is a charming alabaster sculpture of a female dancer. Again, lacy etching identifies appropriate areas of the figure. The delicate designs etched into the alabaster material enhances the upper torso, and the dancing gestures of the arms, also etched with the ornate decor, assist in balancing the composition.

Arye defies the notion of compatibility between style and idea. The buxom figure seems inappropriate for certain prescribed ideas. The figure gains identity from its stable and strong expression, irrespective of the notion it is expressing. *Bolero* features a graceful contradicting of the heaviness of the figure. The negative space between the body's contour and left arm creates a sense of positive shape and negative space working together.

Although the gesture is obvious, the nuances that exist throughout the sculpture create a contemplative mood. One is presented with an icon of sorts, a figure inviting viewer participation. Again, the figure's feet are planted solidly upon the base, illustrating the power within the subject itself. The body structure beneath the figure attire creates a thorough three-dimensionality. Although a mere 12 inches in height, it presents the strength and power of a life-size sculpture.

An added attraction to Arye's alabaster sculpture is the inclusion of a series of amethysts embedded into the embroidery of the subject's attire. Everyone may not agree, but Arye's powerful figure needs no embellishment. The huge hands and feet and comparatively small head indicate a power that is lessened with what appears to be an afterthought. It is understandable that one would alter a style in pursuit of artistic growth. But even without the jeweled adornment, the voluptuous body is powerful with its massive form and deep crevices.

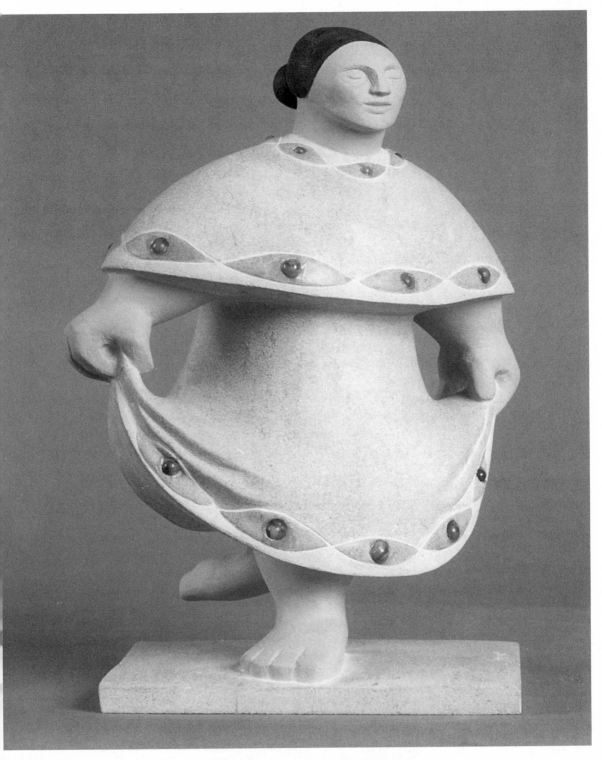

*BAILE by Leonora Arye. Limestone sculpture. 14 × 7 × 11 in.
Courtesy of the artist.*

Baile, a limestone piece with agate beads, uses the decorative attire to advantage. The figure displays strong hands and feet but with a sense of interpenetration. The negative space between the arms and body actually acts as a positive force along with the space delegated to the base of the figure. There is an obvious balance of design with the series of agate beads across the top, midsection and lower torsos.

The artist daringly darkens the hairpiece that becomes the initial focus of viewing. But the balance created at the base of the figure differs from her other works — a delightful change. Leonora Arye is indeed a remarkable sculptor and deserves recognition by an even broader audience.

Career Highlights

Born in New York City.

EDUCATION
Attended the University of Mexico; B.A. degree from Heidelberg College; studied painting at the Art Students League; studied sculpture with Lorrie Goulet and Hana Geber.

SOLO EXHIBITIONS
Mari Galleries, Mamaroneck, New York, 1994; Shirley Scott Gallery, Southampton, New York, 1989; Expo Design, Glencove, New York, 1988; Mari Galleries, Mamaroneck, New York, 1987; C & J Gallery, Little Falls, New Jersey, 1987; Couturier Gallery, Stamford, Connecticut, 1986; C & J Gallery, Little Falls, New Jersey, 1986; Shirley Scott Gallery, Southampton, New York, 1985; Mari Galleries, Mamaroneck, New York, 1984; Shirley Scott Gallery, Southampton, New York, 1981; Mari Galleries, Mamaroneck, New York, 1980.

GROUP EXHIBITIONS
Goodan Gallery, Southampton, New York, 1994; Couturier Gallery, Los Angeles, California, 1993; Hammond Museum, New Salem, New York, 1992; Traveling Show in India, 1990; Pelham Art Center, Pelham, New York, 1987; Hudson River Museum, Yonkers, New York, 1986; National Arts Club, New York, New York, 1985; Salmagundi Club, New York, New York, 1984; Pen & Brush Club, New York, New York, 1983; City Gallery, New York, New York, 1982; Museum Gallery, White Plains, New York, 1981; Albany Institute of History and Art, Albany, New York, 1980; Nadeau Gallery, Philadelphia, Pennsylvania, 1979; Broome Street Gallery, New York, New York, 1978.

SELECTED AWARDS
Anna Hyatt Huntington Award, 1995; Gold Medal, Allied Artists of America, 1994; American Artists Professional League Award, 1990; Paul Manship Memorial Award, 1988, 1990; Morris J. Helman Award, National Association of Women Artists, 1987.

Marta Ayala

According to Marta Ayala, a native of El Salvador, "Keeping the child in me alive at all times allows me to freely explore color, space, texture and volume in a wide variety of media." The above statement to the author indicates Ayala's commitment. Once committed, her mind seldom meanders. It focuses totally on the ingredients, which all but guarantees a successful work of art. The unity of mind, body and spirit in simultaneous action during the creative process is essential to the art form.

There is a sense of the primitive in Ayala's work. In her painting *Self-Portrait*, a young face is sharply contoured, but an outline is used to separate a segment of her body from the background. This is a simple device used by a child to distinguish one shape from another. It is also a mark of the self-taught artist.

Self-Portrait is a simple composition. The image of the artist is predominant and resides in the forefront. A dream image of her becomes secondary both in color and placement. Ayala reveals herself as a contented being. However, one wonders if the dream creates the smile of contentment, or if the smile results from other factors.

The portrayal of life is simply and vividly expressed in the symbolic painting titled *Rebirth*. The subjective portrayal leaves no room for speculation. The newly born animal life is a spiritual commitment to one's own creator. The close-up view of a new life reveals a young bird, symbolic of newborn creatures struggling to maintain a level of survival.

The young bird nestled in a sea of grass is alone in nature's grasp. The calculated brushstrokes, although seemingly spontaneous, shelter the young creature. The bird and environment become one element. Adjacent to a muted sky, the young life will soon be free.

The young fledgling is a lovable creature. Its feathers match the soft grassy area surrounding the subject matter, creating a oneness. The compatibility of subject matter and habitat is a form of subjectivity that forces the viewer to not only acknowledge the subject's presence but to react in a positive manner. The muted sky, although temporarily quiet, seems ready for the bird's flight.

Rebirth also symbolizes the resurrection of man in the hereafter. Thus, Ayala's portrayal is a spiritual and enduring notion. The artist has eliminated an initial baseline by extending the grassy foreground upward, thus incorporating the subject with the surrounding area.

The swirling abstract *Hawk Eyes in the Sky* is a calculated design of geometric shapes that seem cemented in place but maintains a strong appearance of movement.

SELF-PORTRAIT by Marta Ayala. Oil on canvas. 18 × 24 in.
Courtesy of the artist.

The revolving eyeballs are positioned in a slightly vertical pattern. Without knowing the meaning of the work, one is confronted with an exciting, somewhat expressionistic pattern of color, textural contrast and formal composition.

The beauty of *Hawk Eyes in the Sky* rests in the various interpretations possible. Regardless of a literal representation, the painting is a pleasant arrangement of colored shapes. There is an underlying color that creates a spatial effect and amplifies a spatial distance. That background or underlying color represents the sky.

Ayala has repeated her textural environment witnessed in *Rebirth* and other works. The hawk eyes suggest hand grenades, bee hives, torpedoes, bullets and other disastrous elements. Because the work of an artist is somewhat subconscious, interpretations may be equally subconscious, making it difficult to accept certain works.

Ayala's painting *Frutas on Melting Plates* joins several individual elements together to form a single unit. Each plate is a base for a single fruit, but each plate

*HAWK EYES IN THE SKY by Marta Ayala. Acrylic on canvas. 36 × 24 in.
Courtesy of the artist.*

joins others to form a trio or team. The similarity of the fruit and the anchoring plates make the six separate items seem as one. Separate environments also join forces to become one.

The strong triangular foreground is diminished somewhat by the three melting plates that anchor the three separate pieces of fruit. The vertical background strengthens the diversification of arrangement.

A source of light exists solely by choice for the sake of the composition. In order to avoid monotony, Ayala positions each of the three pieces of fruit at different angles. Even though the three images form a baseline at an angle, three separate planes are nonetheless utilized. To keep the top plane in the picture frame, the artist introduces dagger-like shapes protruding downward.

Dreams are a recurring theme for Latin American artists, of which Marta Ayala is no exception. Her drawing *Dreaming* demonstrates the sin of lust and sexual notions, but not without divine observance. *Dreaming* is a complex composition revealing sexual amusement. The dream becomes a pleasurable act. As an artistic composition, Ayala has included three separate compositions, each dependent upon the other. In the lower right hand corner is a female head whose face registers a look of contentment. The dream itself is expressed to the left of the working surface, and the third composition rests in the upper right corner. The image of the

DREAMING by Marta Ayala. Charcoal on paper. 11 × 17 in.
Courtesy of the artist.

heart occupying the third composition appears agitated and disturbed because, as a divine being, sexual thoughts directed toward a mortal being are sinful.

There is a temporary pleasure followed by shame and atonement. Even though the three compositions blend in theory and in arrangement, each must be considered in terms of the whole.

Mujer de Razos Africanos is a simple pose of an African American but emerges as a provocative image. The contemplative form portrays the purity of life. Although the contours of the figure are not vital for definition, they do serve to reinforce the gesture of the individual. A glow of light envelops the human form, creating a hallowed setting. The human figure is not as essential as the emotional environment it creates. It is the mood that portrays the subject, rather than the subject creating the mood.

The diffusion of light positioned at the back side of the figure creates a suggestive and speculative environment. With the lighter areas concentrated in the center of the canvas, Ayala darkens both the top and bottom segments to balance the composition and vary in tone a large segment of the canvas. Although considered in concept to be realistic, this technical aspect creates an emotional distortion that leans toward expressionism.

The exposure of the human body to the outside world is frequently misinterpreted. One can only speculate as to the artist's choice of subject matter to serve a specific cause. The simple pose in *Mujer de Razos Africanos* is an image of contemplation, making one question whether or not the artist's purpose could be served as well with a clothed figure.

Furthermore, there is no disguise. The human form is free for debate and discussion. The artist's intention is not always acknowledged or accepted. Nonetheless, the artist's intent has been registered.

In a sense, Ayala's work falls into the mainstream of American art. Her cultural heritage is evident in her primitive approach. In a statement to the author, Marta Ayala sums up her philosophy: "My vision is called primitive because the vivid colors and naive representations call forth ancient emotions. They are a vibrant and powerful affirmation of life."

Career Highlights

Born in El Salvador.

EDUCATION
Studied at the San Francisco City College, 1977–78; studied at the Art Institute of Sucre, Venezuela, 1980–82; apprentice muralist to Susan Cervantes, 1989–93; studied at San Francisco City College, 1994–93.

SELECTED SOLO EXHIBITIONS
Mission District, San Francisco, California, 1995; Department of Social Services, San Francisco, California, 1995; Mission District, San Francisco, California, 1995; June Steingart Gallery, Oakland, California, 1995; June Steingart Gallery, Oakland, California, 1994; Mission District, San Francisco, California, 1994; Department of Social Services,

Opposite: *MUJER DE RAZOS AFRICANOS by Marta Ayala. Oil on canvas. 24 × 48 in. Courtesy of the artist.*

San Francisco, California, 1992; Mission
District, San Francisco, California, 1991.

SELECTED GROUP EXHIBITIONS
Mission District, San Francisco, California,
1995; Somar Mural Resource Center, San
Francisco, California, 1995; Mission Dis-
trict, San Francisco, California, 1995;
Department of Social Services, San Fran-
cisco, California, 1993; Precita Mural Arts
Center, San Francisco, California, 1992; La
Galería de la Raza, San Francisco, Califor-
nia, 1992; Mission District, San Francisco,
California, 1991.

MURALS
Cesar Chavez School, San Francisco, Cali-
fornia, 1995; Clarion Alley Mission District,
San Francisco, California, 1994; Cleveland
Middle School, San Francisco, California,
1994; Embarcadero Mural Project, San
Francisco, California, 1994; Earth Island
Institute, San Francisco, California, 1993;
Ingleside Presbyterian Church, San Fran-
cisco, California, 1992; Balmy Alley, Mission
District, San Francisco, California, 1992.

Santa Barraza

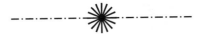

Born in Texas in 1951, artist Santa Barraza is considered to be the backbone of the Chicano artist's movement. Her paintings document her search for her cultural roots. A strong religious affirmation blends with the tradition of Aztec symbolism. Womanhood has a fundamental role in the Chicano culture, and Barraza utilizes it to the fullest.

Our Lady of Guadalupe is an ideal envied by the Mexican society. A cherished role model for women, the Virgin Mother of Christ is often portrayed in art. In Barraza's painting *La Lupe-Tejana*, the Virgin of Guadalupe occupies the central portion of the painting. Acting as a baseline, the forefront masterpiece includes Chicano symbols. The dress of the Blessed Mother is also expressed with symbols combined with pre–Columbian cultural elements.

Barraza's work is devoted to the future of womanhood. In *La Lupe-Tejana*, the woman is united with the earth, the source of life. Her work is consistently both objective and subjective in that the central theme occupies the majority of the working surface, but allows for secondary features to accompany it.

Barraza is seeking a new beginning in blending the old with the new culture, the Mexican with the American. She is currently in limbo, fluctuating between the beliefs of her childhood as a Chicano and her entry into the new world of America.

Her strong belief in motherhood as a motivational force in her work remains a strong element of Chicano art. Mainstream artists give little heed to the woman as a mother, and it is Barraza and her movement who are attempting to inculcate the significance of motherhood into the American mainstream, not as a detachment from Americanism but as an inclusion or facet of American artistic expression.

La Virgen, a 1990 rendition of Our Lady of Guadalupe, presents a sullen woman. Barraza has draped the Virgin with a typical cape covering her head and shoulders. Her Chicano facial features reflect a humility akin to the Blessed Mother. A plant of life stands before her, adjacent to a row of pink roses that compensate for the desolate landscape of cactus-type plant life.

The Virgin, painted in flat geometric planes, contrasts sharply with the expressionistic style applied to the background of three distinct horizontal planes. The churning sky of varying tones of blue settling over a roughly applied mountain range coincides with an equally expressionistic desert land.

There is a primitive appearance as the plant life recedes in opposition to the swirling sands of the desert. Extreme care is rendered to the Virgin image in contrast to the surrounding environment.

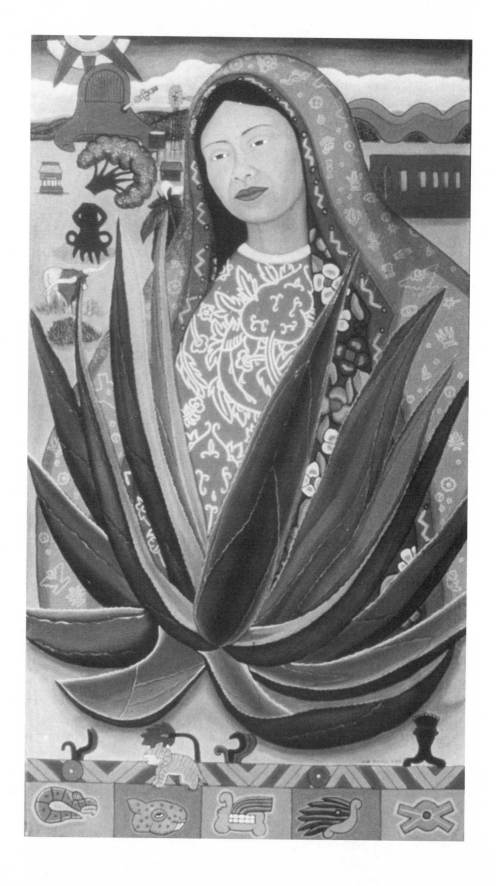

Above: *LA VIRGEN by Santa Barraza. 1990. Oil on aluminum. 8 × 10 in.*

Opposite: *LA LUPE-TEJANA by Santa Barraza. 1995. Oil on canvas. 30 × 50 in.*

Both courtesy of the artist.

Sincerity and a sense of faith in the future can be seen in the face of the Virgin, a sense of premonition. Such events have occurred and appear in Barraza's masterpiece, *La Malinche*, a 1991 production. A small painting measuring a mere 8 by 9 inches, it nonetheless portrays a vivid expression of new life. The maguey plant is positioned in front of the handsome woman who bears in the center of her breasts the image of an unborn child. Barraza has placed the child image where the woman's breasts and maguey plant intercept.

Motherhood again consumes much of the working surface, a focus on the present and future life. The past is portrayed as secondary to a beautiful female image with finely chiseled facial features and an intricately designed headpiece. The woman's eyes appear to glance at her breasts and the maguey plant simultaneously. The background is a deep red color, harboring three crosses reminiscent of the crucifixion of Christ.

LA MALINCHE by Santa Barraza. 1991. Oil and enamel on metal. 8 × 9 in.
Courtesy of the artist.

In front of the crosses rides a man on horseback. In the other corner, a man has been hanged from a tree; an ominous hooded figure stands below him.

Barraza has combined her earlier folk art style with a modern concept. The primitive approach usually utilizes flat colors, while so-called "high art" is characterized by visual recession and advancement of color. By incorporating both styles, Barraza seeks to secure a wider and more diverse audience.

Her painting *Virgen con Corazón*, a 1991 rendition, features a series of diagonal rays of repeated colors. An anatomical heart is painted onto the breast of the Virgin, and within are painted the aorta and major arteries. The heart is more than a physical segment of the Virgin's anatomy; it is a symbolic reference to the compassion and love for mothers and motherhood.

A typical headpiece is draped over her head and shoulder, and the attire of her upper body is designed with glittering and colorful symbols. Barraza relates the Blessed Virgin, the Mother of God, with all mothers.

An appropriate painting executed in 1992 is *Homage to My Mother, Frances*. In it, Barraza places the maguey plant in the forefront as a centerpiece to the surrounding audience of kinfolk and friends. The kindness, compassion and love given to others by her mother are remembered and memorialized in *Homage to My Mother, Frances*. Outside the square centerpiece are op pop female portrait heads, each posed adjacently to symbolic earthly images. The mother is a replica of the *Virgen con Corazón*. The eyes of each participant are wide open as if to celebrate life not for oneself but for the artist's mother and to use the artist's mother as a role model.

Barraza's mother series is motivated not only by a personal concern but cultural identity, as noted in a statement to the author: "My artwork becomes a manifestation of a struggle to create a new American identity, affirming cultural congestation and survival. I express my experience — as a Mexica Tejana, a Chicana — occupying, interpreting, defining and living in a unique space of dissociation of identity, enriched with culture and legends."

Career Highlights

Born in Texas in 1951; lives in Chicago, Illinois; became assistant professor at LaRoche College and at Pennsylvania State University; currently an associate professor at the Art Institute of Chicago.

EDUCATION
B.F.A. degree from the University of Texas, 1975; M.F.A. degree from the University of Texas, 1982.

SOLO EXHIBITIONS
Dos Chihuahuas Gallery, San Antonio, Texas, 1996; Catholic Theology College, Chicago, Illinois, 1995; Kohler Arts Center, Sheboygan, Wisconsin, 1993; Museum of Fine Arts, Oaxaca, Mexico, 1993; Blair County Art Museum, Hollidaysburg, Pennsylvania, 1992; Johnstown Art Museum, Johnstown, Pennsylvania, 1992; LaRaza Galería Posada, Sacramento, California, 1992; Mexican Museum, San Francisco, California, 1991.

GROUP EXHIBITIONS
Suburban Fine Arts Center, Highland Park, Illinois, 1996; Firehouse Gallery, Houston, Texas, 1995; Artspace, New Haven, Connecticut, 1995; Phoenix Art Museum, Phoenix, Arizona, 1995; Gallery 312, Chicago,

HOMAGE TO MY MOTHER, FRANCES by Santa Barraza. 1992. Acrylic. 54 × 60 in.
Courtesy of the artist.

Illinois, 1995; Elmhurst College, Elmhurst, Illinois, 1995; Northwestern University Settlement House, Chicago, Illinois, 1995; Yerba Buena Garden Center, San Francisco, California, 1995; Mexican Museum, San Francisco, California, 1994; Luigi Marrozzini Gallery, San Juan, Puerto Rico, 1994; Fondo del Sol Gallery, Washington D.C., traveling exhibit to New York, Boston, Seattle and San Francisco, 1994; Artemisia Gallery, Chicago, Illinois, 1994; Castillo Gallery, Chicago, Illinois, 1994; Edinboro University, Pennsylvania, 1993; Rosary College Gallery, River Forest, Illinois, 1993; Penn State University, University Park, Pennsylvania, 1993; Insights Gallery, Seattle, Washington, 1993; Long Island University, Brooklyn, New York, 1993; Owen Patrick

Gallery, Philadelphia, Pennsylvania, 1993; Calvin-Morris Gallery, New York, New York, 1993; Carla Stellweg, New York, New York, 1993; Foundation for a Compassionate Society, Rome, Italy, 1992; Channing Peake Gallery, Santa Barbara, California, 1991; Wight Art Gallery, University of California, 1985; Juarez Lincoln University, Austin, Texas, 1977.

Margo Consuela Bors

Margo Consuela Bors' flower paintings flourish with textural details and glowing color. In her serigraph *Sunflowers with Borders* she reveals a unique composition of positive stimuli and negative space. Although negative space is generally considered to be space surrounding the subject matter, or more simply stated, space left over, Bors has used the environmental space as an accent or contrasting element to promote the obvious.

The strong stalk and foliage blend completely with the delicately detailed sunflower itself. The central core of the sunflower is perfectly arranged in a symmetrical design surrounded by a wreath of delicate leaf-like flowers.

Although appearing in midair, the sunflower is balanced by border designs above and below the subject matter. Made up of complex flower patterns, the motif serves as a skyline and a baseline similar to those generally produced by early elementary children. The lower border design is a motif of birds, flowers and human imagery, while the upper border is a series of decorative diamond shapes.

Bors uses mundane objects and commonplace stimuli and creates fascinating work, as witnessed in *Sunflower with Border.* The combination of current stimuli and primitive images of yesteryears presents a unique handling of two cultures. They remain separate within a unified composition. The seemingly empty background becomes a positive force by its very existence.

A second work, *Poppies,* is a linocut. Its total consumption of the working surface elicits a subjective response from the viewer. It is a personal rendition of the artist's favorite stimulus. There is a continuous interweaving of poppy flowers and accompanying leafwork. Every image flows upward as if reaching toward heaven. There is a spring-like sense of reality, a celebration of sorts, life in full bloom and the anticipation of life. The vertical panel is ideal for the subject. Life is associated with the vertical rather than the horizontal. The lively overlapping of realistic shapes seems eager to continue growth. Yet, a climax occurs with the full blossoming at the top of the expression. The unopened poppies are anxious to continue their journey upward to reach the peak of life.

The weaving and overlapping of stems, flowers and leaves creates an exciting spatial background. Although the environment is mute, the positive images invade the negative space to complete the composition. Again, Bors has used the commonplace to create an expression of beauty. One is reminded of the delicacy of a ballet performance of *Swan Lake.*

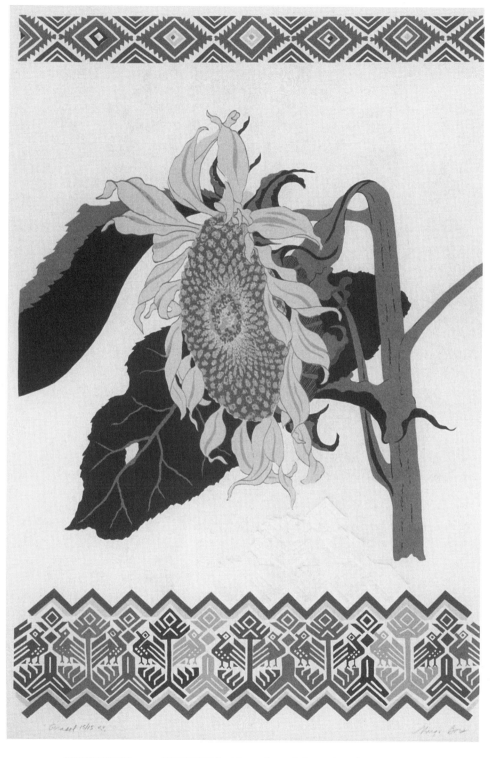

SUNFLOWER WITH *BORDERS* by Margo Bors. Color serigraph. 22 × 30 in.
Courtesy of the artist.

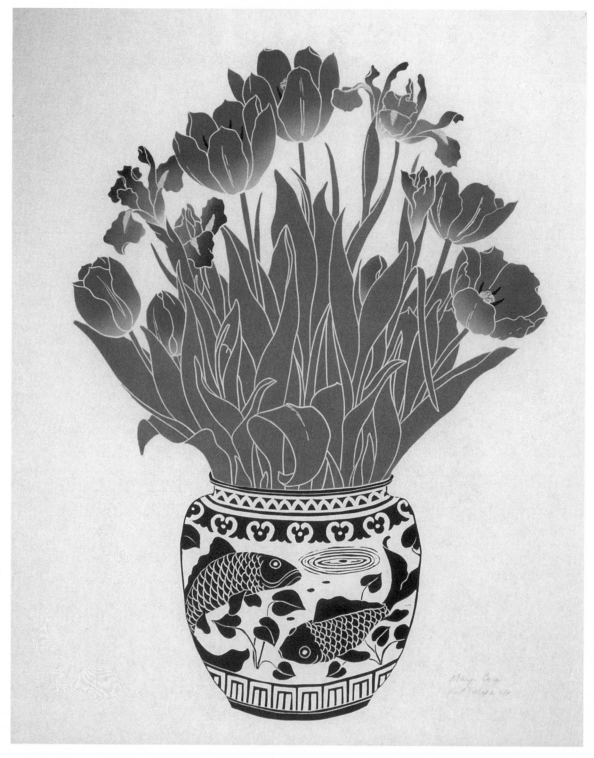

RED TULIPS by Margo Bors. Linocut. 30 × 21 in.
Courtesy of the artist.

In *Red Tulips* the image of flowers is subordinated to the receptacle in which it resides. The subject matter is forced to share its significance with the decorative urn. There is no elaborate environment. Actually, the background is negative space that acts solely to amplify the positive space.

The overlapping of flowers in full bloom and the petals that accompany them appear to be growing out of the urn rather than the earth itself. Depicted on the highly decorative urn are images of fishes, whirlpools and water flowers that are natural inhabitants of the tester.

The flowers that sustain the upper half of the linocut print are repeated in a subordinate manner but nonetheless balance the imagery. Again, the border designs as seen in *Sunflower with Border* are repeated in *Red Tulips*. They occupy the upper and lower segments of the urn as if to enclose and surround the symbolic fish and prevent their escape.

In *Red Tulips*, the artist opens up the flowers to full bloom, thus creating variations of negative and positive combinations. The opening of the flower petals creates not only a variety of positive aspects but results in varying degrees of spatial relationships. Even though *Red Tulips* appears to be formally balanced and centrally located, activity within the subject matter is informal and purposely diversified.

Sunflowers and Mayan Cloth presents ancient Mayan culture and contemporary American. The unusual segmentizing of the Mayan cloth and its extension outside the picture plane stem from the elementary sense of a simultaneous view of the top and front. Bors has arranged three sunflowers in front, forming an implied triangle. Other sunflowers are revealed from the side and rear views. In a dual function of symbolism and naturalism, a Mayan cloth repeats the sunflower image in a series and reveals a tightly knit composition of both transparent and opaque techniques.

The display of a primitive culture as seen in the Mayan cloth and the placement of the transparent vase holding the sunflowers present an abstract approach. The flatness of the Mayan cloth appears almost in contradiction to the vase of sunflowers. Yet, it is compatible with the sunflowers because of the flower motif repeated within the cloth itself. The backside of the cloth is cut away at the backside of the table on which it lies, while the front of the cloth defies reality by lying flatly in space.

Bors' affection for flowers is obvious. The two different styles of painting within a single expression complement one another. *Sunflowers and Mayan Cloth* presents a comfortable atmosphere for viewing.

Margo Bors' *Pink Lilies* is a complex but delicately rendered expression of a petite subject matter. There is competition between the flowered urn and the lilies sprouting from it. Two styles as well as conflicting color schemes constitute the flower theme. The lilies overlapping the flowered vase dominate the composition, partly because much of the vase in which the lilies reside is overlapped, and partly because the pink lilies extend into the surrounding environment.

Bors' work is realistic, with a touch of quiet emotionalism. The primitive appearance of the flowered vase downplays the illusion of three dimensions, while

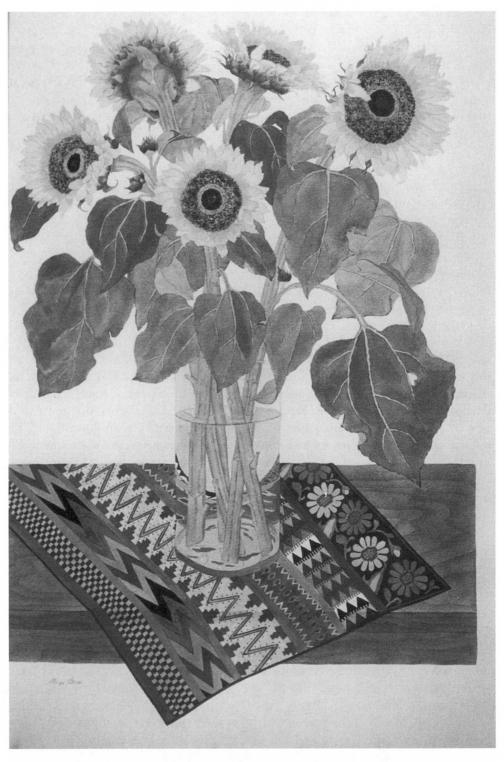

SUNFLOWERS AND MAYAN CLOTH by Margo Bors. Watercolor. 24 × 42 in.
Courtesy of the artist.

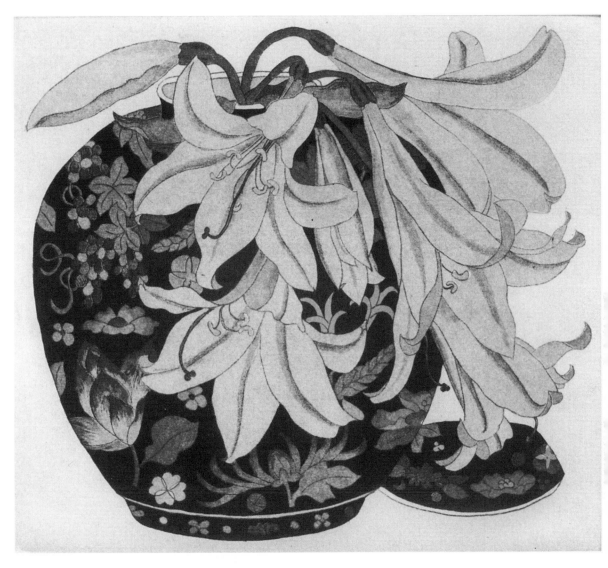

PINK LILIES by Margo Bors. Etching. 9 x 8 in.
Courtesy of the artist.

the lilies stemming from the two-dimensional image of the vase reveal a delicate three-dimensional appearance.

Because of the flat opaque design of the flowers painted upon the vase's surface and coupled with the partially transparent pink lilies, a seemingly contradictory subject prevails. And yet, the two forces appear compatible.

Margo Consuela Bors' flower paintings are mainstream in theme and represent a common ground as an American subject.

A muralist as well as an easel painter, Margo Consuela Bors combines her talents with such renowned artists as Susan and Luis Cervantes and Tony Parrinello in creating murals throughout the San Francisco area.

Career Highlights

EDUCATION

B.A. degree, University of Rochester, New York, 1963; foreign studies, University of Mexico, Mexico City, Mexico, 1992; docent training in Asian Art at the Asian Art Museum and in Native Arts of Africa, Oceana and the Americas at the de Young Museum, San Francisco, California, 1966–73; independent studies in fine arts at San Francisco City College 1976–93.

SELECTED SOLO EXHIBITIONS

University of California Medical Center, San Francisco, California, 1995; HCR Library of Horticulture, San Francisco, California, 1995; Garibaldi Gallery, San Francisco, California, 1992; Goat Hill Gallery, San Francisco, California, 1988; Gramercy Towers, San Francisco, California, 1984; Helen Crocker Russell Botanical Gardens Library, San Francisco, California, 1984; Potrero Branch Library, San Francisco, California, 1983.

SELECTED GROUP EXHIBITIONS

Stanwood Gallery, San Francisco, California, 1995; Triton Museum of Art, Santa Clara, California, 1994; Luther Burbank Center, Santa Rosa, California, 1994; Galería Museo, San Francisco, California, 1993; Arts Concepts Gallery, Walnut Creek, California, 1992; Berkeley Art Center Gallery, Berkeley, California, 1991; Gumps Gallery, San Francisco, California, 1991; U.S.–U.K. exchange exhibit with Barbecan Centre, London, England, 1989; Salford Museum and Art Gallery, Salford, England; University of Warwick, Coventry, England, Royal West Gallery, Bristol, England; Brighton Polytechnic Gallery, Brighton, England, 1989; Banaker Gallery, San Francisco, California, 1987; Civic Center, San Francisco, California, 1981.

SELECTED MURALS

Cesar Chavez School, San Francisco, California, 1995; San Francisco State University, San Francisco, California, 1991; Bryant School, San Francisco, California, 1989; Community Food Resource Center, San Francisco, 21 ft. high × 180 ft. long, 1988; Strybing Arboretum, Golden Gate Park, San Francisco, California, 1985; Potrero Branch Library, San Francisco, California, 1982; Herrick Hospital, Berkeley, California, 1981; Portable mural, Bernal Branch Library, Barclay's Bank, the Mexican Museum and Los Americas Children's Center, all of San Francisco, California, 1977.

Maria Brito

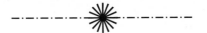

In a letter to the author, artist Maria Brito claims that her work "is a means of communication with others. It is the medium through which I explore my personal experience as I engage in a dialogue with the spectator, who, by seeing my work, can identify with its content and message through the recognition of similar events that have shaped their lives."

It is a tremendous assumption on the part of an artist that a viewer will be receptive to her work, because the work is deeply personal. Since much of Brito's art is intuitively expressed and of a subconscious nature, it is indeed difficult for the laity to experience sensations equal to that of the artist. A case in point is the work *El Patio de Mi Casa (The Courtyard of My House)*. Particular items are obviously recognizable, while others are totally alien. The sculptural installations of Brito are highly personal. Although some objects are readily recognizable, the total expression creates a mood of speculation. Thus, communication remains an unsolved mystery. The viewer accepts the work on a different level, a level not in tune with that of the artist. An initial interpretation may suggest a kitchen in the house. Utensils identified as a cup, pan, towel rack, cabinet and range become communicable items by association.

In another quote to the author, Maria Brito claims: "My work deals with essential and universal existence as defined by emotions, sensations, personal memory, psychological situations, knowledge and perception. However, the ways in which these elements might be present in the works remain as much a mystery to me as I hope they do for whoever views them."

Brito seems to prefer a misinterpretation rather than an artistically correct evaluation, if that is possible. Her work cannot be easily categorized as intuitive since the finished art form is made up of objective, definitive objects recognizable in the literal world. The process of creation for Brito is indeed intuitive, but the final art form suggests otherwise. There is excitement in discovery, and perhaps Maria Brito relishes the fact that she knowingly has created an art form of surrealism. The photo of *El Patio de Mi Casa* reveals a single angle. Thus, a major mystery remains since a portion of the installation is not revealed.

In the intriguing installation *Self-Portrait*, large wheels form the basis of an unusual wheelchair. If one were to ignore the title and enjoy several commonplace items composed into a unique vehicle of transportation, one might eventually journey into the mind of the artist.

The self-portrait suggests several episodes of suffering and frustration: the

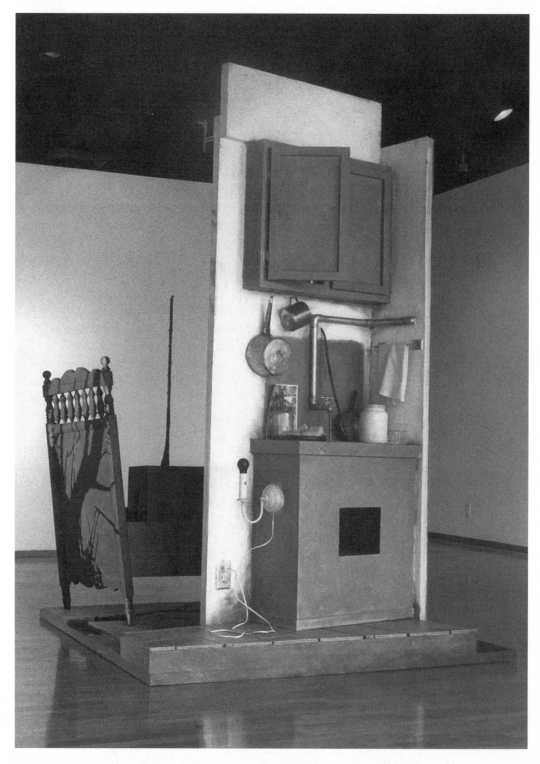

EL PATIO DE MI CASA by Maria Brito. Acrylic on wood/mixed media. 1991.
Courtesy of the artist.

caged-in head gear; the troubled tree branch representing life under stressful circumstances; the flower-like imagery symbolizing a fiery environment and livelihood.

Light plays an important role in the assessment of a sculptural art piece. The beauty of an abstract work of art is in the viewer's search for the truth or the intention of the artist. *Self-Portrait* is a revelation. Each viewer will interpret *Self-Portrait* in light of one's own experience, and viewers' interpretations very seldom coincide with those of the artist.

The huge wheels forming the base of the installation are given significant value by the artist. If the viewer were to seek the meaning of *Self-Portrait*, the joy of observation would be lost. It would be more gratifying to appreciate the work as it exists: its contrast of large and small shapes, its contrast of dark and light, its various textural surfaces, its symbolism, and its contrast of linear and solid forms. Because of her strong Catholic environment, a spiritual aspect is usually present in Brito's works. In *Self-Portrait*, a twig resembling a miniature tree is a symbol of life beyond death. The Crucifixion comes to mind, reminding that in spite of sacrifice and agony, one continues to live according to God's will.

Maria Brito is an exiled Cuban, a woman, a mother, a wife, a Catholic and an artist. Her road to success was frustrating at times but navigated with persistence, patience and prayer.

Introspection: Childhood Memories presents eerie circumstances from which dramatic episodes could be created. The eerie mood is created by the contrast of darks and light surrounding the two naked chairs and the partial wall with opened door. One is also reminded of a confessional in which both priest and penitent are not yet ready to confess and absolve.

One's eye travels from chair to chair to the mysterious space between the open chair and the partially hidden chair, behind the ghostly looking doorway. The cord attached to the open chair and stretching to the partially hidden chair creates a suspenseful visual experience. Since it is a childhood memory, the artist alone knows its meaning.

The space between both chairs creates a visual tension, a mental tug-of-war that is never resolved. It is this unknown aspect that makes for the mystery. Although the installation is personal, particular elements are reminders of past experiences.

The darkness surrounding the installation adds to the mysterious event that has yet to take place. The anticipation creates an emotional intensity that sustains its own control over a future event that will not be visible but mental, a recollection of past experiences. Brito's work may prompt a memory, or it may totally obscure such a remembrance.

The viewer may respond to this work in either a positive or negative manner. Brito insists that her work is intuitive, yet the finished product suggests otherwise. The establishment of three-dimensional objects may be instinctively conceived but are purposely and logically positioned to render an objective image. Her work is contemplative, psychological and spiritual, and the responses to her work are equally so.

Brito's exquisite drawing ability is revealed in *The Juggler*, a fitting title for a serious work. The children in the background appear troubled and in pain. The deeply personal revelation lends itself to extreme speculation. Communication

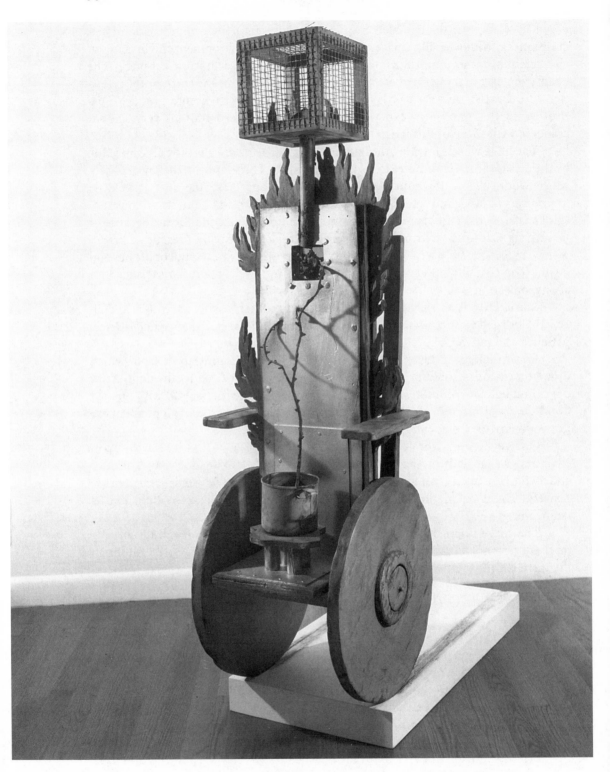

SELF-PORTRAIT by Maria Brito. Acrylic on wood/mixed media. 1989.
Courtesy of the artist.

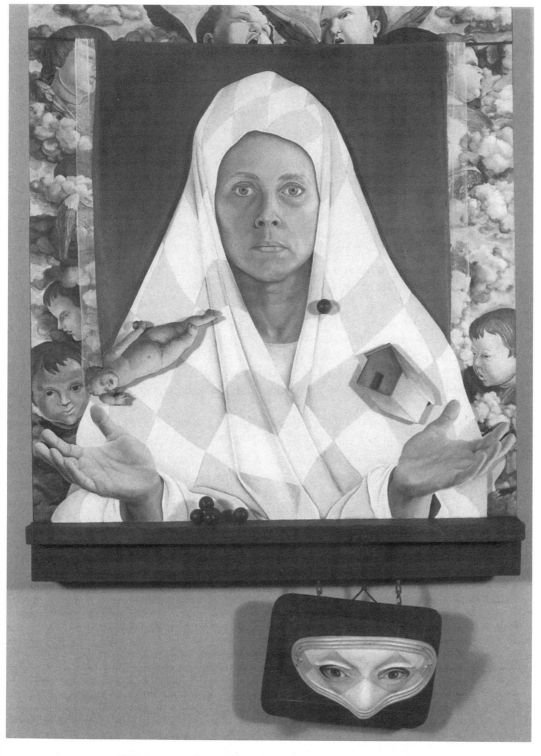

THE JUGGLER by Maria Brito. Oil on wood/mixed media. 1989.
Courtesy of the artist.

becomes secondary to the art form itself. The beautiful woman is shrouded in a pure white headpiece that resembles a nun's habit. The struggle to free oneself of the frustrations of life becomes a tormenting experience. The perfectly rendered face, exquisitely modeled, reveals Brito's mastery of anatomy. The woman's hands are spread apart as if to offer herself to someone greater than she — a universal religious gesture. The mask resides outside the picture plane but is an essential part of the installation, portraying the same eyes as appear in the female form.

The Juggler could well be a self-portrait. Even though a rather strange dilemma is presented, the portrayal of the juggler is magnificently rendered. *The Juggler* is a neatly packaged expression, one that serves the artist well but which leaves the spectator with unanswered questions.

The provocative subject matter of the work, realistically rendered, may well be classified as surrealism by the viewer. In spite of various items of interest, the subject's facial expression demands and maintains the viewer's attention.

Even more provocative is the work *The Traveler (Homage to B.G.)*. The rectangular form in which the subject matter resides is a window frame through which the female form pleads for an answer. A 1993 production, it raises several psychological questions. Because of its intimate nature, the viewer may ignore its meaning and instead focus on the composition, color and technique.

The influence of Spanish master Salvador Dalí is seen in the subject's rendering of clothing. Remnants of the subject's past are attached to a darkened wall. Instead of the infinity represented by the land and sky connection, Brito has attached the sky image to the wall in the form of a picture. Eve is pictured in the Garden of Eden along with a portrait of a small child.

The subject herself is haunted by devils, a crown of naked creatures forming a demonic halo. A jar of fluid leaks onto the floor and into a bucket that is placed outside the installation frame. The hands of the subject are marked with faces. The female is boxed in a small compartment, alone with her horrible past. One is reminded of shock treatments and the electric chair. *The Traveler* is an eerie and surreal portrayal, and the viewer is left with unanswered questions. Regardless of unidentified meanings, *The Traveler* ranks high among the works of American art.

In Maria Brito's installation *Meanderings*, thoughts meander in the form of concrete particles of body parts. The viewer is again treated to a provocative revelation, a search for the intimacy of the artist's life. *Meanderings* could well have been a painting, but the three-dimensional effect is more dramatic.

Instead of the head leaving one's body as portrayed, one is reminded of the soul leaving the body for an unknown destination. As the particles of life painted onto a dark background meander into space and become smaller as they recede, a form of man rises from the dead.

In a letter to the author, Brito explained: "Part of my purpose is to give concrete presence to that which is actually in the mind." *Meanderings* reflects a mental image, perhaps a dream that is recalled and transformed into a concrete structure. Such an intimate expression, much like all of Brito's work, offers a wide range of speculation. An intuitive work is seldom responded to in an equally intuitive manner by the unprepared audience.

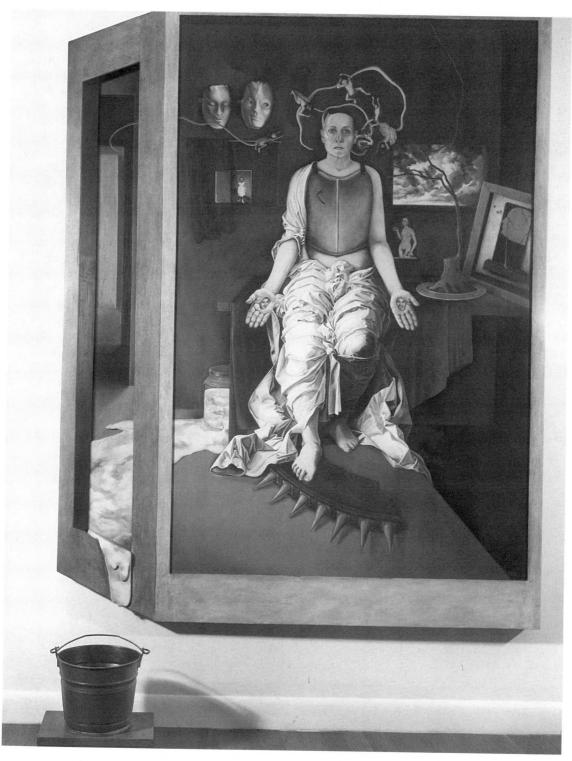

THE TRAVELER (HOMAGE TO B.G.) by Maria Brito. Oil on wood/mixed media. 1993.
Courtesy of the artist.

Career Highlights

EDUCATION

B.E. degree, University of Miami, Coral Gables, Florida, 1969; M.S. degree, Florida International University, Miami, Florida, 1976; B.F.A. degree, Florida International University, 1977; M.F.A. degree, University of Miami, Coral Gables, Florida, 1979.

SOLO EXHIBITIONS

Gutierrez Fine Arts, Miami Beach, Florida, 1994; Barry University, Miami Shores, Florida, 1991; Middleton-McMillan Gallery, Charlotte, North Carolina, 1990; Inter-American Art Gallery, Miami, Florida, 1989; Museum of Contemporary Hispanic Art, New York, New York, 1989; The Anne Jaffe Gallery, Bay Harbour, Florida, 1988; Kennesaw College, Marietta, Georgia, 1987.

SELECTED GROUP EXHIBITIONS

University of Miami, Coral Gables, Florida, 1995; Morton Gallery of Art, West Palm Beach, Florida, 1994; Cornell University, Ithaca, New York, 1993; State University at Cortland, New York, 1993; Galería de la Raza, San Francisco, California, 1992; Museum of Contemporary Art in Chicago, Illinois, 1991; The High Museum of Art, Atlanta, Georgia, 1991; Studio Museum in Harlem, New York, New York, 1990; The Lannan Museum, Fort Worth, Texas, 1989; Lehigh University, Bethlehem, Pennsylvania, 1989; Olympic Park, Seoul, Korea, 1988; Los Angeles Municipal Art Gallery, Los Angeles, California, 1988; Rutgers State University, New Brunswick, New Jersey, 1987; University of South Florida, Tampa, Florida, 1986; Thomas Center Gallery, Gainesville, Florida, 1986; Florida State University, Tallahassee, Florida, 1985; Florida Center for Contemporary Art, Tampa, Florida, 1985; University of Southern California, Los Angeles, California, 1984; Metropolitan Museum & Art Center, Coral Gables, Florida, 1984; Cuban Museum of Art & Culture, Miami, Florida, 1983; Miami-Dade Community College, Miami, Florida, 1983; Aaron Berman Gallery, New York, New York, 1982; Lehigh University, Bethlehem, Pennsylvania, 1982; Frances Wolfson Gallery, Miami, Florida, 1981.

Graciela Bustos

Born in Colombia, Graciela Bustos arrived in the United States and in 1990 received a B.F.A. degree from Eastern Michigan University. Although she is versatile in several media, painting and sculpture are best suited to her talents. Her painting *Mother* reveals a strong expression of the abstract expressionist movement. A 1994 acrylic painting, its several layers of pigment form dramatic effects on the canvas surface. The freedom with which the colored acrylics are dripped, scraped and brushed into place are both instinctive and controlled. It matters little whether the title preceded the painting or was an afterthought. Although the title identifies the painting, several interpretations could be reached in the absence of one.

The head of the mother and her upper torso are rendered in casts of white with little variation. There is an aromatic sense, a sensuous feeling about the figure. Although the paint is controlled, the effects remain free and spontaneous.

Colors are rich and sensuous and remind one of Renoir and the French impressionists. Color is applied over color, and yet numerous colors join forces to create a dynamically rich assortment of colors. Lush purples, brilliant yellows, blushing reds and romantic blues combine to form a beautifully subjective portrayal of a popular subject.

A cross or crucifix is a theme frequently dismissed by artists because of its sacredness. An unworthiness to express the holy sacrifice is the usual reason. Graciela Bustos has avoided the crucifix, but not the cross. In her sculpture *Cross*, the cruciform is present in its simplest terms. The vertical post is black, symbolizing death, and the crossbar is red, representing the blood of the victim.

Cross is composed of a single horizontal and a single vertical. To interrupt the monotony of the simple construction, Bustos adds a guitar as a crosspiece. Done in red and shaped like a huge diamond, the guitar represents a spike used in the crucifixion.

The ceramic sculpture *There Is Hope* is a 1994 production. It is an abstract figurative form that seems gnarled from the base to the tip of the five foot statue.

In a statement to the author, the artist wrote, "My work has a common thread: my love and respect for life, nature, natural materials, and my desire to make the best out of my life." Her sculpture *There Is Hope* is an attempt to overcome emotional obstacles and obtain fulfillment. Like all abstract art, interpretations vary, but in this work the gnarled forms anchored at the base and reaching upward seem to signify a climb to success.

(Continued on page 60.)

GRACIELA BUSTOS

MOTHER by Graciela Bustos. 1994. Acrylic. 47 × 47 in.
Courtesy of the artist.

CROSS by Graciela Bustos. Mixed media. 1994. 75 × 42 × 36 in.
Courtesy of the artist.

BUILDING WITH *KNOWLEDGE by Graciela Bustos. 1994. 52 × 45 × 9 in.*
Courtesy of the artist.

UNTITLED by Graciela Bustos. 1994. Paint on wood. 52 × 79 in.
Courtesy of the artist.

Building with Knowledge is a pop version of a commonplace theme. The artist has utilized books to erect a vertical structure. Books are stacked three abreast horizontally. An irregular formal balance was obtained by the distribution of book color.

Building with Knowledge represents an unusual approach. Nonetheless, it defines Bustos' versatility. The work is a physical form of building knowledge and relates to the mental capacity to absorb the learning within the stack of books, which can be broadened and extended to increase erudition.

A form of controlled abstract expressionism is witnessed in her piece *Untitled*. It was executed in 1994 and reveals a formally balanced series of doodles worked within boundaries. Limited to a skimpy palette of black and white, gray shadows are created by the adjacent positioning of black and white. The title enables the viewer to consider several interpretations, although color, style, and composition supersede meaning.

Career Highlights

Born in Colombia.

EDUCATION
Associate in liberal arts, Oakland Community College, Michigan, 1988; B.F.A. degree from Eastern Michigan University, 1990; Center for Creative Studies, Pontiac, Michigan, 1992.

JURIED EXHIBITIONS
Creative Arts Center, Pontiac, Michigan, 1995; Kalamazoo Institute of Arts, Kalamazoo, Michigan, 1995; Stubnitz Gallery, Adrian, Michigan, 1995; United Community Center, Milwaukee, Wisconsin, 1994; Winder Street Gallery, Detroit, Michigan, 1993; Cobo Hall, Detroit, Michigan, 1993; Saginaw Art Museum, Saginaw, Michigan, 1993; Invitational Sculpture Exhibit, Flint, Michigan, 1992; International Invitational Exhibit, Tubingen, Germany, 1992; Latino Artists Invitational, Frankfurt, Germany, 1992; Concordia College, Ann Arbor, Michigan, 1991; Central Michigan University, 1991; Kalamazoo Institute of Arts, Kalamazoo, Michigan, 1991; The Scarab Club, Detroit, Michigan, 1989.

Pura Cruz

"The struggle to preserve Hispanic traditions in the face of misunderstanding and hostility is the substance of Pura Cruz's posters and mixed media paintings," wrote Helen Harrison in the March 25, 1990, *New York Times*. Cruz cites family folklore and "domestic magic," handed down from generation to generation, as major influences on her art. These folkloric traditions, which Cruz describes as "primitive survival skills," are ripe for exploration in Cruz's art, which according to Helen Harrison "deals with issues of self-transformation and healing." Despite their lack of technical polish and the difficulties they represent in interpretation, "the works nevertheless communicate the psychological force of beliefs that outsiders may write off as superstitious without realizing their spiritual and practical values," wrote Harrison.

The strong Latino belief in the life-death phenomenon enters the realm of surrealism that stems from a native cultural heritage. Strange superstitions and preposterous claims to mythological imagery have been retained by the artist throughout her life, and are eventually revealed in the creative process.

In Pura Cruz's mixed media creation *Adam's Debut*, a 1990 production, a grotesque figure of a pregnant female is pictured. One of her two heads is peering at the viewer, and the other profile is playing a musical instrument. The duality is repeated with a pair of monks moving forward in silence.

There is always mystery connected with the unreal and such exists in *Adam's Debut*. For example, the number two is repeated four times, each slightly different in appearance.

The technical application of pigment is thrust upon the surface in an abstract expressionist manner that accounts for the intuitive force and spontaneous brushwork. There are finely painted diagonal lines defining particular areas of the figurative form either by direct contact or by enclosure. The background appears as a separate element of the painting in terms of imagery. It seems that Cruz is suggesting male monopoly in one sense or complete fantasy that may eventually become reality. Undoubtedly, disagreements occur as to her premise, and various misinterpretations abound when the impossible may eventually become possible.

Since an artist is free to express ideas and imagery contrary to common belief, it is also essential that an audience be given the same freedom. Regardless of diverse criticism of Cruz's work, the essential nature of her work prevails.

Another 1990 production of the Adam series is titled *Adam Gives Birth*. Intended or not, there is a semblance of a cruciform that attaches a religious

ADAM GIVES BIRTH by Pura Cruz. 1990. Mixed media. 6 × 5 ft.
Courtesy of the artist.

significance to the work. The Latinos, being of the Catholic faith, have deep emotional feelings about their spiritual birthright. *Adam Gives Birth* is made up of four rectangular shapes that when combined into a unified composition, form a cruciform suggesting the crucifixion of Christ.

One cannot always ignore titles and ideas and defer meaning in order to enjoy the color and structure of a work. But with this work, being of a somewhat abstract nature, opinions are formed contrary to the artist's intent — a common occurrence. Pura Cruz's work is subject to acceptance as an art form but may be rejected as a message, for art has no moral boundaries except for individual consciousness, only physical boundaries set by the artist.

In *Adam Gives Birth*, the body of Adam is positioned in a pietà position and also resembles the deposition of Christ. The thought is not a sacrilege; rather, it suggests the overlap of what is and what could be, an example of science overstepping its boundaries. The four rectangular shapes that form the cruciform each contain a positive image of the subject matter.

Fast-Forward 2004, a 1994 rendition, reveals parts of the human body, disjointed and distorted as if the particles of a horrid dream. The two obvious wooden crosses — whether a compositional device or a meaningful message — symbolize a crucifixion long past. The three spikes located in the vertical structure of the cross could very well symbolize the three nails piercing the hands and feet of Christ at Calvary. Even if the spiritual intent is unfounded, this technical device has been utilized by artists throughout the centuries.

A fourth painting, *Fast-Forward, 2009-2006*, contains two tall figures — male and female — with lines suggesting electrical wires overlapping their bodies as if some type of transfusion is occurring. There are round outlets attached to the bodies into which these slender tubes would be attached. The figures are dark as if reality is measured by the shadows cast instead of by living beings.

Cruz's work is a battle of the sexes carried to the extreme. According to Helen Harrison in the *New York Times* of February 10, 1991, "Pura Cruz has the last word in the battle of the sexes in *Adam's Debut*, a rough, raw painting with a patent message. Perhaps the debate of biblical scholars, creationists and feminists will all be silenced by modern technology, she suggests."

Birthmark is an unusual composition made up of several photographs of childhood actions and memories. A mixed media rendition of 1991, its six illustrations suggest an orderly and formally balanced composition, each connected by a single wire that weaves in and out of the picture plane. The negative space surrounding the six photos is totally absent of activity except for the interweaving wires.

The connecting wires (lines) suggest a continuation of life as well as a compositional aid. A light switch placed obscurely to the left edge of the work holds a mysterious key to the unknown. Pura Cruz's work is indeed provocative. It demands an open mind and sustained study, and regardless of contrary opinions, her work does demand one's attention.

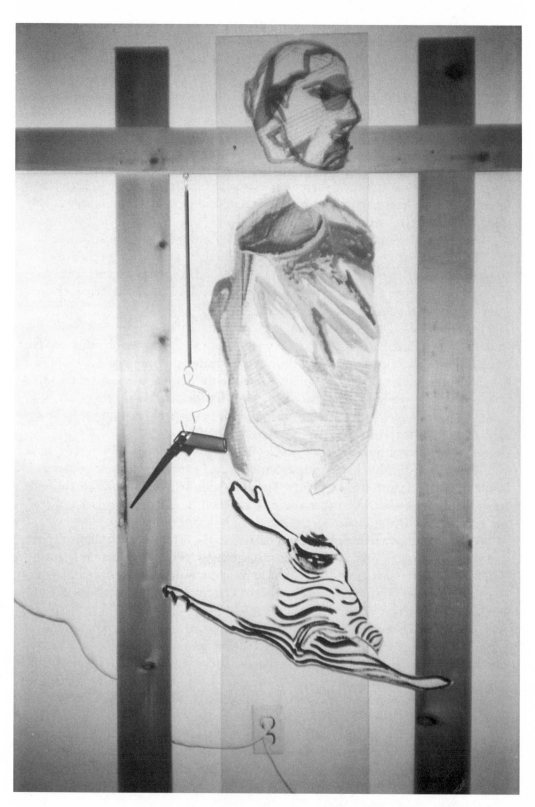

*FAST-FORWARD 2004 (series) by Pura Cruz. 1992. 72 × 48 in.
Courtesy of the artist.*

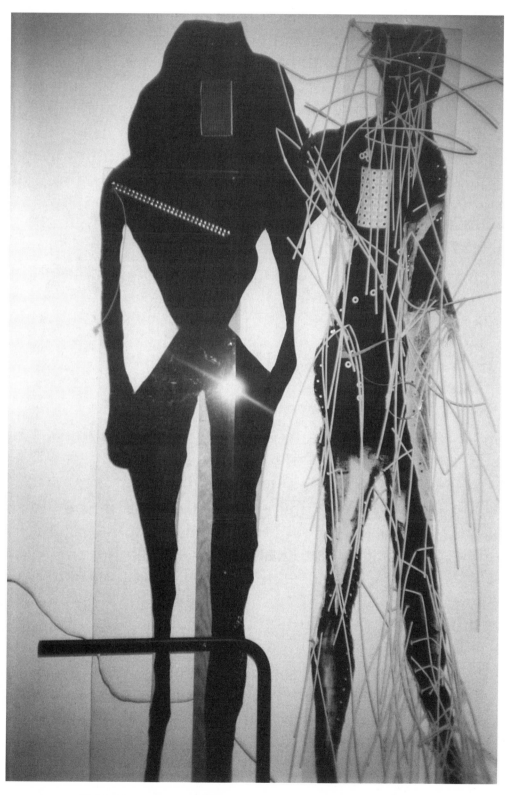

FAST-FORWARD 2009–2006 (series) by Pura Cruz. 1992. Mixed media.
Courtesy of the artist.

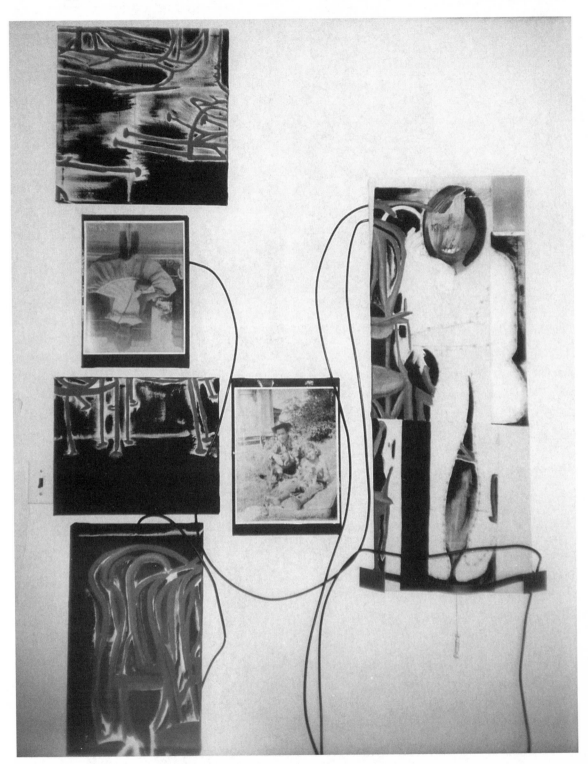

BIRTHMARK by Pura Cruz. 1991. Mixed media. 6 × 5 ft.
Courtesy of the artist.

Career Highlights

Born in Puerto Rico.

EDUCATION
B.A. degree in studio art from Stony Brook University, New York; Suffolk County Community College, Selden, New York; Parsons School of Design, New York, New York.

SELECTED EXHIBITIONS
U.N. 4th World Conference on Women, Beijing, China, 1995; East End Arts Council, Riverhead, New York, 1994; Islip Art Museum, Islip, New York, 1993; Ceres Gallery, New York, New York, 1992; Vanderbilt Museum, Centerport, New York, 1992; Fine Art Museum of Long Island, Hempstead, New York, 1992; Discovery Art Gallery, Glen Cove, New York, 1991; Smithtown Township Arts Council, St. James, New York, 1991; Hillwood Art Museum, Brookville, New York, 1991; Northport/SB Spoke Gallery, Huntington, New York, 1991; Islip Art Museum, East Islip, New York, 1990; Passaic County Community College, Paterson, New Jersey, 1990; Union Gallery, Stony Brook Museum University, Stony Brook, New York, 1990; Greater Port Jefferson Arts Council, Port Jefferson, New York, 1990; Clary-Minor Gallery, Buffalo, New York, 1989; Smithtown Township Arts Council, St. James, New York, 1989; Morin-Miller Galleries, New York, New York, 1988; Hofstra University, Hempstead, New York, 1988; Vasarely Center, Soho, New York City, New York, 1987; Union Art Gallery, Stony Brook University, Stony Brook, New York, 1985; Staller Art Center, Stony Brook, New York, 1985; Suffolk County Community College, Selden, New York, 1983.

PUBLIC COLLECTIONS
Fine Art Museum of Long Island, Hempstead, New York; Islip Art Museum, East Islip, New York; National Museum of Women in the Arts, Washington D.C.; Stony Brook University, Stony Brook, New York.

Elba Damast

Artist Elba Damast was quoted in the exhibition brochure of the Art Museum of the Americas (May 4–June 3, 1995) as saying, "My art exists in action and is the comet that I try to catch by the tail, the ephemeral that I try to hold, what I search for, and finally, what I feel a loss of, the fleeting spirit that I am in a race with, painting and installations being the footprints left by my chase."

Born in Pedernales, Venezuela, in 1944, Elba Damast studied at the School of Plastic Arts in Valencia, Venezuela. Her paintings are three-dimensional mixed media structures. In her *Estudio* series of paintings Damast uses the rectangular shape as the center of interest and surrounds it with a formally balanced grouping of found objects. Although her final results appear simple and direct, the process is complex, dealing with a variety of media, stimuli and techniques. Yet, in spite of the various seemingly contradictory elements, a harmonious blend results.

According to the artist, her product is the result of the process. The fact that the product follows process is logical, but the result is not always self-assuring. In the case of *Estudio 22*, the focal point is an expressionistic childhood configuration of overlapping shapes resembling a bird, a house, and the circular shape of the sun. Etched onto a dark background, it is surrounded by a light singularly-colored border. The outlying surface incorporates delicately applied and extremely objective images that, instead of contradicting the process, advance a compatible union. One is reminded of Joseph Cornell's rectangular structures. Although philosophies differ, concerns for form and composition are foremost.

Estudio 22 is a mere 26 by 20 inches, but its presentation is potent. The formally balanced outer decor is a well-conceived assemblage of personal insights using symbolic signs of vision, time and related images.

Because of the unknown and speculative nature of Damast's work, the viewer is treated to a spiritual journey, destination unknown. The eye becomes the tool for discovery.

In a second work, *Estudio 12*, a similar inset is positioned within a different border. Sharply pointed triangular shapes join forces to surround the focal rectangular shape. Within the shape is a funnel formed like a tornado that is nature's way of alerting its inhabitants. Being an expressionist allows for freedom of acceptance or rejection, and, at times, a vast range of interpretation. Damast's work creates such a dilemma.

Estudio 12 lacks the image of the house but incorporates the unexpected and unpredictable. It is difficult to journey along the same path set forth by the artist.

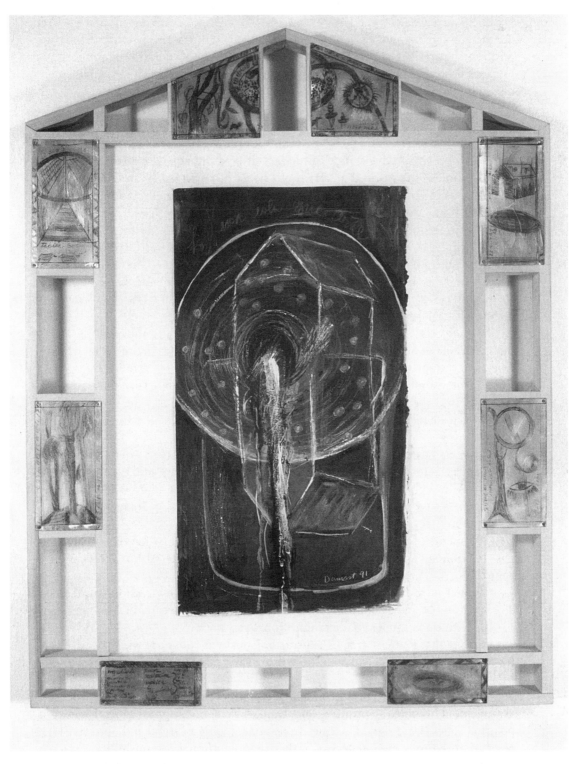

ESTUDIO 22 by Elba Damast. 1991. 22 × 25 × 20 in. Mixed media on paper and wood and zinc plates.
Courtesy of the artist.

A visual journey begins and ends at the core of the work, revolving circularly within the rectangular framework. The diamond shaped edging seems to expand the composition that resides within the broad surrounding border. Although one's visual interest may remain within the inner rectangular, the opportunity exists to extend one's journey outside the focal point.

Art critic Belgica Rodriguez commented on Demast in the June 3, 1995, publication of the Art Museum of the Americas: "The use of collage, graffiti, paint drips, dense textures, metallic screens and found objects is for the artist, a way of liberating her distinctive stance on the act of creating and of expressing her particular vision of the world that surrounds her. The result is a metaphorical assemblage of dissimilar yet harmonious elements, a type of dance of relationships, a play of aggregates."

A third painting in the series, *Estudio 9*, a 1991 rendition, exhibits as the focal point an image resembling both a telephone of the Great Depression era and a chalice. Inhabiting the environment are Spanish idioms related to the telephone. The telephone image barely fits into the designated rectangular shape that is supported by the usual wide border. Surrounding the entire focal point is a Mondrian-type layout with a Joseph Cornell box-type execution.

Estudio 9 is less an expressionistic approach than an intellectual pursuit. Thrust into each corner of the rectangular border is a symbolic image of the visual world — insects of the earth's surface.

As mentioned earlier, Damast's works are indeed of a speculative nature. Journeys into the unknown become adventures of the spirit. The use of realistic images in a surreal composition have made Elba Damast a leader in contemporary art.

Damast has proven through her comparatively miniature works that bigness is not essential for potency. Her paintings of mixed media are squeezed into a small format. Although carefully planned, compositions upon a large working surface may cause a loss of intensity. However, the autobiographical imagery helps preserve the mystery.

Segments of her series denote the abstract expressionist movement. Damast has positioned suggestive images within objectively rendered but illogical environments.

Critics have said that Damast does not work within expressionism. If one is an expressionist, one is unaware of such a definition. One creates in a manner compatible with one's intellectual and emotional response to an idea.

To say that Damast creates expressionistically is to ignore the process of end results. The various elements that the artist has included in her work suggest a series of miniature creative impulses.

Once the accumulation of media and objects are made ready, the process of arrangement becomes an intuitive one. Damast's creations appear objective in composition. There is no sign of instinctive responses, only a careful and objective technique that requires the intellectual rather than emotional responsibility.

Elba Damast seems in a hurry to an unknown destination, displaying a need to achieve, but to an unknown end. She claims that her creations are remnants of

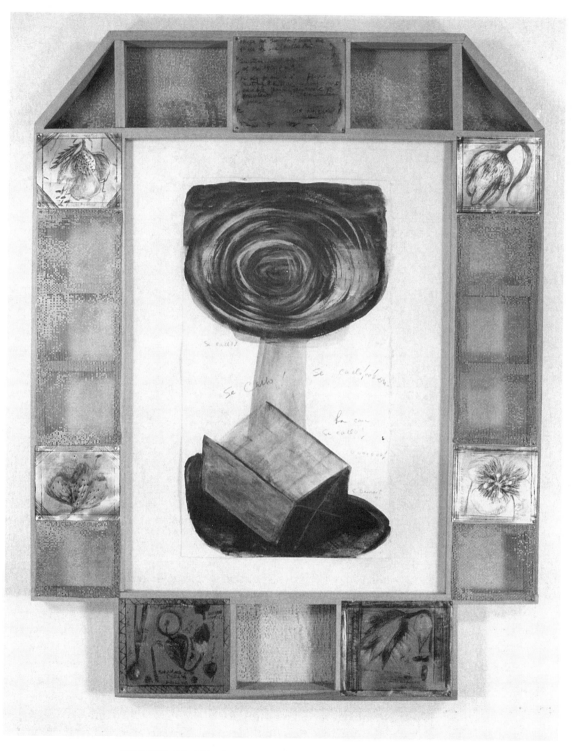

*ESTUDIO 9 by Elba Damast. 1991. 28 × 22 in. Mixed media on
paper and wood, and zinc plates and window screen.
Courtesy of the artist.*

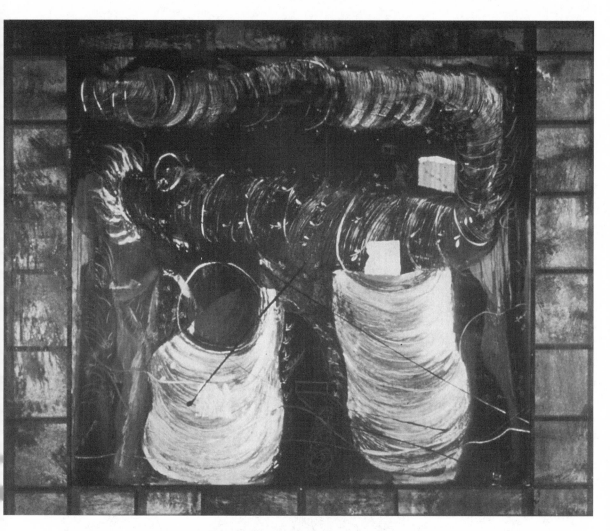

RUINA REINA by Elba Damast. 1990. Mixed media canvas. 84 × 104 in.
Courtesy of the artist.

the chase. If so, her spirit may be expressionistic which leads not to the school of expressionism but postconstructivism. But her artistry is the result of that spirit, a result less of a subjective display than an objective reaction.

Elba Damast has exhibited solo in several countries in three continents: Europe, North America and South America. Her first showing was in Venezuela in 1970 at the age of 26. In addition to her solo exhibitions, Damast has participated in all the major showings in the United States and abroad that featured Latin American women artists.

Elba Damast is a remarkable and versatile artist with strong convictions. The abstract expressionistic mixed media painting *Ruina Reina* is a tornado-like scene of destruction, one of turmoil in action. In this stage of her career, her abstract style is reminiscent of the abstract expressionist movement.

Even though it was executed 45 years after the advent of abstract expression-ism, the personal handling of the medium and the emotional thrust would determine

the rejection or acceptance of this intuitive response. Damast has proven her ability to handle a difficult technique. The artist must stay within boundaries to create an uncomfortable approach to the expression. Because abstract expressionism resembles a reckless adventure into nowhere, slashes and sprits of color eventually join other forces to form a rational sense of discovery.

Although most of the 1991 *Estudio* series are vertically oriented, *Estudio 8* is horizontal in both concept and execution. Geometric shapes are added to the usual border design. Each rectangular and triangular shape enhances the centrally located major expression. Although each aspect of the border design is subjective in nature, its appearance is objective, leading to a compatible composition. In fact, each small, executed concept is an isolated expression separated from the others by muted rectangular shapes. Yet, the small expressions of color, line and form blend into a complete larger work of controlled emotion.

The destructive force of the central image is contained several times within horizontal limits and thus reacts similarly to those smaller shapes bordering the larger rectangular shape. The potentially explosive force present in the center of *Estudio 19* is dramatic because of the instinctive response to the artist's notion of natural violence. It is partially tamed by the muted border and sharp contrast of the dual borders that separate the central figure from the surrounding images.

Some geometric images are purposely blurred to suggest the unknown in nature. These recognizable images reveal an array of nature's inhabitants. The irregular shape of the working surface is made into a formally balanced composition by careful manipulation of the bordered corners. In spite of the intuitive force of the central enclosure, *Estudio 19* is a formally balanced, objective production. Yet, it remains intuitive and allows the viewer to speculate and thus gain satisfaction without knowing the artist's intent. Damast's approach seems one of a contemporary style and reigns in the realm of the mainstream.

Career Highlights

Born in Pedernales, Venezuela, in 1944; moved to New York City in 1972.

EDUCATION
Studied at the Arturo Michelena School of Plastic Arts in Valencia, Venezuela; studied the spiritual centers in India.

SOLO EXHIBITIONS
Joel Kessler Fine Art, Miami Beach, Florida, 1995; Olson Fine Art, Brussels, Belgium, 1994; Plaza de Armas, San Juan, Puerto Rico, 1993; Museum of Contemporary Art, Tegucigalpa, Honduras, 1993; Museum Patronato, San Salvador, El Salvador, 1992; Museo de Arte Costarricense, San Jose, Costa Rico, 1992; Galería de Arte Ascaso, Valencia, Venezuela, 1992; Moss Gallery, San Francisco, California, 1991; Museum of Contemporary Hispanic Art, New York City, 1990; Galleri Orpheus, Eskilstuna, Sweden, 1990; Landskrona Konsthall, Landskrona, Sweden, 1989; Alexander Ernst Gallery, Washington, D.C., 1988; Little John-Smith Gallery, New York City, 1987; Strand Galleri, Södertälje, Sweden, 1986; Galería Freites, Caracas, Venezuela, 1985; Housatonic Museum of Art, Bridgeport, Connecticut, 1984; Jack Gallery, New York, New York, 1983; West Broadway Gallery,

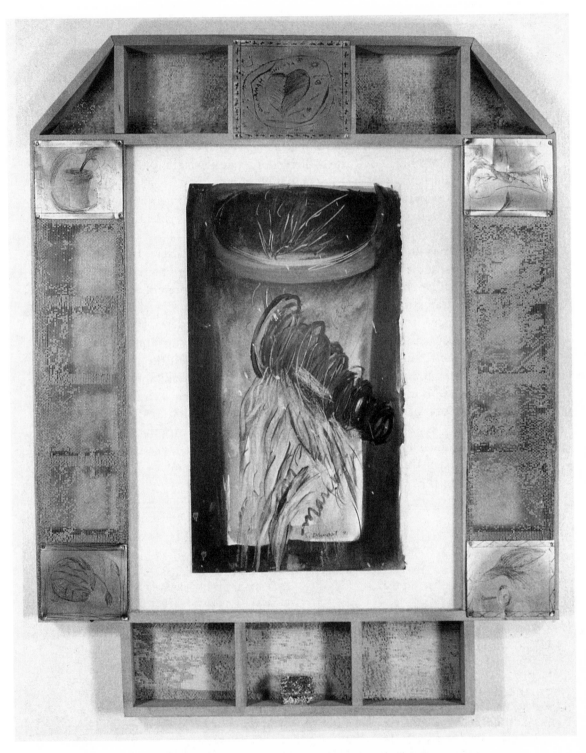

ESTUDIO 19 by Elba Damast. 1991. 22 × 28 in. Mixed media on paper
and wood, and zinc plates, gold leaf and window screen.
Courtesy of the artist.

New York, New York, 1977; Aida Hernandez Gallery, New York, New York, 1973; Banap Gallery, Caracas, Venezuela, 1972; Ateneo de Valencia, Venezuela, 1970.

SELECTED GROUP EXHIBITIONS

Milwaukee Art Museum, Milwaukee, Wisconsin, 1995; Phoenix Art Museum, Phoenix, Arizona, 1995; National Museum of Women in the Arts, Washington, D.C., 1995; Americas Gallery, New York, New York, 1994; Museo Ateneo de Arte Moderno, Santo Domingo, Dominican Republic, 1993; San Diego Museum of Art, San Diego, California, 1991; Art Museum of the Americas, Washington, D.C., 1990; Montclair College, New Jersey, 1989; Museum of Contemporary Hispanic Art, New York, 1988; Bronx Museum of Art, New York, 1981.

Maritza Dávila

Born in Puerto Rico in 1952, Maritza Dávila became one of America's finest printmakers. Her training includes an M.F.A. degree from the Pratt Institute in New York City, with an internship under noted printmaker Clare Romano.

The collograph *Paisaje en Transición (Landscape in Transition)*, a 1994 rendition, is a triptych landscape of seasonal themes. What appears to be a mountain range stretching across the collograph is executed in doodles, forming a textural surface reminiscent of a Paul Klee environment. Each section of the triptych is an individual expression existing on its own merits. However, Dávila has combined three different seasonal themes into a single unit, thus broadening the expression of a panoramic level.

A brilliant sunrise occupies the middle panel which is separated from the lower baseline. One therefore assumes to view the entire expression of a landscape in transition by the three levels of sky, earth and whatever appears below the earth. If considered in terms of religion, one could say that *Paisaje en Transición* symbolizes Heaven above, Purgatory on earth and Hell below.

The arrangement — altar pieces with three panels rounded at the top — is typical of the early Renaissance. The color palette is unique in its use of warm and cool colors. The tones of blues and violets create a somber mood, but the enriching central sky is reminiscent of Easter Sunday or Ascension Day. There is undoubtedly a spiritual message that greets the viewer.

A mixed media sculpture titled *The Three Wise Men* and relating to the birth of Christ was executed in 1993. A vertical box slit with openings on the four sides allows the colorful attire of the wise men to appear through the rectangular openings. The attire and paraphernalia of the three wise men are freely exposed through the openings and at the top of the sculpture. Because one is not granted a full view of the figures, the positioning of the figures creates a "traffic jam" and abstract composition. It is an enticing sculpture, a unique approach to a sacred theme.

The rectangular shape in which the figurative images are placed appears to be constructed of brass or gold plated cardboard while the enclosed figures are constructed of colored paper. A three-dimensional work, it provokes an interest from all angles at and above eye level. *The Three Wise Men* is an unusual attempt at a popular religious theme that plays a definite role in the mainstream of American art.

The impressionistic serigraph *Catedral del Río* reveals a mosaic finish. Within the colorful geometric abstract is a cathedral-type structure of vertical columns that are intercepted by swinging areas originating from the negative space. The

PAISAJE EN *TRANSICIÓN by Maritza Dávila. Collograph. 24 × 18 in. 1994.*
Courtesy of the artist.

THE THREE WISE MEN by Maritza Dávila. Mixed media sculpture. 1993. 15 × 4 × 4 in.
Courtesy of the artist.

CATEDRAL DEL RÍO by Maritza Dávila. Book serigraphy. 9.5 × 10 × 8 in. 1993.
Courtesy of the artist.

three-dimensional structure occupying the frontal plane has vertical columns that
in actuality are overlapping pages.

Defined as book serigraphy, *Catedral del Río* unfolds its pages to form a three-
dimensional display. It becomes an ever-changing expression with the turn of each
page, presenting a new episode of a continuous journey. Thus, there are several
serigraphs in one. Each slight alteration of pages brings a new aesthetic experience.

A handmade paper collograph, *Casas de Memorias Infinitas*, a 1987 image,
translates into homes or families of infinite memories. Within the trio of simple
geometric shapes representing the houses are images of death. Memories are vague
but nonetheless present. The artist utilizes a geometric shape for the three houses
fortified by a black background against a dark blue sky.

Considered both surreal and abstract, *Casas de Memorias Infinitas* recalls past
memories. The images dwelling within the framework of the trio of houses are of
an abstract expressionist nature — a movement established during the late forties.

Dávila has used the rather recent medium of handmade paper to forward her

ARCO DEL *TIEMPO by Maritza Dávila. 1994. Collograph. 27½ × 18 in.
Courtesy of the artist.*

own notions of life. The contemporary medium has been suitable for several Dávila originals.

Arco del Tiempo (Arch of Time), a 1994 collograph, is similar to *Paisaje en Transición*. As a triptych approach, *Arco del Tiempo* houses a series of 12 abstract expressions, each portraying a personal reaction to a given idea that remains unknown. Each of the 12 enclosures is square and separated from each other by a divisional line. The 12 individual expressions are surrounded by a cathedral type arch. In spite of a compact composition, there is a sense of freedom introduced by the divisional lines acting as openings between each of the 12 activated episodes.

Career Highlights

Born in Puerto Rico in 1952.

EDUCATION
B.A. degree in art education with a major in printmaking and a minor in painting at the University of Puerto Rico, 1970–74; Pratt Graphics Center, New York, New York, 1974–75; M.F.A. degree in painting and printmaking from Pratt Institute, New York, New York, 1975–77; M.F.A. internship, assistant to Clare Romano, 1976.

SOLO EXHIBITIONS
Maine College of Art, Portland, Maine, 1993; Memphis College of Art, Memphis, Tennessee, 1993; Delta State University, Cleveland, Mississippi, 1991; Albers Fine Arts Gallery, Memphis, Tennessee, 1990; University of Northern Alabama, Florence, Alabama, 1990; Rhodes College, Memphis, Tennessee, 1988; Albers Fine Arts Gallery, Memphis, Tennessee, 1987; Hostos Community College, Bronx, New York, 1986; La Casa Amarilla, San Juan, Puerto Rico, 1985; Cayman Gallery, Soho, New York, New York, 1983; Jersey City State College, Jersey City, New Jersey, 1981; Fordham University at Lincoln Center, New York, New York, 1981; Contemporary Arts Center, New York, New York, 1980; Coabey Gallery, San Juan, Puerto Rico, 1980; Pratt Institute, New York, New York, 1977; Ponce Art Museum, San Juan, Puerto Rico, 1977.

GROUP EXHIBITIONS
University of Nebraska, Lincoln, Nebraska, 1995; Corcoran Art Gallery, Washington, D.C., 1995; Memphis College of Art, Memphis, Tennessee, 1995; Southeastern Louisiana University, Hammond, Louisiana, 1995; Georgia College, Milledgeville, Georgia, 1994; Partenon Galleries, Nashville, Tennessee, 1994; Charleston Art Galleries, Charleston, South Carolina, 1994; Memphis College of Art, Memphis, Tennessee, 1994; Vinvent Visceglia Arts Center, Coldwell, New Jersey, 1993; Brand Library Art Galleries, Glendale, California, 1993; Santa Monica College, Santa Monica, California, 1992; Goucher College, Baltimore, Maryland, 1992; Allegheny Community College, Allegheny, Maryland, 1992; Sazama Gallery, Chicago, Illinois, 1992; Museo del Libro, San Juan, Puerto Rico, 1991; Del Bello Gallery, Toronto, Canada, 1990; Radford University, Radford, Virginia, 1990; Occidental College, Los Angeles, California, 1990; Memphis Brooks Museum of Art, Memphis, Tennessee, 1989; Prefectural Gallery, Yokohama, Japan, 1988; San Diego State University, San Diego, California, 1988; Museum of Contemporary Hispanic Art, New York, New York, 1988; Bronx Museum of the Arts, New York, 1988; Evanston Art Center, Evanston, Illinois, 1988; Ann Jacob Gallery, Atlanta, Georgia, 1988; University of Wisconsin, Milwaukee, 1987; Mexican Fine Arts Center Museum, Chicago, Illinois, 1987; L'Arlequin Gallery, Kent, Connecticut, 1986; Commonwealth of Puerto Rico, New York, New York, 1986; Memphis College of Art, Memphis, Tennessee, 1986; Alice Bingham Gallery, Memphis, Tennessee, 1985; Minot State College,

Minot, North Dakota, 1985; Moravian College, Bethlehem, Pennsylvania, 1985; Cayman Gallery, Soho, New York City, New York, 1984; Rutgers University, Newark, New Jersey, 1983; Memphis Academy of Arts, Memphis, Tennessee, 1983; Pratt Institute, Brooklyn, New York, 1982; Galería Botello, San Juan, Puerto Rico, 1981; Lincoln Center, New York, New York, 1980; Queen of All Saints Community Art Center, Brooklyn, New York, 1980; Museum of the University of Puerto Rico, San Juan, Puerto Rico, 1979; Women in the Arts Gallery, New York, New York, 1979; Museum del Barrio, New York, New York, 1978; Washington World Gallery, Washington D.C., 1978; Alnico Gallery, Soho, New York City, New York, 1978; Pratt Institute, New York, New York, 1977; Carneigie Library, San Juan, Puerto Rico, 1977.

PUBLIC COLLECTIONS
Lone College, Jackson, Tennessee; Memphis College of Art, Memphis, Tennessee; Moravian College, Bethlehem, Pennsylvania; National Library of Paris, France; Radford University, Radford, Virginia; Tama Art University Museum, Tokyo, Japan; University of Puerto Rico, San Juan, Puerto Rico; University of Tennessee, Knoxville.

Joyce de Guatemala

Born in Mexico City in 1938, Joyce de Guatemala traveled extensively and was educated at Universidad Autonoma de Mexico, Mexico City; the University of Wisconsin, Madison; Silpakorn University in Bangkok, Thailand; and the Universidad de San Carlos in Guatemala. She has exhibited throughout North and South America. She lives and works in Glenmoore, Pennsylvania.

In a brochure of her work published by Lehigh University, the artist said: "My search has always been directed towards the inner thoughts of the human being, towards the inner core of the world. This world of contradictions in which the subconscious becomes the motivating enemy of the conscious, the unreal becomes the real, the living mythology of the present emerging from that of the past."

Although she has worked in several different sculptural media, her favorite medium is stainless steel. De Guatemala has been influenced by Mayan culture and has integrated her intimate feelings into her creations of forms and abstract attitudes. She usually succeeds in creating an internal volume where one's existence is received in a surreal sense of movement and color. Her dream of creating a mythical world is assisted by distorted reflections, inner eerie lights and ghosts of the past.

Again in the Lehigh brochure, art critic Leslie Ahlander stated: "Joyce de Guatemala is an artist whose disciplined talent is combined with an intuitive and spiritual approach which best expresses itself through minimal means. The purity and rigor of geometric forms — as simple as Stonehenge and as pregnant with overtones of meaning — reflect her intense interaction with pre–Columbian culture in her native country. Now the geometries begin to meet nature itself in the form of ancient tree trunks whose burls and textures counterpoint the cool austerity of polished steel. Joyce de Guatemala has a rare intuitive feeling for these juxtapositions and contrasts."

There is a definite spiritual sense of everlasting life in de Guatemala's work. The past, the present and the future combine to form a trinity — the Creator, the Mediator and the Final Judgment. Joyce de Guatemala fuses modern technology and ancient natural forms into a contemplative creation of beauty and austerity. The inclusion of modern media into a natural landscape is seldom appropriate, but de Guatemala's love of nature and her contemplative nature enhances the natural beauty of the environment.

A case in point is *Ritual Site: A Place of Magic*, a sculptural stainless steel form combined with redwood trees. In her outdoor sculpture there exists a oneness with the surrounding landscape. In other words, the perfectionist style blends so uniquely with the outer environment that there no longer exists a separate environment in

RITUAL SITE: A PLACE OF MAGIC by Joyce de Guatemala. 100 × 40 ft. 1994.
Courtesy of the artist.

which de Guatemala's creation resides. The shimmering steel blades attached to the trees are powerful and austere, and yet reflect the warmth of a newborn child. An example of the divinity of nature rather than a division of nature and artist, the creation is so uniquely composed that a spiritual blend is formulated.

Joyce de Guatemala's purpose of creation is not only to fulfill the desire to create but to respond to the need of amplifying an appreciation of nature. In viewing *Ritual Site: A Place of Magic*, one not only enjoys art in the purest sense but reacknowledges the presence of the beautiful redwood trees. Thus, a dual purpose is served—an environmental appreciation and eventual protection, and an artistic adventure. They are not separate entities but a single unit.

An outdoor installation, *Altar for Offerings*, a detail of *A Place of Magic*, includes an owl feather, two bird feathers stuck into tree stumps, two river rocks and a pine cone. The title, utilizing the word "altar," reflects the spiritual aspect of nature. Again, the artist calls the viewer's attention to the pleasure of nature by inserting creative impulses into an established environment. The artist arranges

ALTAR FOR OFFERINGS by Joyce de Guatemala. 1994.
Courtesy of the artist.

the elements into a compact and closely knit composition in order to form a one-ness.

One is enticed to take a closer look rather than the traditional objective view. One may question what is being offered and what is the altar. Is the entire composition the altar or are the elements placed upon the tree stumps the offerings? Perhaps it matters little since there is a blend of all elements, thus avoiding a detachment of parts.

Using the landscape for outdoor sculpture has always been fascinating. The vast space allows sculptors to create forms that merely rest in space rather than utilizing it. Joyce de Guatemala goes beyond the normal or traditional. She combines nature and brings it into her sculpture as an appreciation of art and nature.

The wall sculpture *Sacrificial Arched Hatchet* was executed in 1992 and measures 11 feet in length. It is an example of nature taken from its environment, thus placing emphasis upon the sculpture itself. This piece allows the viewer an intimate study of

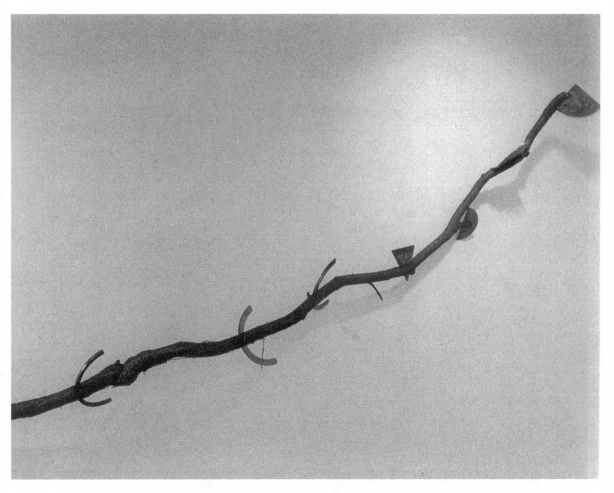

SACRIFICIAL ARCHED HATCHET by Joyce de Guatemala. 11 ft. 1992. Mixed media.
Courtesy of the artist.

the ingredients that make up the creation. Furthermore, it not only provides a deeper
understanding and appreciation of the sculptural form in its natural habitat, but allows
the viewer to see its effectiveness in an alien surrounding. In other words, the sculp-
ture succeeds as an isolated work because the focus is on the sculptural form, which
incidentally creates shadows that enhance and accentuate the message of the artist.

Sacrificial Arched Hatchet is a succession of stainless steel geometric shapes that
are a carefully orchestrated visual symphony. Each steel shape is positioned to accent
a particular area, which in turn motivates the viewer to visually travel to the next junc-
ture. There is no end to de Guatemala's journey; reaching the tip of the sculpture
results in an immediate return trip. The precise incision of steel parts into the branch
of life acts as a unifying ingredient of nature's integration with the creative process.

Another indoor sculpture detached from its natural environment is *Mask
of Zipacna*, which emphasizes the foreground of the installation. Standing on a
balanced formation in the background is a pair of ladder totems titled *Takari* and
Baal. This triangular arrangement of three separate yet complete installations could

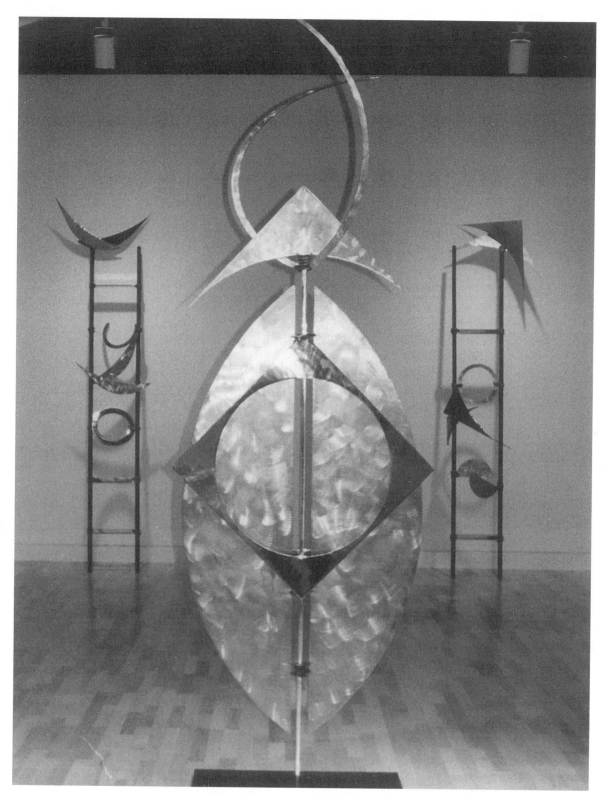

MASK OF *ZIPACNA; TAKARI; AND BAAL by Joyce de Guatemala. 9½ in. × 2 ft. 10 in. × 3 ft.*
Courtesy of the artist.

survive as separate pieces. However, the trio creates a depth of three dimensions. Lighting adds to the drama as shadows are cast against the wall.

The interrelationship between circular, triangular and rectangular shapes — both negative and positive — is a remarkable sight. The vertical stem work concludes with a pair of dynamic arcs that aspire heavenward. A sense of an ascension — a resurrection of sorts — is envisioned.

The shimmering, glowing steel resembles a protective shield. Space between the positive elements creates a three-dimensional structure with the combination of negative and positive aspects. In other words, the piece incorporates space as an objective asset rather than space that just happens to be there.

The beauty of *Mask of Zipacna* is its austere workmanship. The elegance of shimmering steel brings warmth to an otherwise cold and blunt medium. Joyce de Guatemala is an expert in her field who has contributed extensively to the landscape of America.

An unusual indoor sculpture utilizing natural objects is *On the Loom: A Mythological Weaving*. Created in 1992, it is one of the few interchangeable sculptures created by Joyce de Guatemala. The 18 painted rocks woven together with rope and bark form an exciting hanging sculpture. The close-up view reveals the intricate pattern and design that correlates with the curved directions of the hanging ropes and bark.

The details shown and discussed reveal a fascinating display of positive and negative space. Spatial areas create shadows, and overlapping of painted rocks create the spatial three-dimensional effect. The altering of a single rock or strand of rope would dramatically alter the sculpture.

Joyce de Guatemala utilizes outdoor aspects of nature and recreates pleasing sculpture within a confined area. The various ropes weave behind and in front of the painted rocks to form unusual changing moods as the viewer moves about the sculpture. There are several angles from which *On the Loom* can be viewed as a mobile if one were to physically circle it.

The visual intersections created by overlapping ropes and areas where rope and rock collide make for exciting focal points. The possibility of ever-changing arrangements of the natural aspects is not unlike the sense of infinity brought into her work.

De Guatemala's outdoor landscape sculptures continue to excite viewers along the Atlantic Coast, from Florida and Georgia to Pennsylvania, New York, New Jersey and the nation's capital. This Latin American is enhancing the environmental landscape of America.

Career Highlights

Born in Mexico City, Mexico, in 1938; became a legal resident of the United States in 1975.

EDUCATION
Universidad Autonoma de Mexico, Mexico City, Mexico; University of Wisconsin, Madison, Wisconsin; Silpakorn Fine Art University, Bangkok, Thailand; Universidad de San Carlos, Guatemala City, Guatemala; Instituto Femenino de Estudios Superiores, Guatemala City.

SELECTED GROUP EXHIBITIONS
Miami Beach Convention Center, Miami Beach, Florida, 1995; Barbara Gillman

Gallery, Miami Beach, Florida, 1994; Djerassi Foundation, Woodside, California, 1994; New World School of the Arts, Miami, Florida, 1993; Estela Shapiro Gallery, Mexico City, Mexico, 1992; Central Connecticut State University, New Britain, Connecticut, 1992; The Paley Design Center, Philadelphia, Pennsylvania, 1992; Abington Art Center, Jenkintown, Pennsylvania, 1992; Kingsborough Community College, Brooklyn, New York, 1992; The Armory, Philadelphia, Pennsylvania, 1992; 14 Sculptors Gallery, Soho, New York, New York, 1991; Lehigh University, Siegel Gallery, Bethlehem, Pennsylvania, 1991; The Art Alliance, Philadelphia, Pennsylvania, 1991; Moore College of Art & Design, Philadelphia, Pennsylvania, 1991; University of Pennsylvania, Institute of Contemporary Art, Philadelphia, Pennsylvania, 1991; Museum of Contemporary Art of Latin America, Washington, D.C., 1990; Olympic Art/ Sculpture Park, Seoul, Korea, 1988; Temple University, Philadelphia, Pennsylvania, 1987; Municipal Services Plaza, Philadelphia, Pennsylvania, 1987; Cultural Art Commission, Art Park, Rockville, Massachusetts, 1987; Merrill-Lynch International Corporation, Princeton, New Jersey, 1987; Marian Locks Gallery, Philadelphia, Pennsylvania, 1986; Wyomissing Institute of Fine Arts, Reading, Pennsylvania, 1986; Fairmount Park, Philadelphia, Pennsylvania, 1986; Seton Hill College, Greensburg, Pennsylvania, 1985; Penn's Landing Museum, Philadelphia, Pennsylvania, 1983; Museum of Contemporary Art of Latin America, Washington, D.C., 1983; Forum Gallery, Atlanta, Georgia, 1982; William Penn Memorial Museum, Harrisburg, Pennsylvania, 1982; Widner University, The Alfred Deshong Museum, Chester, Pennsylvania, 1982; Stockton State College, Pomona, New Jersey, 1981; Beaver College, Glenside, Pennsylvania, 1981; Cedar Crest College, Allentown, Pennsylvania, 1980; Museum of the Philadelphia Civic Center, Philadelphia, Pennsylvania, 1980; Temple University & Cheltenham Art Center, Ambler Campus, Pennsylvania, 1980; Federal Court Building, Philadelphia, Pennsylvania, 1979; Marian Locks Gallery, Philadelphia, Pennsylvania, 1979; Noble/Polans Gallery, New York, New York, 1978; Ringling Museum of Art, Sarasota, Florida, 1976; Metropolitan Museum of Art and Art Center, Miami, Florida, 1976; Pensacola Art Center, St. Petersburg, Florida, 1976; Fort Lauderdale Museum of the Arts, Ft. Lauderdale, Florida, 1976.

SELECTED SOLO EXHIBITIONS
Marian Locks Gallery, Philadelphia, Pennsylvania, 1990; 14 Sculptors Gallery, New York, New York, 1988; 14 Sculptors Gallery, New York, New York, 1987; Marian Locks Gallery, Philadelphia, Pennsylvania, 1985; Lehigh University, Bethlehem, Pennsylvania, 1983; Cedar Crest College, Allentown, Pennsylvania, 1981; University of Delaware, Newark, Delaware, 1980; Marian Locks Gallery, Philadelphia, Pennsylvania, 1979; Museum of Modern Art of Latin America, Washington, D.C., 1977; Escuela Nacional de Bellas Artes, Guatemala City, Guatemala, 1976; Guatemala Pavilion, San Paulo, Brazil, 1975.

PERMANENT COLLECTIONS
Elkins Park Free Library, Elkins Park, Pennsylvania; Hershey Technical Center, Hershey, Pennsylvania; Kensington Townhouse Project, Philadelphia, Pennsylvania; Lehigh University, Bethlehem, Pennsylvania; Museum of Modern Art of Mexico, Chapultepec, Mexico; Museum of Modern Art of Latin America, Washington, D.C.; The Noyes Museum, Oceanville, New Jersey; Olympiad of Art, Olympic Park, Seoul, Korea; Organization of American States, Washington, D.C.; The John & Mabel Ringling Museum, Sarasota, Florida.

Dora de Larios

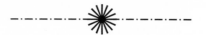

Noted for her mural commissions and architectural structures, Dora de Larios' versatility extends to ceramics and sculptures. She is internationally noted and has exhibited widely throughout the world. Her works have been featured in numerous art periodicals. De Larios' ceramic pieces are basically heads and masks that reflect the spirituality of one's personal sensibility to one's eternal life.

An amazing creation, *Innervision*, a stoneware sculpture, can be interpreted as an icon of contemplation. One is called upon to blend one's vision and commit to mental prayer. The artist's intent is to be totally isolated, shut out from social and personal problems in order to seek the peace and serenity of the afterlife.

Dora de Larios creates six overlapping faces, each partially hidden by strands of manufactured hair. Faces are covered in vertical and horizontal planes. In some images both eyes are covered; others reveal a single eye opening. The overlapping of the six faces forms a single, unified bond. Separate images would have lessened the strength of the unit. The textural nature of the hair serves a compositional need and helps understand the artist's intent.

Another ceramic sculpture is *Goddess*, which combines stoneware and ceramic tile. Dependent somewhat on indirect lighting, dramatic shadows result from the compositional use of lights and darks. A single facial image is clamped between geometric shapes of stoneware resembling a primitive hairstyle. Eyes and mouth are tightly closed, suggesting the inner spirituality that comes only from the idea and practice of atonement.

De Larios uses a variety of materials in her sculptural pieces. In *Goddess* she uses what appears to be incompatible materials adjacently positioned, but they seem totally in unison when viewed as a whole. Ceramic tile is flatly applied to form a two-dimensional surface attached to the three-dimensional upper segment. The tiled surface varies in geometric shapes; some are rounded while others are rectangular and triangular.

Born in Los Angeles, California, of Mexican parents, Dora de Larios offers a bit of philosophy in the 1985 issue of *Evening Outlook*: "Art is a commitment to a way of life. My creativity was a gift that I was given, and my life has to do with creating with this gift. You can't keep it if you don't use it. You have to keep working at it. Really, it is God working through me. God has always been a very important part of my existence."

Her commitment is evidenced in her creation of public art. In the same article, she stated: "I love working on large things that are in a public space. I think

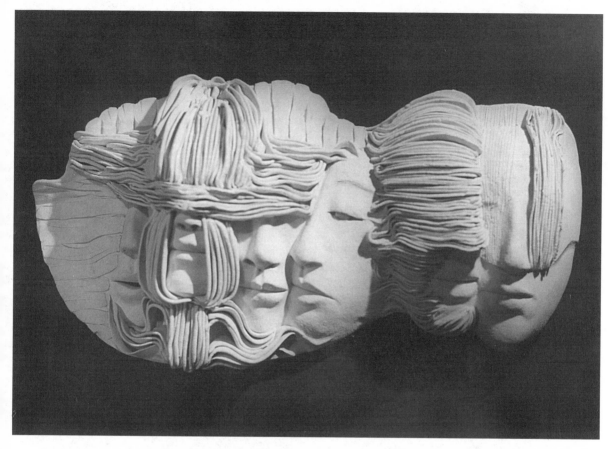

INNERVISION by Dora de Larios. Stoneware. Lifesize.
Courtesy of the artist.

that I can reach more people, and I think that part of what art is for me is a healing process. It has always been enticing for me. It reaches you somewhere that has nothing to do with money. It replenishes the spirit. I like having my art in a public space because you never know who you're going to help."

A second *Goddess* piece, also made from stoneware, is a life-size head surrounded by a textural headpiece. The strong angular nose reflecting strength and the closed eyes suggesting tranquillity are enhanced by a sensuous mouth. The high eyebrows and elongated nose are reminiscent of French painter Modigliani and his portraits of women.

There is a mixture of an Oriental influence along with African and Egyptian resemblance. The eyes, seemingly distorted in length, form an image of a crucifix with the vertical, elongated nose. Perhaps this was unintended, but it is suggested by the spiritual nature of the headpiece.

De Larios' porcelain and ceramic sculptures include masks, which signify the spirituality that the artist maintains as an essential part of her being. Ceramic sculpture is an art form in and of itself, but de Larios extends her talents far beyond the simplistic masks and figure heads that seem to act as a disciplinary or experimental

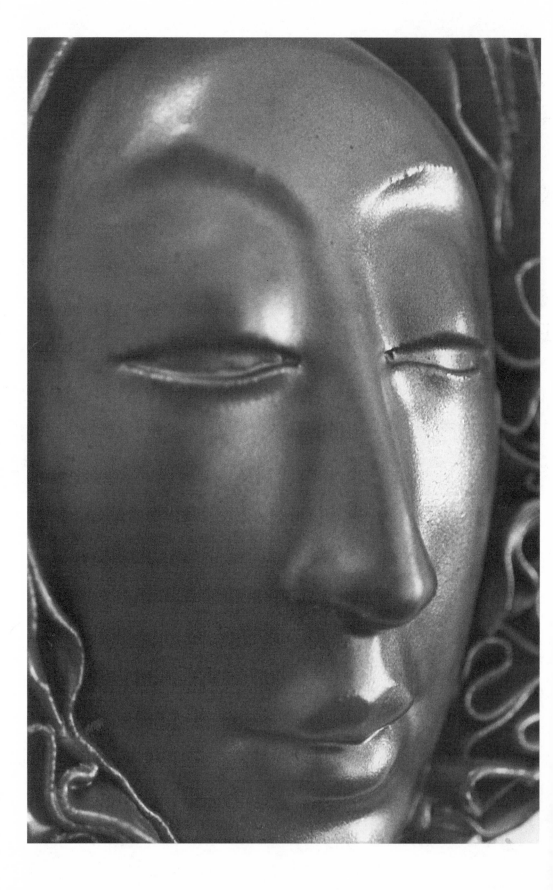

procedure. Yet, they are significant pieces because they sustain a continuous flow of the creative process, thus lessening the chances of inactivity.

Her masks and head shapes may serve purposes aside from the primary need to create. In *Mask*, de Larios uses the crackle effect to activate the otherwise smooth surface.

Although de Larios prefers to create architectural structures and murals in outdoor public places for the benefit of a larger audience, her more intimate pieces are reserved for gallery and museum exhibitions. Her international reputation has granted her the freedom to discriminate between architectural commissions. Of the several major accomplishments throughout the United States and Japan, *Homage to Quetzalcoatl* was a noteworthy contribution to America and to herself as a tribute to her divine maker. She has always considered divine guidance as her source of inspiration.

Homage to Quetzalcoatl, an architectural masterpiece of cement and brass, measures 36 feet tall and 20 feet wide. It was commissioned by the city of Pasadena. The structure is divided, the upper section shaped into a pentagon of black tile and the lower section designed with tiles of blue nuances. A dragon-like brass logo forms an irregular cloud shape that joins forces with a perfectly balanced brass circle intercepted by a series of horizontal and diagonal separations. The design allows the darkened tile background to sustain a sense of unity.

A dual triangle of brass completes the black tile background. Anchoring the brass design are cool blue colors ranging from dark (black) to a gradation of blue to light (white). A perpendicular angle is formed at the base of the structure in which the white tiled design of the vertical structure joins forces with the horizontal plane.

The sides of this gigantic architectural sculpture are laden with beige, horizontal colored cement brick. The structure has two levels: the upper level serving as the landscape at eye level, and the lower section.

Dora de Larios' creations are a labor of love because she is following what she feels is God's plan for her: a truly rare sense of belonging.

Career Highlights

Born in Los Angeles, California, of Mexican parents.

EDUCATION
Degree from the University of Southern California.

SOLO EXHIBITIONS
M.O.A. Gallery, West Hollywood, California, 1990; M.O.A. Gallery, West Hollywood, California, 1988; Marsha Rodell Gallery, Brentwood, California, 1982; Bakersfield College, Bakersfield, California, 1975; Anhalt Gallery, Los Angeles, California, 1974; Griswall Gallery, Claremont, California, 1974; Anhalt Gallery, Los Angeles, California, 1969; Fleisher/Anhalt Gallery, Los Angeles, California, 1967; Zora Gallery, Los Angeles, California, 1964; Ramon Lopez Gallery, Siera Madre, California, 1962; Gump's Gallery, San Francisco, California, 1959; Little Gallery, Birmingham, Michigan, 1958.

Opposite: *GODDESS NO. 2 by Dora de Larios. Stoneware.
Courtesy of the artist.*

GODDESS by Dora de Larios. Stoneware.
Courtesy of the artist.

HOMAGE TO QUETZALCOATL by Dora de Larios. 36 × 20 ft. Cement and brass.
Courtesy of the artist.

INVITATIONAL EXHIBITIONS
Muckenthaler Cultural Center, Fullerton, California, 1989; California Craft Museum, San Francisco, California, 1987; Chaffey Community College, Rancho Cucamonga, California, 1987; Scripps College, Claremont, California, 1986; Transamerican Gallery, Los Angeles, California, 1986; Craft and Folk Art Museum, Los Angeles, California, 1986; The Elements Gallery, New York, New York, 1984; Los Angeles Municipal Art Gallery, Barnsdall Park, California, 1984; Wooster College, Wooster, Ohio, 1983; Southern Alleghenies Museum of Art, Loretta, Pennsylvania, 1982; Gallery 8, LaJolla, California, 1982; Rodell Gallery, Brentwood, California, 1981; Nandell Gallery, Los Angeles, California, 1980; Pasadena Museum, Pasadena, California, 1976; Los Angeles County Museum, Los Angeles, California, 1976; Wichita National, Wichita, Kansas, 1975; Boston Art Festival, Boston, Massachusetts, 1974; Utah State University, Logan, Utah, 1973; Long Beach Museum, Long Beach, California, 1972; Scripps College, Claremont, California, 1971; Craft and Folk Art Museum, Los Angeles, California, 1970.

ARCHITECTURAL COMMISSIONS
Trammell Crow Company, Santa Fe Springs, California, 1993; Villa Parke Community Center, Pasadena, California, 1992; Famco Investments, Chinatown, Los Angeles, California, 1989; Alan Sleroty Building, Los Angeles, California, 1988; Lawry's California Center, Los Angeles, California, 1987; Huntley Hotel, Santa Monica, California, 1985; Hilton Hotel, Anaheim, California, 1984; Nissan Corporation, Carson, California, 1983; Progressive Loan Association, Beverly Hills, California, 1982; Long Beach Community Hospital, Long Beach, California, 1980; Makaha Inn Resort, Oahu, Hawaii, 1979; Central Park Development, Nagoya, Japan, 1979; Hawaiian Gardens Civic Center, Hawaiian Gardens, California, 1978; Rowland Heights County Library, Rowland Heights, California, 1978; Security Pacific Bank, Pomona, California, 1978; Camarillo City Hall, Camarillo, California, 1977; Norwood, El Monte County Library, El Monte, California, 1977; Lynwood County Library, Lynwood, California, 1977; Compton County Library Mural, Compton, California, 1974; Tetiaroa, Tahiti, French Polynesia, 1973; Kona Surf Hotel, Kona Coast, Hawaii, 1971; Contemporary Hotel, Disney World, Orlando, Florida, 1970; Scientific Surgical Corporation, Beverly Hills, California, 1969; International Pipe and Ceramic Corporation, Parsippany, New Jersey, 1966.

15

Aurora Dias-Jorgensen

Aurora Dias-Jorgensen claims that the artist interprets God's world, that the process is a sacred act and each painting a prayer. This belief thoroughly describes Dias-Jorgensen's approach and intent in the creation of her art.

Born in 1918 in Brazil at the mouth of the Amazon River, Dias-Jorgensen began painting seriously at the age of 32 at the New York Art Students League. In a letter to the author, she described her current work:

> The intensity of color, the rise and fall of shapes are of continuing fascination for me. I feel an excitement in the rhythm of movement and the drama of color. Always there is a leap into the unknown, the expression of self, which in my case is partly Brazilian. I was born on the mouth of the Amazon, so that I try to symbolize, in non-specific terms, the volume of water that flows, the impenetrability of the woodlands with hidden waterfalls and bird life. There was a time when I made protest paintings. Trees were witnesses to the terrifying changes we impose upon the earth. I described the effects of atomic explosions and acid rain. Now I translate those feelings into totems. I say to myself: Nature is the human condition. No need to describe. Just be simple. Tell the truth. All is sacred.

Her description fulfills the definition of abstract expressionism. In her painting *Purification*, her notion of prayer comes into play. The purity of soul seems to be represented in the suggestive form to the right of the painting. The existence of a body form seems to disappear as the spirit takes over. The colors swirling upward are extensions of the earth reaching heavenward. Although the artist has stretched a yellow band across the canvas, it is intercepted by three oval shapes resembling oversized eyeballs. Yet, one envisions a continuation of yellow rays beyond the painted surface.

Dias-Jorgensen speaks of the unknown through *Purification*. The artist even allows color and shape to determine a definition or destination. She creates a mood that defines the unknown — an emotional mood of warmth, love, trust, envy, compassion and hate. But because Dias-Jorgensen believes that each work of art is a prayer, it fulfills the unknown: "I have always considered a painting, particularly one of spirituality, a sermon." Her paintings proclaim an awareness, a sense of the spiritual.

97

PURIFICATION by Aurora Dias-Jorgensen. Oil on canvas. 5 × 3 ft.
Courtesy of the artist.

For Aurora Dias-Jorgensen, painting becomes the link between the creation and the acceptance. Her personal intuitive expression sets the stage for a spiritual experience, but the viewer must be in a spiritual or contemplative mood to receive it.

Dias-Jorgensen's painting *Transgressions* is a personal reflection of faith. Being an abstract expressionist, misinterpretations vary from belief to total rejection. Colors are symbolic of emotional states. *Transgressions* reveals the sins committed against a divine being. The brilliant colors surrounding two black figures suggest human forms as sinners.

Because abstract expressionism lends itself to suggestive criticism, *Transgressions* may symbolize segments of hell and purgatory. Dias-Jorgensen does not explain the meaning of her individual paintings.

Dias-Jorgensen's manipulation of color coincides with the emotional fervor present during her creative process. Her paintings appear spontaneously rendered. There is little room for mistakes; if they occur, they are quickly erased in favor of newly applied color.

The environment is made up of three distinct planes, each harboring its own inhabitants. Although geometric in shape, the planes symbolize emotional traits peculiar to those humans engaged in transgressions. Dias-Jorgensen's works are contemporary mainstream and reflect the color-field intuitive forces of the abstract expressionist movement of the fifties.

Jungle Waterfall, although lacking a spiritual sense, translates into God's creation and is thus echoed by the artist. The title stems from her concern for natural habitation and the freedom to grow and develop according to divine guidance. As Dias-Jorgensen has stated frequently, nature is sacred. *Jungle Waterfall* is a vertical painting. Bright blues representing the falling water are surrounded by green foliage of the jungle. Interrupting the placid setting of greenery are stumps resembling trees that were once tall and elegant. The jungle greens include a trio of isolated ponds that lack the intensity of the waterfall. Clifford Still and Franz Kline come to mind when viewing the works of Dias-Jorgensen.

Since objective ideas are seldom considered when practicing abstract expressionism, titles are often attached to paintings after completion. *Carnival* seems as if intuition created a complex duality of color and shape. Space is considered only as the process consumes the working surface. There is no negative space. The colors and shapes strongly suggest an excitable activity. Colors suggest gaiety and laughter, and shapes reflect the human condition.

From the outset, the environment is slowly eliminated as each colored shape is added to the composition. Dias-Jorgensen does not suggest a procedure, but a finished product should strive for a balanced composition in terms of color and shape. Colors do not recede or advance according to preconceived theories.

Excitement is connected with Dias-Jorgensen's style of painting. Because the destination is unknown, one's arrival is either pleasant or frustrating.

Following page: *TRANSGRESSIONS by Aurora Dias-Jorgensen. Oil on canvas. 5 × 3 ft. Courtesy of the artist.*

CARNIVAL by Aurora Dias-Jorgensen. Acrylic on canvas. 36 × 48 in.
Courtesy of the artist.

ON THE WING by Aurora Dias-Jorgensen. Oil on canvas. 36 × 48 in.
Courtesy of the artist.

On the Wing, a superb example of the intuitive process, is similar in composition to her other works. There is a strong vertical push upward symbolizing a sense of Christ's resurrection or ascension. Even though such titles are not mentioned, the artist's spiritual attitude and religious concepts regarding nature create a feeling of confirmation.

The variety of shapes and colors distributed within the working surface symbolize the various time changes and nature's seasonal changes. Her paintings, regardless of titles, reveal a splendor, a celebration of life. Colors abound in *On the Wing* with varying degrees of joy and contentment. Even her painting *Sacrifice* dwells in beautiful pinks and is shaped like a crucifix.

Aurora Dias-Jorgensen may well be described as a painter of the spirit. Her paintings appeal to one's emotions and purposely avoid the intellectual sense of visual objectivity. Nature's images are unrecognizable yet appeal to emotional reactions that stem from the visual acceptance of color and its technical application to canvas. Because of her ties to abstract expressionism, Aurora Dias-Jorgensen is associated with the intuitive movement of mainstream art.

Career Highlights

Born in Brazil in 1918; moved to the United States in 1922.

EDUCATION
Studied at the New York Arts Students League; studied with Manso and Dorfman.

SOLO EXHIBITIONS
Ceres Gallery, Soho, New York, 1995; Broome Street Gallery, Soho, New York, 1993; Sirovich Gallery, New York, New York, 1987; Lida Gallery, New York, New York, 1982.

SELECTED GROUP EXHIBITIONS
Schering-Plough Gallery, Madison, New Jersey, 1995; Marcella & Eltman Gallery, Milford, New Jersey, 1995; John Harms Center for the Arts, Englewood, New Jersey, 1994; Brooklyn Botanic Gardens, Brooklyn, New York, 1994; Chelsea Mansion, East Norwich, New York, 1994; Cork Gallery, Lincoln Center, New York, New York, 1993; Ceres Gallery, New York, New York, 1993; Museum of Provincetown, Massachusetts, 1993; Washington & Lee University, Lexington, Virginia, 1993; Wilkes Art Gallery, North Wilkesboro, North Carolina, 1993; A.R.C. Gallery, Chicago, Illinois, 1992; Stony Brook University, Stony Brook, New York, 1992; New York Academy of Sciences, New York, New York, 1992; Broome Street Gallery New York, New York, 1991; Bergen Museum of Art & Science, Bergen, New Jersey, 1990; Adelphi University, Garden City, New York, 1987; Castle Gallery, New Rochelle, New York, 1986; Passaic County Community College, Passaic, New Jersey, 1986; Mocha-Museum of Contemporary Hispanic Art, New York, New York, 1985; Cayman Gallery, New York, New York, 1984; Museo del Barrio, New York, New York, 1980; National Academy of Design, New York, New York, 1979.

Geny Dignac

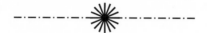

Artist Geny Dignac was born in 1932 in Buenos Aires, Argentina, and moved to Washington, D.C., in 1954. She remained there until she moved to Arizona 18 years later in 1972. Her unusual medium of expression consists of fire, light and heat. Her artistic expressions are difficult to define because they consist of three stages of emotional responses. Her work relates particularly to the "happening events" of the sixties. However, Dignac's fire events reflect the anticipation of an event, the actual event, and the aftermath of an event. Thus, the viewer experiences three exciting stages of the creative process: the beginning, the expression in full bloom, and the end.

In *North American Women Artists of the 20th Century* (edited by Jules and Nancy Heller), Dignac said: "Lightning is the gesture of the storm. Flames are the gesture of the fire. Fire is a magical element. Magical thinking is art." Her reasoning relates to the abstract expressionist school of thought. Dignac's fire expressions are "happenings," and although the original composition is destroyed, the remains are final.

The fire itself becomes both the process and the product. Yet, the construction or composition before fire enters the scene is a sculptural form worthy of note. The medium of fire immediately alters the composition. Finally, the aftermath reveals a third emotional response.

Dignac's fire gestures are ever-changing. The process somewhat dictates the outcome, and yet, as an abstract expressionism, one is never quite sure of the finality. The work is also open to personal interpretations; the author senses the theme of the Crucifixion. One is drawn — intentionally or not — to the structure's composition.

Since Dignac's fire gestures are temporary, the only record of their existence are photographs taken before, during, and after the event. The excitement is heightened by the unpredictability of the process.

Also referred to as environmental sculpture, Dignac's fire gestures incorporate other elements. A successful environmental sculpture was her parade of gloves mounted along the landscape. When lit, they produced an illuminating scene not unlike that of a major airport runway lit up in the darkness of the night. *Burnt Glove,* a 1979 collage, is a close-up view of a single glove. Even by itself, it presents a dramatic message. The three burnt spots are individually controlled so that a total composition is presented.

Dignac has explained her fascination with fire in the 1985 issue of *Kansas*

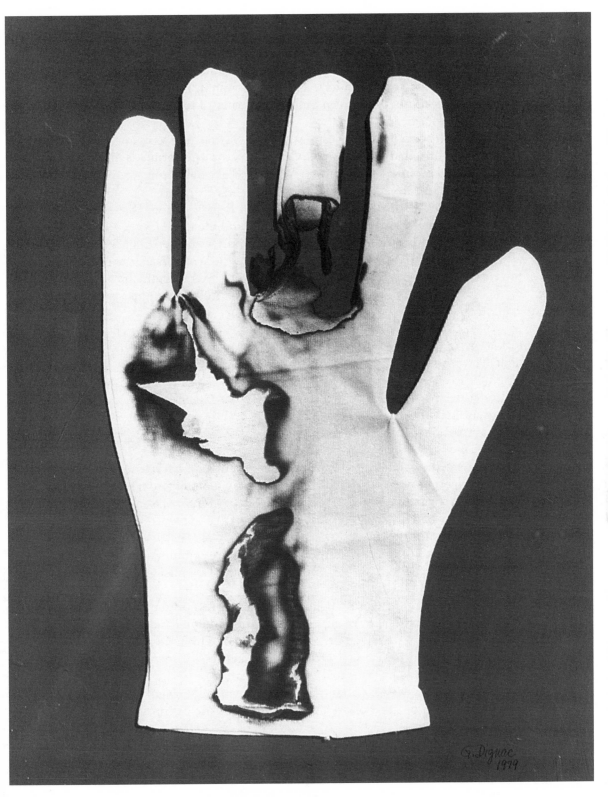

BURNT GLOVE by Geny Dignac. 1979. Collage.
Courtesy of the artist.

Quarterly (vol. 17, no. 3): "Fire is an innate element to me. I respect its power, but I am not intimidated by it. I am mesmerized, incantated, enchanted, bewitched, obsessed and possessed by it. I have a love affair with it. It is so much a part of me. I become the medium for it. I can pull all the strings. I can travel with it, let it go, bring it back."

Although her explanation seems strange, it was a natural outgrowth of a child's curiosity and imagination. In a sense, Geny Dignac is a performer, a magician. Her environmental exploits are art forms in progress. They differ from traditional sculptures that exist for decades or even centuries.

To record the simultaneous renderings of her fire gestures, Dignac composes a series of temperature gauges, location sites and gloves. Arranged in an Andy Warhol–like composition, Dignac includes a horizontal series of white gloves, all but one punctured with a circular hole. Given the symbolic nature of the work, the viewer is left to personal interpretation. A third layer of symbolic photographs define the location of her fire gestures. It is a photographic pop version of her exploits.

Aside from her fiery sculptures, Geny Dignac arranges neon lighting to form exotic environments. A 1969 rendition, *Vulcan*, combines Plexiglas and fluorescent light. The process is more controlled than the fire gestures, thus forfeiting the freedom of her other works. In *Vulcan*, four horizontal planes are established within a vertical panel. Each displays an unusual lighted environment utilizing curved arches and ovals. Light is exquisitely fused to present an ethereal atmosphere. There is a sense of surreality, a feeling of eternal life that emanates from the projected lighting. *Vulcan* is a bold, pleasing exhibit of fluorescent lighting.

Under certain conditions, with proper environmental backgrounds, subsidiary creations emerge from the shadows and reflections emanating from the fire gestures. In the 1969 production *Fire Sculpture E.D.M. Model for Corten Steel*, Dignac creates both positive and negative responses, the positive superseding the negative. Although both are physically disconnected, the two images become one because neither would exist without the other. The structure resembles a cruciform again. Whether intended or not, the subconscious remains a significant aspect of the creative act.

The artist's fire events are similar to abstract expressionist paintings. Although freedom exists, there is always the exciting aspect of unpredictability.

Dignac admits that her works no longer belong to her once the flame is lit. She sets the stage for the event to follow, then becomes a spectator and can only envision landscape change created by her fire gestures.

One can only wonder about the next plateau Geny Dignac will reach. The panoramic scope of her work does not suggest artistic expressions on a smaller scale.

Her "happening" expressions have been witnessed throughout North and South America and Europe and are represented in galleries and museums throughout the world.

VULCAN by Geny Dignac. 1969. 98 × 50 × 6 in. Plexiglas.
Courtesy of the artist.

FIRE SCULPTURE E.D.M. MODEL FOR *CORTEN STEEL*
by Geny Dignac. 1969. 18½ × 1 × 1 ft. Gas with 6 jets of fire.
Courtesy of the artist.

Career Highlights

Born in Buenos Aires, Argentina, in 1932; lived in Washington, D.C., area 1954–1972; moved to Arizona in 1972.

LECTURES SINCE 1969

Tucson Museum of Art, Tucson, Arizona; Center for Art & Communication, Buenos Aires, Argentina; Arcosanti Foundation, Arizona; School of Visual Arts, Caracas, Venezuela; New York University, New York, New York.

SELECTED INTERNATIONAL INVITATIONAL EXHIBITIONS 1958 TO PRESENT

Museum of Modern Art, Colombia (Bogatá); Museum of Modern Art, Buenos Aires, Argentina; Palais de Beaux Arts, Brussels, Belgium; Galleria d'Arte Moderna, Ferrara, Italy; Fundación Joan Miró, Barcelona, Spain; Space Pierre Cardin, Paris, France; Institute of Contemporary Arts, London, England; International Cultural Center, Antwerp, Belgium; Latin American Art Foundation, San Juan, Puerto Rico; Louisiana Museum of Art, Denmark; Galería 22 & Cinema 2, Caracas, Venezuela.

SELECTED GROUP INVITATIONAL EXHIBITIONS 1958 TO PRESENT

Corcoran Gallery of Art, Washington, D.C.; Institute of Contemporary Arts, Washington, D.C.; Flint Institute of Art, Flint, Michigan; Brooklyn Museum of Art, Brooklyn, New York; North Carolina Museum of Art, Raleigh, North Carolina; Museum of Fine Arts, Boston, Massachusetts; Everson Museum of Art, Syracuse, New York; Ringling Museum of Art, Sarasota, Florida; Frick Museum, Pittsburgh, Pennsylvania; Tucson Museum of Art, Tucson, Arizona.

PRIVATE AND PUBLIC COLLECTIONS

Fundación Joan Miró, Barcelona, Spain; Museo del Banco Central del Ecuador; Palzzo del Diamanti, Ferrara, Italy; extensive private collections in the United States, Italy, Germany, Spain, Argentina, Chile, Ecuador and Venezuela.

Catalina Gonzalez

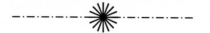

Catalina Gonzalez uses a single stimulus to develop a series of drawings and paintings. In one series she focuses on a single female form and its various physical movements and postures. In *Boom Box* (1981) a simple pose is transformed into an abstract, partially commercial pattern. There is a glint of American painter Richard Linder's style.

Although the subject is rendered in flat patterns, there exists a sense of the three-dimensional. The combination of line and shape define the subject matter. Contour drawing is the basis for the female image, and line is used to define the form as well as aid the composition.

The facial expression and the woman's pose hint at commercialism, yet there exists the abstraction which has life both in the mainstream of American art and in the beckoning of modern advertising.

The line used as an edging to a shape as well as a contour to the female form is the basis for her drawing. *Boom Box* is a collection of geometric shapes nestled within the confines of an established form. The background, or what is commonly called "negative space," is echoed throughout the foreground figure so that the entire drawing is completely within the dimensions of the working surface.

There is an equal distribution of naked contour lines that demand attention because they exist on their own. Each line is carefully positioned. The head form is particularly composed. Line and shape blend into a pleasing facial gesture. To complete the drawing, Gonzalez structures geometric shapes similar to those in the foreground figure into the environmental background, adding interest to an otherwise empty area and completing the total composition.

In *Bird of Paradise* (1979) Gonzalez concentrates on the upper torso and focuses particularly on the head that commands half of the drawing surface. Contour lines again play an essential role. Instead of the usual naturalistic portrayal, the artist carefully uses geometric shapes to represent the facial features. Her purpose is less logical than artistic and serves an emotional as well as compositional need. What appear to be superficial physical needs instead are utilized as essential elements of occupying space. With its centrally located figurehead, immediate attention is given to the unusual hair style.

Again, one may consider it a commercial ad, but contemporary artistic elements place *Bird of Paradise* in the class of contemporary art. Gonzalez uses the plot pattern with three-dimensional characteristics to formulate a valid style.

Gonzalez utilizes the geometric shape to advantage by incorporating it into

BOOM BOX by Catalina Gonzalez. 1981. Graphite on bristol board. 14 × 18 in.
Courtesy of the artist.

the background, thus creating a totality. The viewer is exposed to the entire working surface instead of ignoring much of the canvas. Others may argue that negative or muted space is a natural result of the foreground presence. Thus, it can never be ignored. Nonetheless, it is seldom acknowledged. However, Gonzalez avoids such criticism with the introduction of line and shape to correspond with those within the foreground figure.

Triangle (1991) veers considerably from any hint of commercialism with a total abstraction, a refinement of line and shape. A pose similar to the figure in *Boom Box* and *Bird of Paradise* is seen in *Triangle*, except that Gonzalez now uses the total working surface as a positive force. Abstract geometric shapes become integral aspects of the expression. There is a notable relationship between the subject matter and environment. In fact, the inter-relationship between foreground and background makes for a unique composition—a total expression in which a perfect union is established between foreground and background. A line appropriately weaves throughout the drawing, acting as both contour and outline—not as an afterthought but as a preconceived attempt to unify the composition. *Triangle* is an exquisite example of abstract art in which interpenetration and overlap of shapes coincide. There is a pleasant blend of the linear and the solid. One first recognizes the abstract nature of the drawing before identifying the subject matter.

Dark and light areas are carefully positioned to insure carefully rendered and completely compatible expression. One is not immediately faced with a delicately expressed female form, but rather one is forced to discover the identity of the subject matter that is partially hidden amid the pleasantries of lines and shapes.

Closed Doors (1991) reveals a different gesture while retaining a similar technique used in her other works. The vertical figure revealing the upper torso approaches a three-quarter view, revealing a full face. Again, the commercial element is revealed in the hairstyle, which reflects an intuitive approach but which in actuality is carefully planned and executed.

Although the hairstyle appears as reckless abandon, it offers an exciting contrast to the lower portion of the drawing. The contour line again is utilized in appropriate body parts. In order to satisfy the vertical working surface, the artist introduces alongside the outer boundaries vertical rectangular shapes to match the vertical posture of the subject. Areas of light and dark are applied as compositional essentials rather than any natural light sources or resulting shadows.

On the Move discards the front view in favor of a rear glance of the entire figure. Furthermore, the subject is directly tied to the background by horizontal rectangular shapes that cut across the background space. The artist includes some elements that appear to serve no purpose other than compositional.

The back view leaves the figure anonymous so that any female viewer becomes the subject. The flat planes of the background strongly suggest an abstract approach to understanding. A literal translation is lessened because of the flat patterns existing on a frontal plane.

The horizontal lines are positioned with the firm conviction of connecting the background to the subject in the forefront, even though distortion results. The beltline of the female form extends across the entire working surface.

BIRD OF *PARADISE* by Catalina Gonzalez. 1979. Graphite on bristol board. 9 × 12 in.
Courtesy of the artist.

TRIANGLE by Catalina Gonzalez. 1981. Graphite on bristol board. 12 × 16 in.
Courtesy of the artist.

ON THE *MOVE by Catalina Gonzalez. 1980. Graphite on bristol board. 11 × 15 in.*
Courtesy of the artist.

On the Move differs from other works in that the background joins forces with the positive aspects of the figurative form. Visual perspective and physical proportions are lacking, reflecting a lack of interest in a realistic portrayal.

Career Highlights

Born in 1963 in California.

EDUCATION
Self-taught; several apprenticeships in photo-realism and on-the-job training.

MURALS
Coconut Grove Supper Club (two 18 ft. murals on a dome), San Francisco, California, 1994; Café Dolce Vita, Trampe L'oeil Mural (600 sq. ft.), San Francisco, California, 1994; Joy of Life, residential mural (8 by 40 ft.), San Francisco, California, 1994; Muni Barracade, Muni community project mural, San Francisco, California, 1994; San Francisco Art Commission mural (10 by 36 ft.), San Francisco, California, 1993; Bay View Hunters Point, child development mural project, San Francisco, California, 1992; The Greenery, sky mural (450 sq. ft.), San Francisco, California, 1992; The Quake, Night Club, earthquake mural, San Francisco, California, 1992; St. Vincent DePaul Soup Kitchen, underwater mural project, San Rafael, California, 1992.

Liliana Wilson Grez

Born in Chile in 1954, Liliana Wilson Grez explains her artistic purpose in this statement to the author: "My work is about life: human suffering, power, greed, cruelty, indifference and beauty. What I do is draw what I perceive and through it I paint out the suffering and senselessness that exists in the world. Whatever image comes to me has to be drawn beautifully, even if it is something horrible because I love beauty. I feel that if I am going to give something to someone, I want it to be beautiful. As disturbing as it may be, I have beauty in it so people will want to look at it. Beauty is the only hope that I have; that is why it is important to my work."

Grez's emphasis on beauty in the face of tragedy is intriguing. A raging tornado is a terrifying sight, but according to Grez the composition, emotional content and technical rendering of pigment in her painting of a tornado yield beauty. Therefore the manner in which a concept is approached and executed can be a beautiful act.

In her 1992 painting *Greed*, the artist has indeed beautified the sin of greed. The color, composition and technique are beautiful to behold. One wonders if the concept of greed is lost altogether because of this treatment. One might even be lead to assume greed to be morally sound and ethically acceptable.

Because of greed, man is like a fish out of water. Caught in a whirlpool and out of control, man drowns in his own greed. Grez has added a bit of humor to her painting, although she makes it quite clear that the intensity of greed not only destroys oneself but others.

Greed is a painting of symbolic reds; a sea of blood can be an extreme interpretation. Because of its surreal concept, *Greed* beckons an intellectual audience. The beauty of which Grez speaks has to do with the exquisite rendering of a limited palette and the compositional balance of similar entities. The manner in which the lonely figure mounts the distant shore contemplating the future of a greedy society makes for a poetic conclusion.

Escape, a 1992 pencil drawing, reveals the frenzied look of society attempting to escape from its own shadows. They are identical twins, those members of society whose injustices serve only to encase their own sins from which there is no escape. Without the title, the viewer is apt to introduce varying interpretations, but Grez gives fair warning and a clue to understanding. The birds stationed on each side of the drawing anchor the composition and detain the exit of the two subjects. It is a subtle but effective ploy. Grez has used the twin scheme to represent all of society.

Above: *TEARS OF DESPAIR by Liliana Wilson Grez. 1992. Acrylic. 4 × 4 ft.*
Courtesy of the artist.

Another exquisitely rendered pencil drawing, *Ciego*, a 1993 production, pictures a blind man with a leader dog and a cane as a feeler. It is a simple composition creating a contemplative mood for the viewer to readily acknowledge and appreciate.

The unusual composition — which would normally lead the viewer out of the picture plane — is retained by the taut dog leash that seems to halt any psychological

Opposite top: *GREED by Liliana Wilson Grez. 1992. Acrylic. 4 × 8 ft.*

Opposite bottom: *ESCAPE by Liliana Wilson Grez. 1992. Pencil. 12 × 16 in.*

Both courtesy of the artist.

movement of the subject. The drawing is tempered by the delicate pencil strokes that add to the silent world of the victim of blindness. The cause of blindness is not revealed. Nonetheless, it is a tragedy that the artist has hoped to cushion with a beautiful rendering. One is placed in a stilled mood, a moment of contemplation. Grez admits that her work gives no answers and that it is a continuous search. The works themselves are images of her life and should be enjoyed as such. The search becomes its own reward.

Broken Crown, a 1988 pencil drawing, is a portrait of a young man whose dreams of joy have been shattered. His hope exists only in the hereafter. Grez again extracts beauty from tragedy with a delicate and appropriate rendering. However, the tragedy remains unidentified. The subject occupies the entire frontal plane, thus allowing the viewer total freedom from secondary intrusions. The portrait approaches photorealism in style and leans close to surrealism. Her work has this magical, yet undeniably elusive, quality. In a sense, it is a search for the unknown, not to identify the unknown but rather to enjoy the search that is never ending and ever changing.

An extremely subjective portrayal of a single portrait similar to the work of American pop artist Chuck Close is *Tears of Despair*, a 1992 rendition. The strong geometrically shaped head reveals a resignation to life's circumstances but a determination to overcome and resolve the problems.

The painting absorbs the working surface. Negative space is minimal so that full focus is on the subject, but the red background casts a haunting effect upon the sculpturally classic features of the subject. *Tears of Despair* leads one to believe that the solution is the afterlife. Indeed, beauty reigns within the classical use of color and the solidly joined facial features, which seem to suggest an endless sense of hope.

Falling Men, a 1995 rendition, displays the futility of power, greed and injustice. Grez's portrayal defines the concept of no return; there is no safety net. The triplet male images have fallen into an endless journey, while the viewer is left to determine the answers.

Throughout her work Grez expresses her notions of greed, power, indifference and injustice, but her elegant rendering tends to dissuade the viewer from accepting her message. The notions that she detests are exquisitely expressed, and beauty does lie within. It is this paradox that remains unresolved.

Career Highlights

Born in Chile in 1954.

EDUCATION
Law School, Catholic University of Valparaíso, Chile, 1971–77; Instituto de Bellas Artes, Vina del Mar, Chile, 1976–77; Austin Community College, Austin, Texas, 1980–83; Southwest Texas State University, San Marcos, Texas, 1991–95.

SOLO EXHIBITIONS
Guadalupe Cultural Arts Center, San

FALLING MEN by Liliana Wilson Grez. 1995. Acrylic. 2 × 3 ft.
Courtesy of the artist.

Antonio, Texas, 1991; Los Manitas, Austin, Texas, 1986.

GROUP EXHIBITIONS
Western Illinois University, DeKalb, Illinois, 1996; Dougherty Art Center, Austin, Texas, 1996; Guadalupe Cultural Arts Center, San Antonio, Texas, 1995; University of Texas, El Paso, Texas, 1994; Laguna Gloria Art Museum, Austin, Texas, 1994; Coronado Art Gallery, Austin, Texas, 1994; El Paso Museum of Art, El Paso, Texas, 1994; Franklin Gallery, Austin, Texas, 1993; Guadalupe Cultural Arts Center, San Antonio, Texas, 1993; Doughterty Art Center Gallery, Austin, Texas, 1992; Latina & Chicano Perspective, Bayfront Gallery, San Francisco, California, 1992; Circollo della Rosa, Rome, Italy, 1991; Franklin Plaza Gallery, Austin, Texas, 1991; The Esperanza Peace & Justice Center, San Antonio, Texas, 1991; University of Texas, Austin, Texas, 1990; Galería Sin Fronteras, Austin, Texas, 1989.

Carmen Herrera

A Cuban artist of great stature, Carmen Herrera was born in Cuba in 1915. Her artistic training included time in Europe, the United States, and Cuba. Her numerous showings throughout Europe and the United States have been assessed in favorable terms by the finest art critics and historians.

In 1956, Emily Genauer of the *New York Herald Tribune* commented: "Those who are interested to see how much Cuban art has advanced in style have a showing of Carmen Herrera's work at the Galería Sudamericana to indicate it. One of Cuba's more respected contemporary painters, Miss Herrera uses plot, geometrical forms, mainly, and stresses textural quality through the varied surface impasto she develops with her moderately high pitched colors."

During the same year, Dora Ashton of the *New York Times* wrote: "Carmen Herrera is one of Cuba's best non-objective painters. Her vivid oils at the Galería Sudamericana are organized in flat, intricate patterns and evoke the sharp light and native excitement of Cuba. Señorita Herrera, whose work relates to the French concrete school, adheres strictly to the single plane, but her high original color (such combinations as bright pink, orange, tan, black and gray) activates each of her works, giving it a lively extra dimension."

In a 1965 issue of the *New York Times*, noted critic Hilton Kramer reported: "Within the limits of the geometrical and hard-edge modes, a painter's success often depends on a correct gauging of what personal innovations are possible within the impersonal conventions of these styles. Miss Herrera shows a canny understanding of this problem and is thus able to confer something distinctly her own on a pictorial realm now widely and expertly practiced."

Because of her studies in Europe and the United States, Herrera arrived on the international scene early on in her career. Linked to the abstract expressionist school, Herrera's paintings relate to the works of Mark Rothko, Ad Reinhardt and Clifford Still. Throughout her career Herrera's work was orderly and simple. She began by creating optical space by utilizing systems of adjacent bands of black and white paint.

In the book *The Latin American Spirit*, Herrera is quoted as saying in relation to op art: "At the time I never thought I was creating op art. It simply resulted from my rational ordering of black and white."

As Herrera became more discriminate, she developed a more personal handling of black and white with a freedom of distributing shapes and colors into appropriate areas. It is an extreme intellectual practice to limit one's palette to a few colors, thus forcing the use of white to tint a pure color into varying degrees of intensity.

122

The abstract expressionist deals with the intuitive placement of color within space and the spatial relationship between colors on a frontal plane. There is no visual perspective, and yet, the advancement and recession of color is forever present and is determined not so much by size as intensity.

According to Stephen Westfall, in the March 1989 issue of *Art in America*: "During a career spanning roughly four decades, Herrera's painting has paralleled several movements in Abstract art — including the cool wing of Abstract Expressionism, post paintly abstraction and Minimalism — without belonging to any of them.

"Herrera's compositions flirt with symmetry without quite giving in — a quality that creates a subtle pictorial tension. The planes in her painting appear to vibrate optically but the hot color and the eye pulsing harmonies she favors are less important for this effect than the interlocking figure-ground relationships in her compositions."

Robert Fulford of the *Toronto Daily Star* wrote in 1962: "Miss Herrera, a Cuban born artist who has lived in the United States for some years, works in clear, pure colors and the simplest possible shapes. What she achieves with simple components is genuinely startling. Her pictures have a sharp, pointed impact; they force the viewer to look at shapes in HER way, to see two-dimensional arrangements through her eyes. The experience of doing so is refreshing and pleasant — indeed, one of the most directly pleasing experiences of the season."

The repetition of a single geometric shape and the limitation of two extreme opposite colors are never more obvious than in Herrera's optical version *Untitled*. This painting of 1952 preceded the origin of op art because it was never meant to be classified as such. Herrera merely intended to experiment with the placement and repetition of two opposing colors in their purest forms and to distribute them in a spatial environment. The result is a clear, direct and simple arrangement that creates a pleasant visual experience.

Carmen Herrera is a consistent artist who pursues quality and the thrill of discovery. In *Untitled*, there appears an element of optical illusion, but because the purpose was not to create visual sensations of uncertainty, it cannot be labeled op art. *Untitled* has to do with the interaction of two extreme colors when positioned adjacent to one another and then repeated in a similar manner. Because both positive and negative elements are similar in size and shape, it avoids the possibility of optical illusion. Furthermore, it avoids monotony because of the slight alteration of the diagonals. The artist has created a work that eludes the label of op art as well as the classification of abstract expressionism.

Twenty-five years later, Herrera used a single shape of golden color and thrust it upon a sharp contrasting environment. The result is a dynamic relationship between two explosive colors: purple and gold. The angle of the positive shape dictates the shape, size and intensity of the negative space. Actually, the positive geometric shape and its surrounding space become one. Again, Herrera avoids the possibility of an optical illusion by altering colors so that a perfect harmony ensues. Americans Clifford Still and Franz Kline emerge as artists similar in approach to that of Carmen Herrera.

In *Saturday,* executed in 1979, Herrera creates a tension between two extremes in color, dealing with positive and negative space. Although the central or single image is usually considered the positive aspect and the surrounding space labeled as the negative aspect, Herrera succeeds in harmonizing the two extreme colors while introducing a tremendous tension within the positive element itself by elongating the lower segment of the gold image. Were the surrounding space a different color, the result would have been disintegration rather than integration.

There is a spiritual element in *Saturday.* The shape, size, color and angle contribute to the semblance of the Crucifixion, and the color reflects the golden feast of the resurrection or rebirth. The angle also suggests the thrust of the spikes that pierced the hands and feet of the Savior. This is speculation, but abstract expressionism, more than other schools of thought, lends itself to freedom of interpretation.

In 1988 Herrera painted *Lemon Yellow and Cobalt Blue,* an adventure with two complementary colors that identify with a highly advancing color and a definitive recessive color. Working with a perfectly square canvas, Herrera divided the painting into two equal parts. Rather than concentrate on either color or visually move from one segment to the other, the artist interpreted each

UNTITLED by Carmen Herrera. 1952.
25 × 60 in. Oil on canvas.
Courtesy of the artist.

SATURDAY by Carmen Herrera. Oil on canvas. 64 × 42 in. 1978.
Courtesy of the artist.

segment with the opposing color: cobalt blue into lemon yellow and lemon yellow into cobalt blue. Suddenly, this added juncture became the focal point and altered the visual approach and eventually the visual interpretation. The two equal rectangles were still equal but not rectangular. The entire painting took on a new meaning. The ability to hold in check the exposure of two major complementary colors equal in the absorbance of space is an intellectual feat.

Colors that generally clash and elude compatibility are ripe for Herrera's ventures into color. For example, colors such as orange and blue are considered a poor combination, especially when lacking other colors as reinforcements. Yet, Carmen Herrera, using a limited palette of two colors — one primary and one secondary — combines them into the pleasant painting *Cadmium Orange with Blue*, a 1989 production.

The distribution allotted each color becomes a significant factor in establishing a compatibility. There appears to be a larger blue area than orange, and yet, measurements of each would bear out any discrepancies in space occupancy. It is this manipulation of color in space that marks Herrera's painting as mainstream. Josef Albers may well have been an influence since she had broad studies in art history and frequented galleries and museums both in Europe and the United States.

To realize the delicacy of Herrera's composition, one only needs to reverse the posture of *Cadmium Orange with Blue*. To position the area of cadmium orange at the base of the painting would destroy the balance. The blue positioned atop the orange would visually suggest a burden upon the brighter color. Thus, a lack of compositional unity would result.

Noted as a color-field painter of the abstract expressionist movement, Carmen Herrera has succeeded in propelling her work onto the international scene.

Painted a year after *Cadmium Orange with Blue* was an extension of the 1989 product called simply *P.M.* The red-orange color is expanded almost to the point of eliminating the darker color of blue. Again a perfect square is used. At first glance one sees a single color with a dark border, but after several studies, one notices the use of two colors.

The equalizing of recessive and advancing areas permits abstraction to develop as an integrating force rather than one of segmentizing the whole. At the same time a tension prevails which is never ending, a tug-of-war whose opposing forces are equally forceful and that result in an intensified battleground. It is this intensity that best describes and identifies the abstract expressionist movement.

It is conceivable that Herrera's painting could extend beyond the canvas surface, thus suggesting a larger working surface, a near panoramic approach. It is also conceivable that *P.M.* can be interpreted several ways depending on the angle from which the painting is viewed.

Abstract expressionism is characterized by its freedom from tradition and its exclusion of representational content. The above definition applies to Herrera's *P.M.* in that it is a result of the intuitive process. Since abstract expressionism is based solely on the intuitive process and the response to a given idea or a natural event without respect to visual representation, the intellectual or visual senses are utilized prior to painting.

LEMON YELLOW AND COBALT BLUE by Carmen Herrera. 1988. Acrylic on canvas. 42 × 42 in.
Courtesy of the artist.

Carmen Herrera is represented in several museums in Cuba and the United
States, including the Jersey City Museum of Art, the New York University Medical
Center, the New York City Institute of International Education, the Museo de San-
tiago de Cuba and the Museo de la Havana in Cuba. She has also received several
grants including the Institute of International Education and the Creative Artists
Public Service Program.

CADMIUM ORANGE WITH *BLUE by Carmen Herrera. 1989. Acrylic on canvas. 42 × 42 in.*
Courtesy of the artist.

Career Highlights

Born in Havana, Cuba, May 1915; worked and lived in Paris, 1948–1953; lived in New York City since 1954.

mount College, Paris, France; studied at Havana University; studied at the Art Students League, New York City.

EDUCATION
Studied under J.F. Edelman at the Academy of San Alejandro, Cuba; studied at Mary-

SOLO EXHIBITIONS
Jadite Galleries, New York, New York, 1992; Rastovski Gallery, New York, New York,

1984, 1986, 1987, 1988; Alternative Gallery, New York, New York, 1965; Cisneros Gallery, New York, New York, 1963; Trabia Gallery, New York, New York, 1956; Galería Sudamericana, New York, New York, 1955; Eglinton Gallery, Toronto, Canada, 1951; Lyceum, Havana, Cuba, 1951.

GROUP EXHIBITIONS
Housatonic Museum of Art, Bridgeport, Connecticut, 1994; Vista Gallery, New York, New York, 1994; Jadite Galleries, New York, New York, 1994; Artists Space, New York, New York, 1993; Rastovski Gallery, New York, New York, 1989; The Bronx Museum of the Arts, New York, New York, 1989; Museum of Contemporary Hispanic Arts, New York, New York, 1987; Jane Vorhees Zimmerli Art Museum, Rutgers University, Newark, New Jersey, 1987; Center for Inter-American Relations, New York, New York, 1974; Long Island University, New York, New York, 1972; New York University, New York, New York, 1972; Cisneros Gallery, New York, New York, 1967; Jerrold Morris International Gallery, Toronto, Canada, 1962; Galerie Olga Bogroff, Paris, France, 1953; Salon d'Art Moderne, Zurich, Switzerland, 1952; Musée d'Art Moderne, Paris, France, 1951; Salon des Réalités Nouvelles, Paris, France, 1949, 1950, 1951, 1952.

Nora Chapa Mendoza

Born in Weslaco, Texas, in 1932, Nora Chapa Mendoza has exhibited nationally and internationally, including in Germany, El Salvador, Nicaragua and the United States. Born in poverty, Mendoza is self-taught and even as a youngster felt destined to become an artist. Her images of migrant workers are provocative.

In the fall 1995 issue of *Labor's Heritage*, Robert Quivroz, the director of the Migrant Worker Program in Flint, Michigan, said, "Through [Mendoza's] art she gives migrant workers some of the long needed recognition that they deserve." In the same issue Mendoza stated, "These paintings were more challenging than anything I have ever painted — trying to put across the pain of these people."

Poverty wages and long hours are major migrancy problems, along with unemployment. In her painting *Employment Agency*, Mendoza features four migrant workers huddled in frustration before a consolidated employment agency. Paint was applied with palette knife, then scraped and reapplied in order to create a mood of poverty. The four unemployed workers form a circular composition. Each head is topped with a shabby sombrero, and each figure appears upset and offended that work has been discontinued.

Mendoza's technical use of color makes the background of buildings appear as condemned and worthless. One is reminded of the homeless creatures of the Great Depression recorded by Reginald Marsh, Ben Shahn, the Soyer brothers, and others. The migrant workers were treated like slaves, and Nora Chapa Mendoza shares that pain as each painting tells its story.

Las Piscas de Tomate reveals four migrant workers picking, lifting and toting bushels of fruit and vegetables. Mendoza arranges four workers each in a different position and different angle to project a compelling composition. There is no joy in work. There are no smiling faces, only signs of drudgery, weariness and frustration.

There is a hint of a panoramic view since the worker to the far right appears to be leaving the scene as if life existed outside the picture plane. Yet, the artist has slowed down the moving process by inserting a figure in a stooped position. Each figure is viewed from a slightly different angle to avoid monotony.

Nora Chapa Mendoza is a realist with a touch of expressionism. The technical application of paint is scraped on in a seemingly roughshod manner, but this translates into an appealing emotional mood that suits the subject being expressed. Each figure is left unidentified and focused on the single chore of carrying out the master's charges.

The acrylic medium is ideal for Mendoza's approach. Her themes of migrant

EMPLOYMENT AGENCY by Nora Chapa Mendoza. 20 × 13 in.
Acrylic/mixed media on poster board.
Courtesy of the artist.

workers and landscapes are suitable for both opaque and transparent portrayals. The versatility of the medium allows for looseness where appropriate and tightness where needed. The looseness allows for continuous activity of the artist's subjects while activating areas that are by nature less exuberant.

Poverty at its lowest is witnessed in Nora Chapa Mendoza's painting *Barrio como Vivimos*. A tenement village translates into rat-infested shacks with little protection from inclement weather, unhealthy sanitation and disease. The artist has suggested in the arrangement of her subject matter a panoramic view of endless desolation.

Again, the acrylic medium allows for both transparent and opaque applications of pigment. Although all homes connect into a horizontal formation, the condemned buildings are vertical in structure. Acceptance of their condition in life is common since change for the better is improbable. Families accustomed to a life of poverty have little recourse but to live day by day. A profound faith usually supersedes the call for better living quarters.

Mendoza's composition includes inhabitants who bring no joy to the environment. Their shabby attire is compatible with the slovenly living conditions and

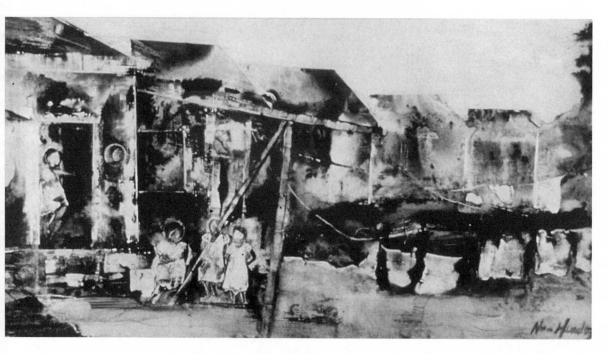

*BARRIO COMO VIVIMOS by Nora Chapa Mendoza. 15 × 24 in. Acrylic.
Courtesy of the artist.*

pessimistic outlook on life. The children housed in one shack appear as war orphans and their environment as the remains of a barrage of shellings. The artist leaves no doubt as to her purpose. Recording and presenting a dismal situation is the first step toward finding a solution.

A collage of mixed media, *Guatemala* is a 1992 production. The brilliant colors sparkle and shine in the foreground while the background shimmers in golden celebration. The painting sparkles with electrifying colors representing a nation of rich resources and cultural activities.

Perhaps the artist saw in Guatemala that which was absent from her own native Mexico. *Guatemala* is a landscape of sorts, not an urban setting or a rural scene. It is a landmark of splendor, a utopia of sorts celebrating an age of charm and beauty. Mendoza had switched from her earlier works and explored the imaginary: a landscape of a glittering foreground and golden cliff-like dwellings forming a mountainous terrain above the gala celebration. A serene sky dwells quietly in the distance. *Guatemala* is an intensely activated work of art. It is a compact composition, emotionally charged but controlled by the intellect.

Mujer con Serape and *Familia*, two earlier works of the late seventies, are wonderful examples of the abstract expressionist movement. Both are expertly expressed using negative space effectively to amplify the subject matter.

Familia is an overlapping, interpenetrating composition of geometric shapes

*Opposite: FAMILIA by Nora Chapa Mendoza. Acrylic and mixed media. 30 × 12 in.
Courtesy of the artist.*

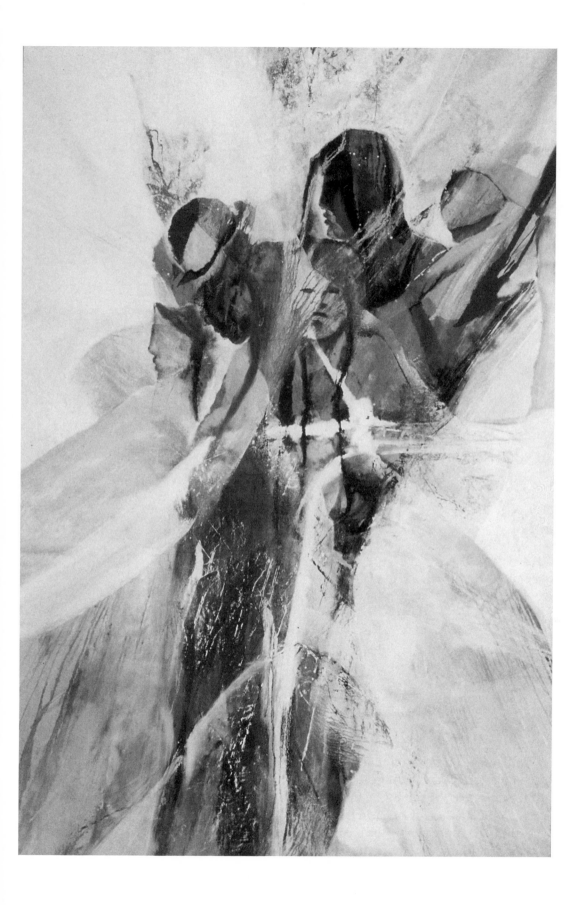

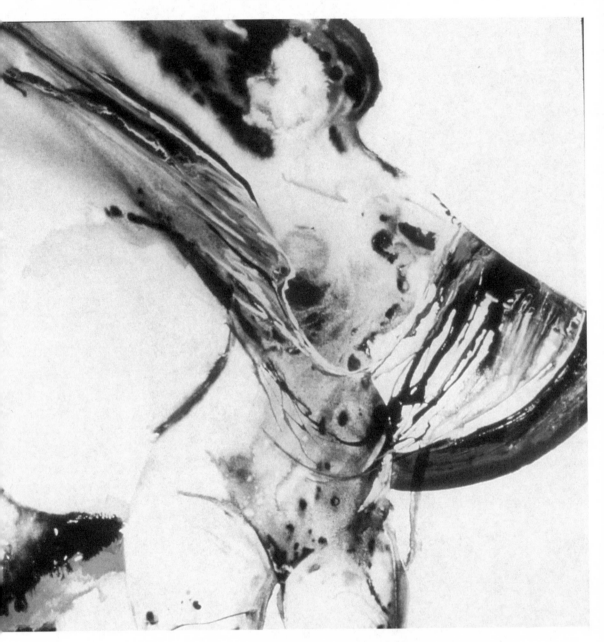

MUJER CON *SERAPE by Nora Chapa Mendoza. 1979. Oil on canvas. 40 × 40 in.*
Courtesy of the artist.

that suggest a group of human figures. The background is a sweeping combination of light transparent colors that not only inhabit the environment but overlap and complement the subject matter of human forms.

Abstract expressionism is a difficult technique to master. The process is intuitive, and consequently the results are frequently unknown. In the case of *Familia*, one is not certain of the intent or the expectations of the artist. Sometimes the artist

is unaware of the meaning of the results. *Familia* is an exciting piece because there is seldom a rest period or location. Perhaps the background may be considered a rest area, but usually gazing at the negative background only fortifies the strength of the positive aspect — the subject matter itself.

Familia is a controlled instinctive effort. Frequently, an intuitive painting is titled after the painting is complete. *Familia* could have easily received other titles, and it, along with *Mujer con Serape*, appears to be the results of sheer joy.

Mendoza's later works seem humanitarian in its focus, while her earlier works were searches for a particular style. In *Mujer con Serape* she has captured the gesture of a swirling serape wrapped around a female dancer. Paint is both delicately controlled and seemingly erratic in its application. The swooping strokes of red representing the serape activate the entire painting and complement the facial features and lower torso.

Nora Chapa Mendoza is a strong, versatile painter whose recognition needs to be further acknowledged and whose works belong in the mainstream of American art.

Career Highlights

Born in Weslaco, Texas, in 1932.

EDUCATION
Self-taught.

SOLO EXHIBITIONS
The Grand 1894 Opera House, Galveston, Texas, 1994; Moore Memorial Library, Texas City, Texas, 1994; Unified Community Center/Cultural Arts, Milwaukee, Wisconsin, 1994; Lee Hall Gallery, Marquette, Michigan, 1994; Mott College, Flint, Michigan, 1994; University of Toledo, Toledo, Ohio, 1994; Madonna University, Livonia, Michigan, 1994; George Meany Memorial Archives, Washington, D.C., 1994; Michigan State University, East Lansing, Michigan, 1993; Livonia Civic Center Library/Art Gallery Livonia, Michigan, 1993; Rockham Center Gallery, Ann Arbor, Michigan, 1993; Mid-West Hispanic Conference, Maryville, Indiana, 1993; Mott College, Flint, Michigan, 1993; Biegas Gallery, Detroit, Michigan, 1993; Urban Park Gallery, Detroit, Michigan, 1993; Kellogg Center, Lansing, Michigan, 1993; University of Michigan, Ann Arbor, Michigan, 1993; Dos Manos,

Royal Oak, Michigan, 1993; Michigan State Library, Lansing, Michigan, 1992; Wayne County Building, Detroit, Michigan, 1992; Bowen Library, Detroit, Michigan, 1992; Fine Arts Theatre, Detroit, Michigan, 1992; America House, Tubigen, Germany, 1992.

SELECTED EXHIBITIONS
Kalamazoo Institute of Arts, Kalamazoo, Michigan, 1991; University of Nebraska, Lincoln, Nebraska, 1991; University of Michigan Art Gallery, Ann Arbor, Michigan, 1990; Scarab Club Gold Medal Exhibition, Detroit, Michigan, 1988; Galería Xavier Kanton, Managua, Nicaragua, 1987; Michigan State University, Lansing, Michigan, 1986; Illinois Union Art Gallery, University of Illinois, Champaign, Illinois, 1986.

MAJOR SELECTED COLLECTIONS
First Heritage Corporation, Southfield, Michigan; Aretha Franklin; Mayor of Detroit, Michigan; Mayor of Lansing, Michigan; Michigan State Medical; Rockefeller Plaza; United Farm Workers of America; University Club of Michigan.

Ruth González Mullen

In a statement to the author, Ruth González Mullen said: "My work reflects the cross-culturalization that touches first generation Cuban American artists. The icons which are part of Cuban society with its strongly Spanish roots, the pagan themes which permeate the work and the combination of indigenous symbols with those of the Christian faith are the central themes of my work. My goal is to research the iconography that I have observed and to let it become a thematic springboard." Mullen's words suggest that her cultural customs and beliefs are essential only as motivation for themes other than those relating to her ancestral heritage. It further suggests that alien approaches are welcome. Ensuing results need not relate to past experiences but rather to experimental testing of new ground.

Much of the Latin American culture is reflected in their religious beliefs and customs. The display of the crucifix in their homes, the choice of a particular saint as a role model, the rosary as a tribute and prayer to the blessed mother of Jesus, a painting of Christ as an icon to be contemplated, and the altar and sanctuary in which the blessed body of Christ is celebrated for parishioners are examples of essential stimuli and their reasons for expression.

There is a sacred attitude toward these symbolic ideas and they are expressed in a profound spiritual manner. Their life is a belief in the hereafter, an eternal life. Yet, it is the life upon earth through which the kingdom of heaven is gained.

There is a sharp split between the expression of cultural beliefs and the technical practice of painting. The self-taught artist is considered a folk artist who ignores the natural scheme of things. Anatomy is distorted, visual perspective is ignored and the whole world is dealt with in a personal, selfish manner. Concern for composition is less important than a total inclusion of essential images, and a painting is complete only when all needed aspects are included.

Mullen's beliefs and customs are indeed a springboard to an individual style not unlike that of the abstract expressionist. Her series of paintings titled ¿Dónde Vas, Maria? ask the question, "Where are you going, Mary?" It pictures an abstract female form painted in four separate panels, but when fit together they form a provocative display of anatomy.

Extreme distortion enables the viewer freedom to meander visually about the composition and seek out bodily flesh. Because of the work's abstract nature, the viewer is apt to misinterpret the artist's intent. However, the beauty lies not in the concept as much as in the fluid manipulation of pigment and the unification of all segments of the expression.

The interpenetration and overlapping of geometric shapes perform both transparent and opaque duties. There is a freedom of flow that makes for an abstraction of strong contrast.

Positioned in the upper central area of the painting is a cruciform symbol suggesting the death of Christ. One wonders who is asking the question, "Where are you going, Maria?" that adds to the mystery. This painting by Ruth Mullen is provocative and worth further study. Although pleasantly presented, to the viewer it is nonetheless compelling and emotionally disruptive. Subtlety and intensity blend into a unique expression.

Murmullos de Paz (Murmurs of Peace), another example of Mullen's abstractions, is more controlled then her series titled *¿Dónde Vas, Maria?* Yet, it contains a similarly mysterious and compelling sense of the unknown. Coupled with sharp contrasting geometric shapes are areas of lacy fabric made up of numerous tiers of minute dots that form self-sufficient geometric shapes.

Geometric shapes weave throughout the painting. The overlap and interpenetration create opaque and transparent images. The blend results in a serene and

¿DÓNDE VAS, MARIA?
by Ruth Mullen.
4 panels. Oils. 36 × 72.
Courtesy of the artist.

MURMULLOS DE PAZ by Ruth Mullen. 36 × 48 in. Oils.
Courtesy of the artist.

peaceful abstraction. The rather voluptuous curvatures of several areas present a pleasant and relaxing atmosphere.

There is no particular format or composition. It seems that lines forming shapes flow freely throughout the composition. Yet, there are sharp, abrupt intersections that halt the peaceful movement. The motif of circular images as complete units would cause a disturbance within the movement if not placed within larger free-roaming areas. Again, Mullen has succeeded in stylizing her personal beliefs and customs.

A detail of *Dónde Vas, Maria, No. 1* reveals the technical discipline accorded the painting. The textural quality of the peaceful elements reveals the complexity of the design. There is a contrasting union of bold and rather stark areas adjacent to pleasantly quiet movements that penetrate the bold geometric shapes.

Each of the four detailed panels is an individual expression. Circular planes overlap and, coupled with interpenetrating planes, make for a definite statement.

A second detail of *Dónde Vas, Maria?* introduces the intricate dot system

¿DÓNDE VAS, MARIA? NO. 1 DETAIL by Ruth Mullen. Oils.
Courtesy of the artist.

practiced by Mullen. Geometric shapes surrounded by weaving and curving borders contrast with the delicately dotted areas, which add excitement to the adjacent swooping brushstrokes.

As separate panels there is a noted neglect of unity. The focal point seems centrally located, almost to the point of distraction — an intersection of incoming routes converging on a single point. However, as a quarter panel of the whole, harmony resides within the total composition.

Ruth Mullen's discipline is best revealed in the realistic portrait *Frieda with Her Altar*. The relaxed pose seems to identify the artist with a particular mood. Her work suggests a serenity that welcomes the viewer. The female figure glances out of the picture plane, but only momentarily. The viewer is treated to the exquisite design of the subject's attire.

Delicately applied flower designs monopolize the model's dress and create a pleasant contrast to the smooth flesh tones of the arms and feet.

Evidently, the subject (Frieda) is more essential than the altar mentioned in the title because of its partial view. Jewelry plays a significant role in Latin American culture. Frieda proudly displays three ornate rings and a pair of earrings. The subject's attire is transparent enough to exhibit the roundness of the female's legs

FRIEDA WITH *HER ALTAR* by Ruth Mullen. 16½ × 22 in. Graphic.
Courtesy of the artist.

that form the lower torso. In spite of the intricate design of the subject's clothing, there is no distraction from the female form. *Frieda with Her Altar* is a remarkable portrait revealing the artist's intense concentration and focus.

Career Highlights

Born in Havana, Cuba, in 1939.

EDUCATION
B.A.A. magna cum laude, Auburn University, Auburn, Alabama, 1961; M.F.A. degree Newcomb College, 1969; Graduate Fellowship, Tulane University, New Orleans, Louisiana.

SOLO EXHIBITIONS
New Orleans Museum of Art, New Orleans, Louisiana, 1991; Northwestern State University, Natchitoches, Louisiana, 1989; Rhino Gallery, New Orleans, Louisiana, 1986; Tulane University, New Orleans, Louisiana, 1979; Orleans Gallery, New Orleans, Louisiana, 1968.

SELECTED GROUP EXHIBITIONS
Bienville Gallery, New Orleans, Louisiana, 1994, 1995; International Design Center, Long Island, New York, 1992; Jacob Javitz Center, National Association of Women Artists New York, New York, 1992; World Trade Center, New Orleans, Louisiana, 1989; Miriam Warmsley Gallery, New Orleans, Louisiana, 1988; Biloxi, Mississippi Art Association, 1986; Old Quarter Gallery, New Orleans, Louisiana, 1984; Tulane University, New Orleans, Louisiana, 1972; Mobile Art Association, Mobile, Alabama, 1969; National Arts & Crafts Exhibition, Jackson, Mississippi, 1968; Jefferson Arts Festival, New Orleans, Louisiana, 1967.

Celia Alvarez Muñoz

Celia Muñoz is an outstanding artist of remarkable talents who has succeeded in blending the two worlds of religious differences of Catholicism and Protestantism. She benefits from the cultures of both Mexico and the United States. Born in El Paso, Texas, in 1937, she provides a strong voice for women's rights.

Reared by a strong Catholic mother and a far less disciplined father, Muñoz became an activist at an early age. Sandwiched between the economically poor territory south of El Paso and the rich nation of the United States, Muñoz fought the contradictions of both countries. Her attempts to bridge the gap of the socially discontented Mexico and the glamorous America are explained by author Anita Creamer in the March 22, 1989, issue of the *Dallas Morning News*: "In her art, she explores the universal yet unique conflicts that surge through life; the rush to assimilate and the slow sorrow of displacement; the clash of cultures and generations that continue even in her own children's lives; the freedom and the burden of making choices."

Muñoz believes in opposites. Everything has an opposing force, and thus becomes a matter of choice. Her continuous rebellion against dogmatic rules and laws that shackle human and religious freedoms and moral judgments is reflected in her art. Throughout her career she has been driven to blend the two cultures within herself to better understand her own existence. After painting, Muñoz tackled the art of installation, conceptual art, and narrative art, treating each separately and collectively.

Throughout her life Muñoz has attempted to bridge the gap between the two languages by utilizing both Spanish and English tongues to identify each work of art. Within the installation *Postales*, descriptive phrases in both languages aid in the understanding of her work. A painting is coupled with a neatly and appropriately lettered phrase, which adds not only to the strength of the exhibition but its educational value. Each descriptive phrase is a wish for the future not predetermined as a child, or a yearning for a better life for one's family.

Space has always been a factor in Muñoz's work. Not only is the two-dimensional space of the empty canvas significant, but the occupation of space by the human person places a psychological demand upon the artist. Thus, the installation demands that each work of art be spatially correct and appropriate and that the physical space allowing for physical movement not be limited.

The combination of the narrative and the visual is evident in her work *El Límite*. The narrative enhances and explains the visual. It is not essential as a work

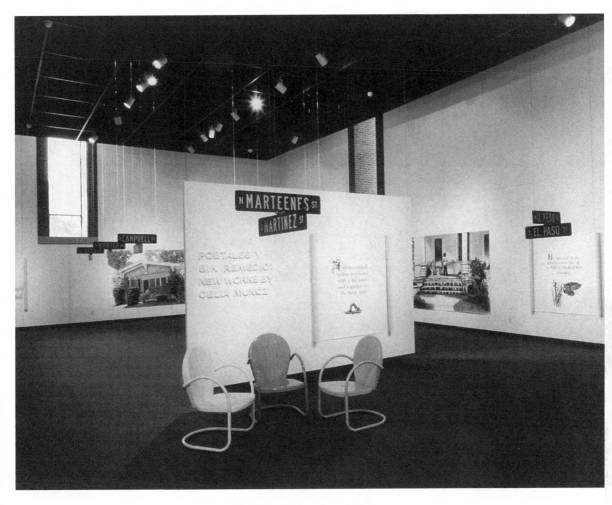

POSTALES by Celia Muñoz. Installation.
Courtesy of the artist.

of art to combine the narrative with the visual, especially if its purpose is to explain the visual, which visually is left for the viewer to interpret. However, Muñoz felt the need to incorporate the two cultures — the visual representing the Spanish and the narrative explaining in English the visual. The combination becomes an educational tool to understanding a dual culture.

The visual aspect of *El Límite* is a symbolic representation of an imaginary trainload of contrary items typical of a child's world. Muñoz's obsession with opposites is illustrated with an uncertainty of choice between the old world of Mexico and the new world of America.

Aside from the obvious message, *El Límite* can be appreciated from the story behind the initial work of art. Again, the visual and the narrative can be enjoyed separately or collectively.

A combination of photography and the narrative, coupled with a collage approach, results in a memory of the artist's childhood. Both the narrative and the

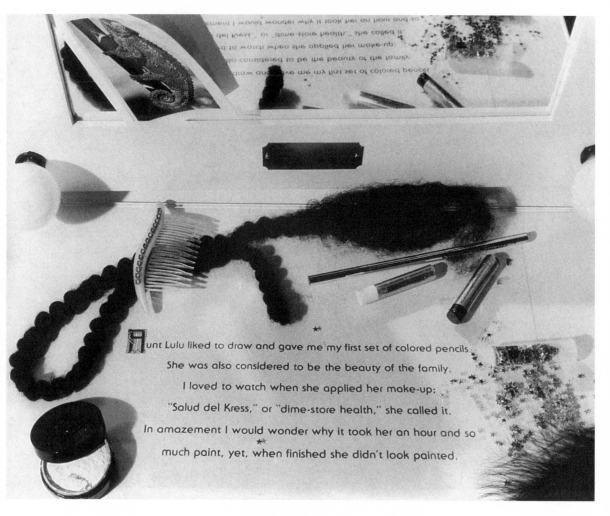

THE CHAMELEON by Celia Muñoz. Photograph. 16 × 20 in.
Courtesy of the artist.

visual coincide to illustrate a childhood experience. Muñoz has combined items of her Spanish heritage with the English language of the New World.

The positioning of each item is carefully conceived and executed so that surrounding space amply accommodates all items. Each object leads toward another, creating a chain of items that illustrate a single childhood recollection.

The Chameleon symbolizes Muñoz's Aunt Lulu, whose constant facial changes reveal a changeable human being whose process of cosmetic adornment fascinated Muñoz as a child but that always resulted in an attractive Lulu.

Sentimental Journey, a 1993 production, combines the visual with the narrative. A nostalgic painting of a beautiful woman is nestled in an environment of blue water and distant mountains. Since a single event and single location are shown, in order for the journey to be complete, Muñoz adds an imaginative tour of her own. To analyze the painting without first reading the words would lead to a misinterpretation

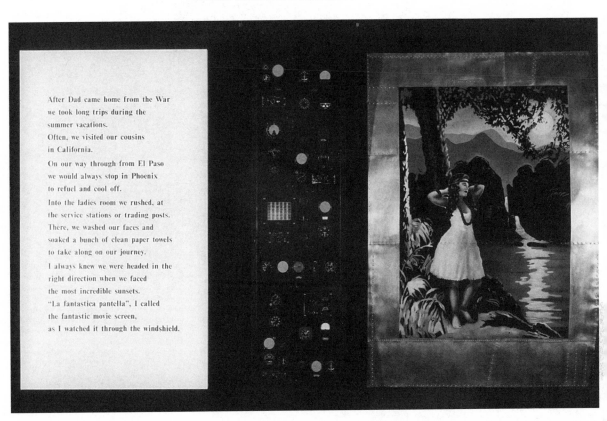

SENTIMENTAL JOURNEY by Celia Muñoz. 1993. Mixed media.
Courtesy of the artist.

of the work. On the other hand, the painting could well be appreciated on its own merits. However, because Celia Muñoz is a talented storyteller, the two media of expressions are compatible.

Toledo mixes sculpture, painting and narrative to relive a childhood memory. Muñoz's sole purpose of combining her Spanish heritage with a contemporary style is to unite the two cultures. A painted scene of Toledo, a replica of El Greco's famous painting, is a vertical panel that includes the artist's narrative explanation of her conceptual form.

According to a review in the February 25, 1994, issue of the *Providence Journal-Bulletin*, "Few artists have found a richer source of imagery and inspiration in their wonder years than Celia Alvarez Muñoz. This Texas artist uses her memories of growing up in the American Southwest in the 1940's and 50's as the starting point for an alternately funny and affecting exploration of race, gender, identity and ultimately, the American Dream itself."

I used to hear the old ones say that the site of a buried treasure gave off an intense red glow. One such place was in grandmother's backyard. The event occurred every evening at about seven. That was also around the same hour that the ritual took place of burning the daily papers from the privy called "Toledo."

TOLEDO by Celia Muñoz. Mixed media. 7 × 6 × 4 ft.
Courtesy of the artist.

Career Highlights

Born in El Paso, Texas, in 1937.

EDUCATION
B.A. degree from University of Texas at El Paso, 1964; M.F.A. degree from North Texas State University, Denton, Texas, 1982.

SELECTED SOLO EXHIBITIONS
Center for the Fine Arts, Miami, Florida, 1993; Center for Contemporary Arts, Santa Fe, New Mexico, 1993; San Diego Museum of Contemporary Art, San Diego, California, 1991; Dallas Museum of Art, Dallas, Texas, 1991; Adair Margo Gallery, El Paso, Texas, 1990; New Langton Arts, San Francisco, California, 1989; Longview Museum & Art Center, Longview, Texas, 1989; University of Texas at Arlington, Texas, 1989; Center for Contemporary Art, El Paso, Texas, 1989; San Angelo Museum of Fine Arts, San Angelo, Texas, 1988; Lannan Museum, Lake Worth, Florida, 1988; Tyler Museum of Art, Tyler, Texas, 1988.

SELECTED GROUP EXHIBITIONS
Steinbaum Krauss Gallery, New York, New York, 1993; Ronald Feldman Fine Arts, Inc., New York, New York, 1993; Cornell University, Ithaca, New York, 1993; Mexican Fine Arts Center Museum, Chicago, Illinois, 1993; Lubbock Art Center, Lubbock, Texas, 1993; Phoenix Art Museum, Phoenix, Arizona, 1993; Manchester Art Centre Limited, Manchester, England, 1993; Wichita State University, Wichita, Kansas, 1992; The Mexican Museum, San Francisco, California, 1992; Security Pacific Gallery, Seattle, Washington, 1992; Whitney Museum of American Art, New York, New York, 1991; University of California, Los Angeles, California, 1990; Dallas Museum of Art, Dallas, Texas, 1989; Addison Gallery of American Art, Andover, Massachusetts, 1989; University of Colorado, Colorado Springs, Colorado, 1989; Kimball Art Museum, Fort Worth, Texas, 1989; National Museum of Women in the Arts, Washington, D.C., 1988; The Aspen Art Museum, Aspen, Colorado, 1987; Midtown Art Center, Houston, Texas, 1986; San Antonio Art Institute, San Antonio, Texas, 1984; Texas Christian University, Fort Worth, Texas, 1983; University of Wisconsin, Madison, Wisconsin, 1983.

SELECTED COLLECTIONS
Harvard University, Cambridge, Massachusetts; Longview Art Museum, Longview, Texas; New Mexico State University, Las Cruces, New Mexico; San Antonio Museum of Art, San Antonio, Texas; San Diego Museum of Contemporary Art, LaJolla, California; Stanford University, Stanford, California; The Getty Center, Malibu, California; University of Alberta, Edmonton, Canada.

22

Elena Presser

To interpret music in abstract visual terms is indeed difficult. To unite in a controlled manner demands discipline and total objectivity. Labeled *Visual Music*, Presser's musical forms lend permanence to Bach's genius and perhaps serve as a forerunner of pure avant-gardism.

Presser strives to listen and relisten to repeated details and nuances of tone and develop and construct from various materials a complete visual rendition of the musical score of a great musical master. Each resulting effort is not limited to the presentation of novel and imaginative materials, as Presser has the freedom to compose and arrange the essential variations of emotions according to her personal preferences. So there are no hints of unoriginality. The manner in which Presser is emotionally and intellectually affected determines the visual artistic result.

So intimate is Presser's work that to understand her and her art is to understand Bach, and yet, Presser's work stands alone as masterpieces of three-dimensional sculpture. But what an added joy when understanding the motivation behind Presser's work.

Elena Presser describes her *Goldberg Variation 20* as: "The music preserves a mirrored symmetry in the form of seven, reflecting each other vertically and horizontally. The motion of the arpeggios covers an immense range using the two harpsichord manuals that open like a threaded fan. The triplets sound as laughter and giggles, turning into chromaticized beads from the feeling of joy and delight. Such merriment and happiness echoes human joy in the form of a square and a triangle. Like a tightrope walker, this human being holds 86 beats of living and the ecstasy of life."

This 1984 production, like all her works, uses paper, pastel, pencil, silk threads, silver wire and nails. Creating an art form to music, especially a painting, is usually executed in a simultaneous manner; that is, the painting is completed when the music stops. Presser's approach is scientifically objective even though the intuitive forces are allowed to enter the expression.

Presser creates methodical and at times predetermined works of art. Such comprehensive form of expression demands physical dexterity along with visual and intellectual concentration.

The joy of creation seems to be in the process rather than the product — enjoying the aesthetic experience of creation. After completion of the act, a temporary satisfaction occurs, but soon the challenge of a new work emerges. Presser's various series of Bach relate a detailed focus on each movement and a unification of

GOLDBERG VARIATION 20 by Elena Presser. 1984. Mixed media.
Courtesy of the artist.

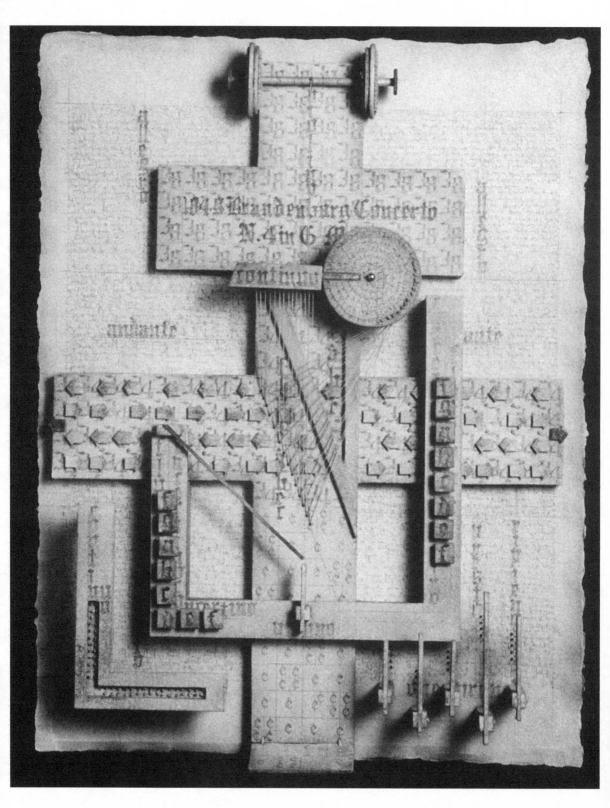

1049 BRANDENBURG CONCERTO 4 IN G MAJOR by Elena Presser. 1989. 13¾ × 10¾ × 2 in. Mixed media. Courtesy of the artist.

the various emotional changes in tempo and intensity. The use of geometric shapes results in an abstract transition from the auditory to the visual. The abstract nature of music becomes abstract art. Presser's highly personal approach relies on her profound interest in Bach's compositions. It is doubtful one could argue against Presser's philosophy of art or her approach.

The puzzling aspect of Presser's art is the denial and acceptance of particular movements. All art forms contain artistic aspects that do nothing to benefit the whole. Music, like art, has several aspects of overkill that are denied entry into Presser's world.

From an artistic viewpoint, *1049 Brandenburg Concerto 4 in G Major* reveals the influences of Paul Klee, Joseph Cornell and Wassily Kandinsky. Appearing like scientific inventions, geometric shapes are formed by intersecting vertical, diagonal and horizontal lines. A form of relief is created with the addition of three-dimensional bits of materials that add to the composition as well as enhance the total expression. Although informally balanced, the *Brandenburg* series appear to be in formal balance through equal distribution of space. The echo of instrumental sound creates three-dimensional shadows. Large rectangular shapes occupy the major portion of the *Brandenburg Concerto* background. Added to the positive aspects are smaller geometric shapes, which instead of congesting areas add to the unification of the whole.

There are within Presser's constructions several end results or miniature compositions that if enlarged could survive as complete works of art. But Presser's works are predestined, complete only when the last piece of the puzzle is set appropriately in place. However, there are afterthoughts as any artist will admit. There are always additions and subtractions to be recorded, creating changes that affect the entire composition. But Presser guards against such changes. Her sophisticated works demand the utmost discipline and dignity throughout the process.

In her construction *Cantata 140 Wachet auf ruft uns die Stimme*, two opposing geometric shapes blend into a compelling sculpture. The standing sculpture is not unlike a contemporary architectural structure. It is an intriguing concept, that of creating an architectural design from a Bach cantata. There is a solidity of form even though the area utilizing slender, vertical structures spiraling upward is in direct contrast to the core of the composition.

Neither area dominates the other since both are of a triangular nature. One is composed of a series of linear triangles balanced by a single, solid triangular shape. The combination poses a paradox, but compatibility reigns because of the similarity of each basic structure.

In the 1994 exhibition catalog *Elena Presser: Works on the Music of Johann Sebastian Bach* (University of Wyoming Art Museum), Dr. Paula Harper, a professor of art history at the University of Miami, said of Presser's work: "The conceptions that music and visual art can share ... the intuitively understood order and clarity of a mystically mathematical system are made visible in Presser's fervent, sensuous, joyous, sometimes triumphant constructions. The discipline that refines them intensifies their passion."

Harper goes on to describe Presser's process of creation: As Presser listens to the music, she makes spontaneous marks that cover a sheet of paper. These marks resemble writing but are actually "line calligraphy," a response to the music. (Harper compares this process, with its simultaneous movement of music and hand, with contour drawing.) In this way she fixes on paper what she feels as she hears the music.

From this plane of paper Presser builds upward or outward, with techniques that include "cutting, folding and rolling the paper and sometimes stitching through its layers, stretching and knotting the silk threads; carving, wrapping and assembling the shapes of the balsa wood, adding drawn letters and numbers in Gothic style, coloring the paper with many thin, rubbed layers of pastel, texturing the surface with clusters of embroidered French knots."

These intricate compositions suggest musical instruments — harpsichord-like structures with taut-stretched wires — or sheets of music manuscript, scattered with note-shapes and numbers. "In style," writes Harper, each piece "manifests a classical quest for timeless balance and perfection tempered by a baroque sensitivity to underlying tensions, drama and flux."

Elena Presser is extremely fond of Bach's second wife and thus was motivated to execute 12 sculptures and 22 wall reliefs for a major work called *Notebook of Anna Magdalena Bach*. It is an exquisite, powerful work using the most basic and simplest of materials. Again, regardless of its motivation, it stands alone as a major art accomplishment.

It is difficult to describe Presser's work: it could be sculpture or graphic design; some are three-dimensional while others are reliefs; and some are simply called constructions. There is a deliberate attempt to include a single environment. The three-dimensional positioning of the triangular shapes allows freedom of movement so that the intuitive process can once again be employed.

Partita 4 in D Major looks like a miniature image of a major cathedral. The golden glow of color and the placement of materials makes for a grand entrance to a living monument. The artist has transformed a great musical figure and his work into a visual delight. Elena Presser has transformed Bach's major musical scores into a visual form so that the world might forever enjoy both her work and Bach's.

Career Highlights

Born in Buenos Aires, Argentina, in 1940.

EDUCATION
University of Buenos Aires, 1962; A.A., Miami-Dade Community College, 1975; University of Miami, 1976; B.F.A., Florida International University, 1978.

SOLO EXHIBITIONS
Rockefeller Center for the Arts, Fredonia, New York, 1986; Center for the Arts of Kennesaw College, Marietta, Georgia, 1986; Art & Culture Center, Hollywood, Florida, 1986; Frances Wolfson Art Gallery, Miami, Florida, 1985; McKissick Museums, Columbia, South

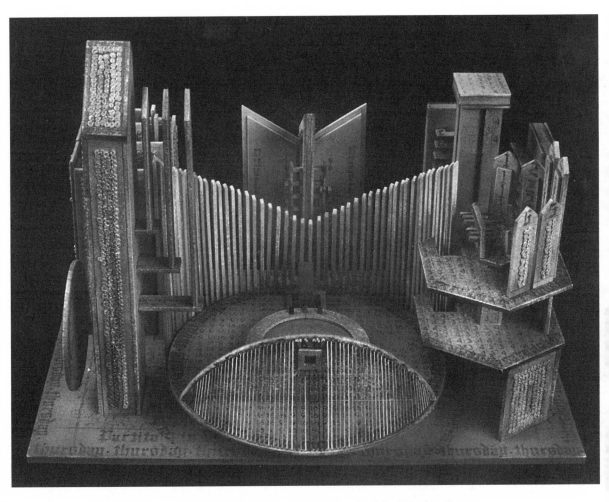

PARTITA 4 IN D MAJOR by Elena Presser. 1995. 9¾ × 13 × 9 in. Mixed media.
Courtesy of the artist.

Carolina, 1985; Center for the Arts, Muhlenberg College, Allentown, Pennsylvania, 1985; Barbara Gillman Gallery, Miami, Florida, 1979.

SELECTED EXHIBITIONS

Lowe Art Museum, Miami, Florida, 1994; Center of Contemporary Art, North Miami, Florida, 1993; Bernice Steinbaum Gallery, New York, New York, 1992; San Antonio Art Institute, San Antonio, Texas, 1991; Dunedin Fine Art Center, Dunedin, Florida, 1991; D & D Government Center, West Palm Beach, Florida, 1991; Scottsdale Cultural Council, Scottsdale, Arizona, 1990; Orlando Museum of Art, Orlando, Florida, 1990; Florida State University Gallery, Tallahassee, Florida, 1990; Henry Street Settlement House, New York, New York, 1990; Helene Grubair Gallery, Miami, Florida, 1989; Art Institute of Fort Lauderdale, Florida, 1988; City Gallery of Contemporary Art, Raleigh, North Carolina, 1987; Jacksonville Art Museum, Jacksonville, Florida, 1986; Polk Public Museum, Lakeland, Florida, 1985; Anderson County Art Center, South Carolina, 1985; Leila Taghinia–Milani Gallery, New York, New York, 1984; Valencia Community Collage, Orlando, Florida, 1984; Barry College, Miami, Florida, 1984; University of West Florida, Pensacola, Florida, 1984; Philadelphia Arts Alliance, Philadelphia, Pennsylvania, 1983; Aaron Berman

Gallery, New York, New York, 1983; Four Arts Center, Tallahassee, Florida, 1983; Fort Lauderdale Museum of Art, Fort Lauderdale, Florida, 1983; Netsky Gallery, Miami, Florida, 1983; Broward Community College, Fort Lauderdale, Florida, 1982; Aaron Berman Gallery, New York, New York, 1982; Frances Wolfson Gallery, Miami, Florida, 1982; Edison Community College, Fort Myers, Florida, 1981; Montgomery College Gallery of Art, Washington, D.C., 1981; Lowe-Levinson Gallery, Miami, Florida, 1980; Fort Lauderdale Museum of Art, Fort Lauderdale, Florida, 1979; Visual Arts Gallery, Miami, Florida, 1978; Continuum Gallery, Miami, Florida, 1977.

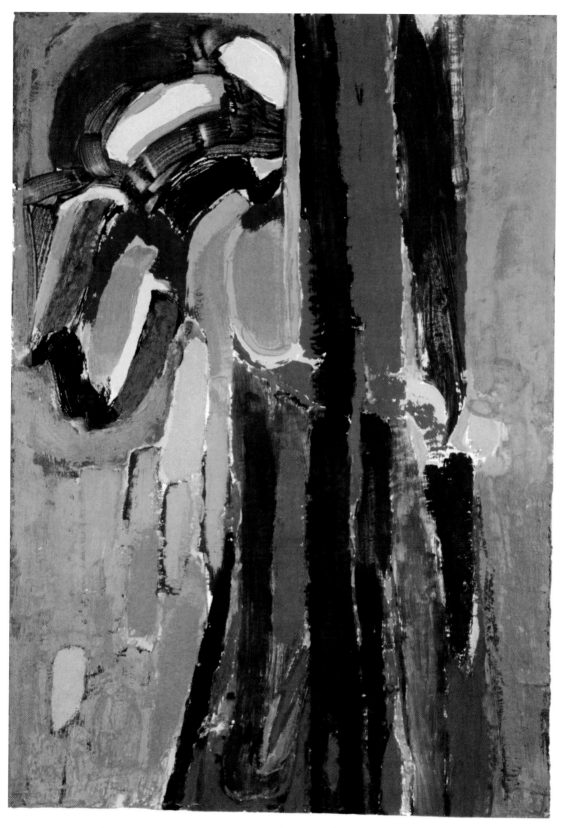

*JUNGLE WATERFALL by Aurora Dias-Jorgensen. Oil on canvas. 40 × 28 in.
Courtesy of the artist.*

Opposite, top: A MOUTHFUL by Theresa Rosado. 1994. Acrylic on wood. 22 × 30 in.

Opposite, bottom: WE DROVE ALL NIGHT by Theresa Rosado. 1995. Acrylic on wood. 10 × 18 in.

Above: LIMBS by Elba Rivera. 1993. Oil on canvas. 48 × 41 in.

All courtesy of the artists.

WHAT COLOR WAS YOUR GRANDMOTHER? by Bibiana Suarez. 1991. Pastel on paper. 80 × 54 in. Courtesy of the artist.

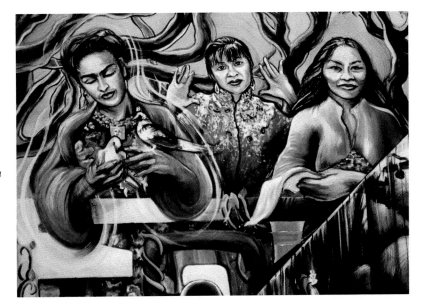

RIGHT: *THE PROMISE OF LOMA PRIETA: NOT TO REPEAT HISTORY by Juana Alicia. 1992. Detail of mural. Courtesy of the artist.*

BELOW: *GUATEMALA by Nora Chapa Mendoza. 1982. Mixed media collage. 20 × 24 in. Courtesy of the artist.*

Matilija Poppies a/p *Margo Bors*

*OPPOSITE, TOP: CASAS DE MEMORIAS INFINITAS by Maritza Dávila. 1987.
Handmade paper collograph. 20 × 24 in.*

OPPOSITE, BOTTOM: SACRIFICE by Aurora Dias-Jorgensen. Oil on canvas. 60 × 60 in.

ABOVE: MATILIJA POPPIES by Margo Bors. Linocut. 20 × 13 in.

All courtesy of the artists.

OPEN GATE by Soledad Salame. Mixed media on canvas. 71 × 50 in.
Courtesy of the artist.

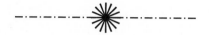

Josefina Quezada

Josefina Quezada is a versatile artist, a master of several styles, from her impressionistic 1958 work *Tropical Fruits* to her 1994 realistic version *Basket with Pumpkins*. Her versatility is also witnessed in her various subject themes.

Although her theme in *Tropical Fruits* has an expressionistic flavor, it is carefully conceived and composed with no particular aspect receiving undue attention. The series of fruit objects are carefully positioned with slight overlap, making each object significant.

Details and textural surfaces of *Tropical Fruits* are created by scraping color on and off the working surface, thus exploring the apparent erosion of color. The contours of individual fruits are predrawn with pigment applied roughly within. To avoid a separation between subject matter and background, Quezada applies a similar technique to both subject and environment. There is the sense of the panoramic, a sense of an endless display of fruit that suggests activity outside the picture plane.

Basket with Pumpkins, a 1994 rendition of a similar theme, has nature contained within a limited environment except for a single object residing outside the major stimulus, forming a secondary habitat. A table dressed with a covering acts as an anchor. The basket of pumpkins becomes subordinate to surrounding items and the checkered cloth lining the basket. Each pumpkin is positioned to aid the composition by creating visual attention to all areas of the painting. Visual activity in the foreground and background is subdued in order to avoid subjecting the stimulus to a secondary role.

The subject matter totally absorbs the composition. Technically, it is a detailed realistic portrayal with a bit of crudeness to give it a cultural touch. The checkered cloth acts as a divisional marker between the upper and lower segments of the basket.

The subject matter is commonplace, but Quezada deals with it in a precise and direct manner. A realist such as Quezada uses nature as a stimulus and executes a portrayal beyond the natural. Her intent is not to imitate but to react to it emotionally and create the image of nature rather than nature itself. To purposely set out to duplicate the visual totally mute to any degree of emotion would result in a naturalistic version. Quezada confronts nature with no prearranged routine but prefers to accept the degree of emotion within herself at the time of creation.

The 1987 production *Out of the Frame* pictures a beautiful young woman occupying center stage both in and out of the painting frame. The glamorous woman is delicately draped in a silken shawl that falls over her bosom and is clutched at

TROPICAL FRUITS by Josefina Quezada. 1958. Acrylic on canvas. 36 × 48 in.
Courtesy of the artist.

her waist with a delicate hand. Portrayed in a half shadow, her face resembles a dual personality, a surreal appearance of a mysterious figure. The hair falling gracefully behind her matches the velvety folds of the shawl. Her right hand holds a parasol minus the atmospheric protection. The skeletal form resembles a surreal mood as if a dream world had overtaken the real one.

A Venetian boat struggles in the waters that are overshadowed by the attractive female form in the foreground. The painting is realistic but rendered in a surreal fashion. Quezada is an artist whose various styles indicate a search for a personal and intuitive approach.

The title illustrates the device used by such contemporary artists as Rauschenberg, Rivers and deKooning. Extending a portion of the painting beyond the picture plane brings the image of the surreal world into the real world. Quezada's approach could have been more dynamic. Nonetheless, her technique is effective.

The flowery background suggests a utopian environment. *Out of the Frame* is a compelling illustration of life, perhaps a choice of two worlds. It is a pleasant painting, long to be remembered for its foreboding appeal.

The 1965 painting *Girl Offering Flowers* leaves a question as to the identity of the receiver. Although the female wears a wedding dress, her shoeless feet reflect a contradiction. The offering of flowers, although suggesting an unknown recipient,

BASKET WITH PUMPKINS by Josefina Quezada. 1994. Oil on canvas. 20 × 24 in.
Courtesy of the artist.

could be a saintly person called upon for divine intercession. A lit candle and flowers strongly suggest that the subject is a bride. However, since her facial expression is one of sorrow and grief, the subject may be a widow offering flowers for the deceased.

Girl Offering Flowers is an unusual composition of fleshy geometric areas that lead into a series of compatible overlapping triangles. The positioned angle of the subject's arms creates a tension that activates an otherwise quiet area.

The muted background, which seems to amplify the female subject, sustains an element of eeriness and nostalgia. There is a dramatic sense of the unknown, a resignation of sorts, by a subject who is the victim. Perhaps *Girl Offering Flowers* illustrates a solemn moment of thanksgiving for which a smile is inappropriate. Diagonal lines amplify the suggestive nature of the prevailing stillness. The female peering intently at the candle is readying herself if the flame should expire.

The clown is a symbol of sorrow and laughter, of life and death, of elation and despair. For centuries it has been subject matter for artists. For Josefina Quezada, it is a symbol for the intensity that exists between life and death. Her 1974

OUT OF THE FRAME by Josefina Quezada. 1987. Acrylic on canvas. 36 × 48 in.
Courtesy of the artist.

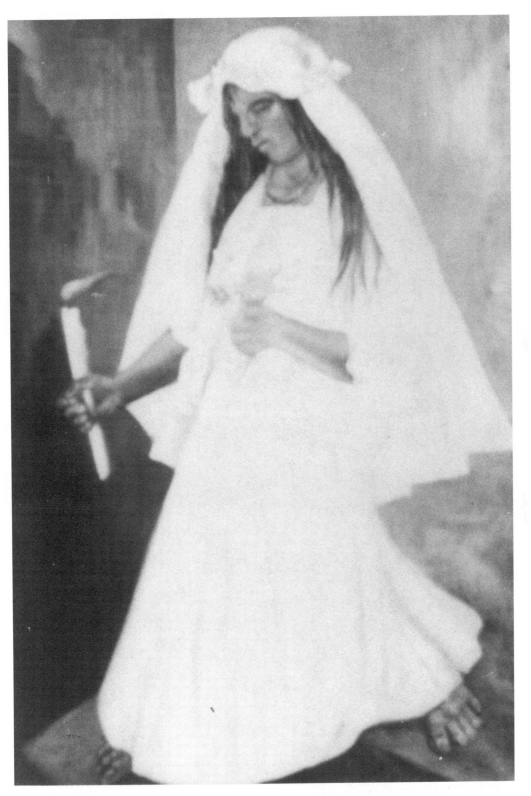

GIRL OFFERING FLOWERS by Josefina Quezada. 1965. Oil on canvas. 80 × 24 in.
Courtesy of the artist.

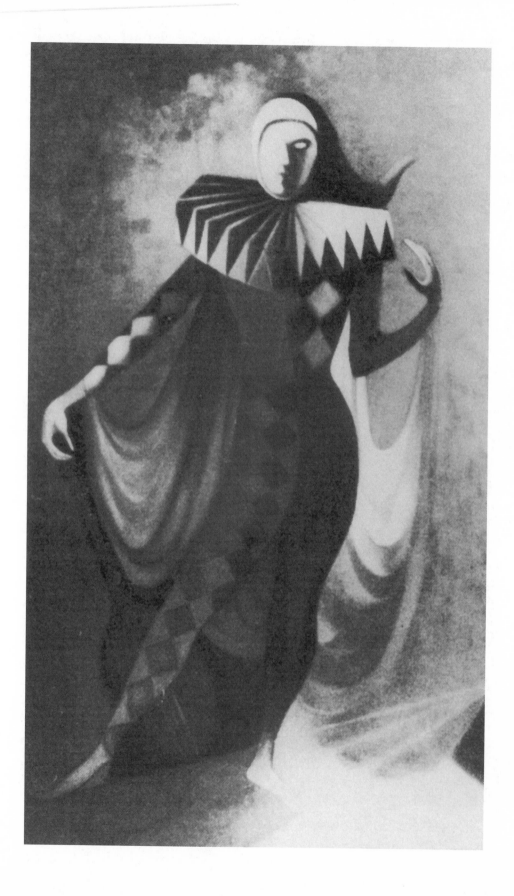

painting *Trovatore* is both real and unreal. A sophisticated harlequin attire, a ghost-like figure, is portrayed in an equally eerie environment. But there is a circus-like atmosphere that attempts to shed light upon unknown causes. The clown emerges from a misty fog, its face only half identified as hands and feet offer gestures of a dance routine.

Trovatore is a general statement in which design and composition play important roles, and since the clown image remains unidentified, the mystery remains unsolved. Yet, one need not interpret its meaning. The decorative attire and the smooth rhythmic pattern of the dancing figure are a welcomed pleasantry.

The spacious background is rendered in muted tones of color. Light and dark areas are carefully considered and positioned appropriately to form a well-devised composition. The clown image is frequently conceived as a self-portrait of the artist. Identified or not, the clown figure is usually a personal commentary on society.

Career Highlights

Born in 1928 in Guadalajara, Mexico.

EDUCATION
Studied mural painting under David Alfaro Siqueiros; studied photography and art at the University of Mexico; A.A. degree from Southwestern College, San Diego, California.

SELECTED GROUP EXHIBITIONS
Guadalajara, Mexico; Houston, Texas; Los Angeles, California; Madrid, Spain; New York, New York; San Diego, California; Tijuana, Mexico.

SELECTED SOLO EXHIBITIONS
Acapulco, Mexico; Guadalajara, Mexico; Los Angeles, California; New York, New York; San Diego, California.

PERMANENT COLLECTIONS
The National Museum of Women in the Arts, Washington, D.C.; murals established in Mexico, Los Angeles and San Diego, California.

Opposite: *TROVATORE by Josefina Quezada. 1974. Oil on canvas. 36 × 60 in. Courtesy of the artist.*

Elba Rivera

In only three years, artist Elba Rivera has displayed strength in three familiar styles — realism, surrealism and abstract expressionism. Her realistic *Family Expectations* is a classical composition of overlapping figures, each destined for individual accomplishment. Executed in 1993, it depicts several generations. In addition to an overlapping composition of female figures there is the mystery of the unexpected. A critical analysis of each human does not identify the future, making it difficult to ascertain the expectations of coming events, whether tragic or blissful.

Family Expectations appears to be a gathering of people whose appearances suggest family unity. Colors are rich and dramatic. Rivera makes a special effort to isolate the mother and child within a rectangular shape. Individually different attire suggests individual personalities unable to fulfill their respective desires. None of the female forms appear content; rather, they seem saddened by inadequate prospects for the future. Only the mother holding the child seems to enjoy the scene. In spite of Rivera's title, *Family Expectations* allows its audience speculation and the freedom for self-prediction and interpretation.

A 1994 surrealist painting *Oil Spill* is a dramatic exposé of cruelty to animal life, particularly a bird whose slow death is revealed in Rivera's crude but surreal definition of negligent homicide. The background environment is darkened to illustrate the gloom of the event and create a sharp contrast between the bird and its habitat. A black swan covered with oil — symbolizing man's inhumane concern for nature's creatures — resides in the background.

Rivera substitutes a human head in place of the dying bird's head, and a close-up view shows a suffering human being with a grotesque face and bleeding mouth. Rivera makes it clear that God's creatures are not safe among mankind.

The composition is unique because the victim is in the process of suffering while creating a current event. It is happening each moment in review. The act has been executed but the effects of that act are still occurring. Furthermore, man has replaced the bird in order to experience the tragedy. Rivera has kept the subject matter in full view, a subjective portrayal that avoids any extraneous trappings that could interrupt the concentration between the viewer and the painting.

The artist's concern for man's negligence in regard to nature could not be more provocative. It is a shocking picture and serves a worthy purpose in bringing about a more considerate society.

Eye to We, another surrealist painting executed in 1994, is an eerie display of

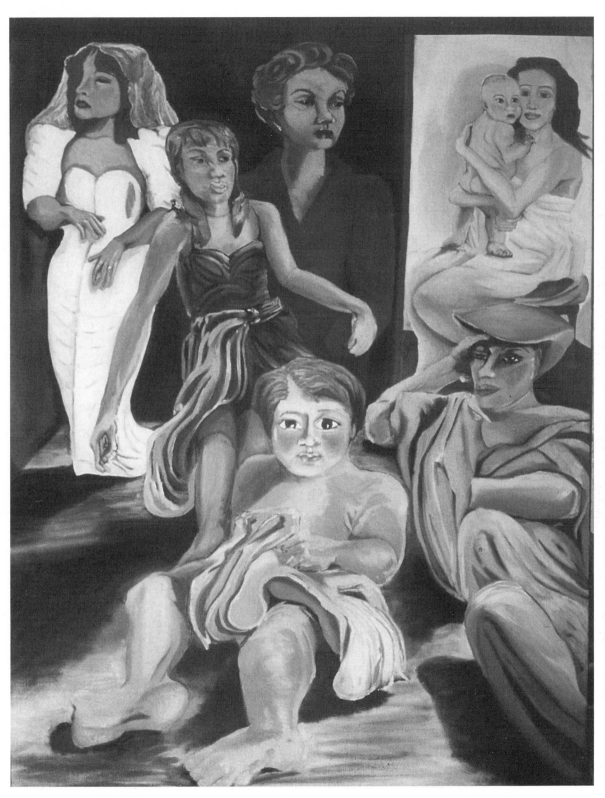

FAMILY EXPECTATIONS by Elba Rivera. Oil on canvas. 1993. 3 ft. 2 in. × 2 ft. 6 in..
Courtesy of the artist. (© March 1993 by Elba Rivera. All rights reserved.)

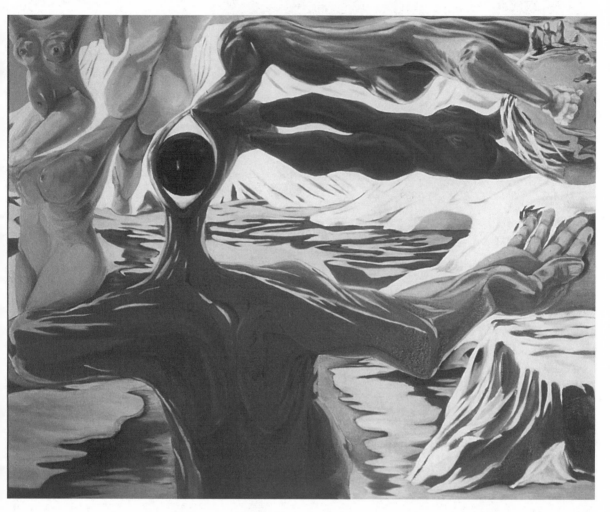

EYE TO WE by Elba Rivera. 1994. Oil on canvas. 3 ft. 2¼ in. × 4 ft.
Courtesy of the artist. (© April 1994 by Elba Rivera. All rights reserved.)

nude forms frolicking about in an underwater scene. The headless humans are
swimming, wading and diving amid a foreground figure whose head is replaced
with a single huge eye that is peering not at the water occupants but at the viewer.
The audience become participants.

Surrealism is always difficult to analyze or interpret because of its intimate
nature. Surrealism has been described by surrealists as the real world. Often dic-
tated by dreams, those dreams replace real life. Regardless, the personal inner
thoughts and dreams are indeed difficult to comprehend and thus interpret.

Eye to We is no exception. The composition is a series of overlapping human
forms, mainly female ones that bounce back and forth horizontally. The bluish
water acts as a complementary environment for these headless creatures.

Oakland Bay Bridge, a 1994 rendition, is a fanciful display of a famous land-
mark. But Rivera makes it more than a recording. Her primitive approach and sen-
suous coloring make for a jubilant scene, a landscape difficult to identify with any

OAKLAND BAY BRIDGE by Elba Rivera. Oil on canvas. 1994. 3 ft. 3 in. × 4 ft. 6 in.
Courtesy of the artist. (© January 1994 by Elba Rivera. All rights reserved.)

artistic movement. It has the naïveté of a Paul Klee, the excitement of a Kokoschka and the purity of color of a Grant Wood.

Although titled *Oakland Bay Bridge*, the bridge itself is not the focal point of the painting. The red foreground anchoring a series of houses executed in a primitive manner is initially noted. One moves along the bay enjoying scenes tucked away into the hillside. It is not until the majority of the painting is viewed that one notices the bridge.

Rivera's direct approach to her subject matter allows for dramatic color effects. The brilliant red landscape in the frontal plane brings the viewer into the scene and into the painting. Once in, the view is a casual one, scanning the horizon only to retreat to the numerous landscape sites surrounding the bay. *Oakland Bay Bridge* is an excellent example of a blend of expressionism and primitivism.

One would not expect to find an impressionistic technique in Rivera's work.

MATADOR by Elba Rivera. 5 × 4 ft. Oil on canvas. 1992.
Courtesy of the artist. (© April 1992 by Elba Rivera. All rights reserved.)

Yet in her 1993 painting *Limbs* she uses the dot system to identify a large segment of her background. Clouds tucked away behind a series of tree limbs and lying across an ultramarine blue sky are executed in a dot pattern of red and white that forms in the distance a pinkish cast.

The living limbs take on the appearance of human arms and legs groping upward as if energetically revealing one's existence. A series of three visual aspects recede into space. The sky as the remotest plane is overlapped by the clouds, which in turn are overlapped by the limbs that originate in the foreground. Again, a combination of art movements occurs in *Limbs*, a blend of the real, the surreal and the impressionistic.

In *The Matador*, Rivera again relishes in the intuitive. Her positioning of the matador is unique. Not centrally located or a dominant figure, it is significant nonetheless due to remote character and placement on the picture plane. Although the figure of the matador is treated realistically and objectively, the image blends into the impersonal and remote environment. It is the red cape with its nuances of red and numerous folds and wrinkles that dominates the composition.

The scene includes a second matador. The visual distance between the two makes for an intensified spatial interest because of the inevitability of a confrontation. Rivera's paintings do more than just record and report. They call for a more humane society, a more compatible relationship between nature and oneself.

Career Highlights

Born in El Salvador in 1947; grew up in the Mission District of San Francisco, California.

EDUCATION
Attended Laney College as an art major; worked as an assistant to muralist Susan Cervantes.

SOLO EXHIBITIONS
Ethnic Trip Studio, San Francisco, California, 1995; Open Studio, Oakland, California, 1994.

GROUP EXHIBITIONS
Somar Gallery, San Francisco, California, 1995.

MURALS
Cesar Chavez School, San Francisco, California, 1995; Balmy Alley, San Francisco, California, 1995; Cleveland Elementary School, San Francisco, California, 1995; Women's Building, San Francisco, California, 1994.

Anita Rodriguez

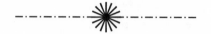

According to Anita Rodriguez, a Mexican painter, death is reason to celebrate for it is the end of momentary life before eternal life begins.

In a statement to the author, Rodriguez said: "The image of death in Mexican art dates back to earliest pre–Columbian architecture and artifacts. It has always been understood as part of a cycle rather than the end of everything, as in Anglo-American thought. Death is the stage that precedes rebirth. It is the necessary decay that nourishes new seed. It is a moving point in time — not a static state."

This is more a religious belief than a philosophy, a belief of Christians throughout the world. It is difficult for a layperson to accept her paintings as characteristic of dancing skeletons amid a bed of beautiful flowers, yet there is a compatibility of the death and the resurrection that follows. The skeleton symbolic of death and the flowers representative of rebirth together make a joyful reunion. Without death there would be no rebirth. Everlasting life is echoed throughout the Catholic liturgy.

Rodriguez's skeletal images symbolize the insignificance of life upon earth except for the purpose of serving God and His Son, thereby gaining the kingdom of Heaven. She qualifies this in a letter to the author: "My paintings are not about death. They are about life. About music, dance and flowers (flowers are the sex organs of plants and therefore the symbol of creativity, beauty and eternal perpetuation). I can say that the *calaveras* in my paintings are more full of life and having a better time than a lot of people with meat on their bones. My paintings celebrate life and laugh joyfully in the face of death's inevitability."

Anita Rodriguez declares the joy of death. In her paintings are brilliant colors suggesting total happiness. In her painting *La Boda (The Marriage)*, Rodriguez brings together all the personalities of a wedding party. In the desert under a brilliant blue sky a fleshless couple face a skeletal celebrant as skeletal witnesses look on. A geometric lean-to serves as a sanctuary backdrop. There is a sense of the monumental. The artist's works are architectural in design with a hint of stained glass splendor. One must look upon her work as surrealistic in a visual sense but the logic behind her imagery makes it realistic. Her philosophy is meaningful and subscribes to the age-old Catholic belief of eternal life.

A second painting, *Tierra Amarilla (Yellow Earth)*, includes the trinity of Christ's birth, death and resurrection as identified by the crucifixes perched at the top of the painting. At the far end of the church interior is the Blessed Mother, probably the Lady of Guadalupe. She is surrounded by golden rays with a brilliant blue background serving as the sanctuary walls.

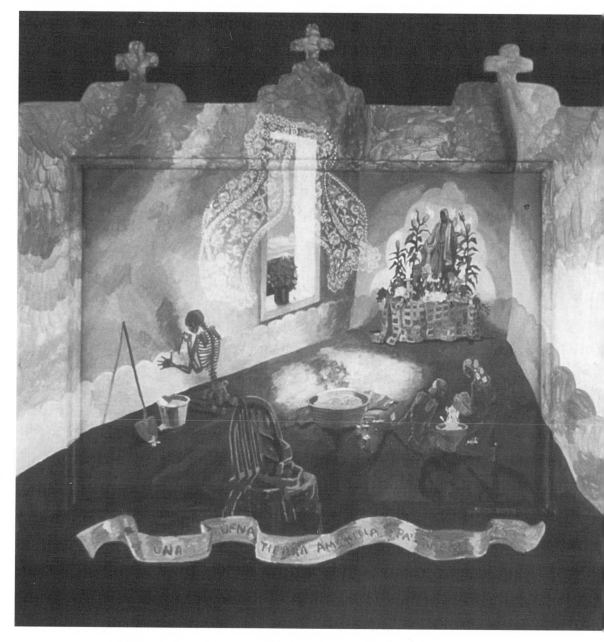

TIERRA AMARILLA by Anita Rodriguez. 1994. Acrylic. 23⅓ × 29 in.
Courtesy of the artist.

The subject matter in Anita Rodriguez's paintings is usually centrally located. Secondary images occupy appropriate areas that demand attention while blending into a total expression. However, more essential than composition is the notion being expressed and the intensity with which it confronts the viewer. Rodriguez's images are delightful. Their carefree movements are reminiscent of a Joan Miró or Paul Klee painting. *Tierra Amarilla* was finished in 1995, a year after *La Boda*.

Rodriguez claimed to the author that "as an artist the image of the *calavera* is much much more than a beautiful and intricate natural phenomenon. It is a reminder that life is not only precious and to be treasured every minute, but that death is not to be feared. The fear of death and its denial is the first denial — triggering a chain of denials. The fear of death engenders all deceit and ends by actually preventing one from living. The daily remembrances of death give one great personal power — the power to distinguish between the important and the trivial. It teaches one to love life, to celebrate it and respect its fragility. It makes one treasure loved ones and to appreciate the simplest joys."

Rodriguez makes a strong statement on one's waste of life and makes a stronger case for the need to cherish life in its purest and simplest form. In the Catholic faith, the Holy Rosary is recited at the death of loved ones with the Glorious or Joyful Mysteries rather than the once customary Sorrowful Mysteries. The funeral becomes a celebration of a soul destined for heaven rather than a human being leaving this earth.

Rodriguez's paintings appear as stained glass windows. They also reveal the inside and outside of the environment. In the 1994 work *Vamos a Tirar Chanclas*, the foreground is an exquisite colorful tile flooring that sets the mood of the madcap's action. The background is a mixture of azure blues and ultramarine blues that add to the surreal and eerie environment. Again, the subject matter — of a couple of madcaps dancing frantically to a rapid beat — is centrally located. Flowers again surround the performers.

In another 1994 production, *Corrida de la Hija*, the artist again sets the action upon a colorful tile flooring against a background of blue nuances. Dazzling flower bouquets deck the madcap's skirt as the skeletal form dances to a joyful tune. Surrealism is evidenced in the receding horizon. The diminishing tile flooring joins an azure blue sky, suggesting, in a sense, the notion of eternal life.

Rodriguez's paintings resemble altar pieces and or stained glass window shapes much like those executed during the Renaissance. Flowers are consistently employed as symbols of eternal perpetuation. Crosses are consistently included, reminding viewers of death before the resurrection. By reminding one of death, Rodriguez hopes to declare the important elements of life in order to accentuate the positive aspects and diminish or eliminate the negative.

A second painting titled *La Boda*, executed in 1995, is a more complex composition than the earlier work. Complete with a band and wedding cake, the married couple celebrate with friends. The invited guests drink toasts to the newly married couple. Visual perspective is introduced with the colorful and complex tablecloth that recedes into space and also acts as a stabilizing force for the entire composition. The skeletal bride wears a gown of shimmering flowers. In both versions of the wedding, the artist adorns the groom with a head that only adds to the surreal nature of the creatures.

Not much has been said about the exterior dimensions of the working surface.

Opposite: *VAMOS A TIRAR CHANCLAS by Anita Rodriguez. 1994. Acrylic. 28 × 48 in.*
Courtesy of the artist.

CORRIDA DE LA *HIJA* by Anita Rodriguez. Acrylic. 48 × 28 in.
Courtesy of the artist.

LÁGRIMAS DE *PERLAS by Anita Rodriguez. Acrylic. 53 × 32¾ in.*
Courtesy of the artist.

The unusual shapes of Rodriguez's paintings add an important dimension to the work. The viewer is immediately drawn to the unusual shape of the canvas or paper. Compositional problems on the canvas add to an already complicated theme.

The use of an unorthodox shape forces the viewer to pay immediate attention and allows for artistic freedom. Whether the dimensional shape is caused by the notion being expressed or by a previously established working surface, a formal balance results. In her painting *Lágrimas de Perlas (Tears of Pearls)*, a 1995 rendition, a vale of earthly tears becomes tears of pearls in heaven. The madcap is decked in beautiful flowers and wears a crown of jewels. An unusually shaped cloud of lace embroidery appears as a halo over the madcap's head. Cupids play lovely tunes on flutes and violins. A lush, azure sky adds to the gala event. All activity is directed toward the joyful facial expression of the madcap.

The winged cupids are appropriately placed within the composition, and the full-blowing flowers make for a full celebration. The madcap sustains the significantly central position flanked by and meshed with gorgeous flowers and lovely cupids.

Because Anita Rodriguez's paintings resemble altar pieces and stained glass windows, there is indeed a profound religious fervor motivating her work. Not only does Rodriguez celebrate life with her paintings, but they are reminders of the essentials of life.

Career Highlights

Born in Taos, New Mexico, in 1941.

EDUCATION
Self taught — influenced by family of artists.

SOLO EXHIBITIONS
Handsel Gallery, Santa Fe, New Mexico, 1994; Albuquerque Convention Center, Albuquerque, New Mexico, 1994; Handsel Gallery, Santa Fe, New Mexico, 1992; Atelier Gallery, Taos, New Mexico, 1991; Dejavu Gallery, Taos, New Mexico, 1991; First State Bank, Taos, New Mexico, 1990.

SELECTED GROUP EXHIBITIONS
Mayor of Guadalajara's Gallery, Guadalajara, Mexico, 1994; Orange County Center for Contemporary Art, Santa Ana, California, 1994; Martinez Hacienda, Taos, New Mexico, 1994; Taos Civic Center, Taos, New Mexico, 1994; Stables Art Center, Taos, New Mexico, 1994; Millicent Rodger's Museum, Taos, New Mexico, 1993; Doughterty Art Center, Austin, Texas, 1992; La Luz de Jesus Gallery, Los Angeles, California, 1992; Mexican Museum of Fine Arts, Chicago, Illinois, 1992; Firestone Building, Santa Fe, New Mexico, 1992; Capital Building, Santa Fe, New Mexico, 1992; Mante's Gallery, Taos, New Mexico, 1991; Santa Fe Center for the Arts, Santa Fe, New Mexico, 1990; Stables Art Center, Taos, New Mexico, 1989; Las Palomas de Taos, New Mexico, 1989.

Patricia Rodríguez

Patricia Rodríguez, whose installations mirror her memories and beliefs, adheres to a Christian environment. In her work *All Souls Day*, she establishes a three tier sculptural form of speculation representing purgatory, the earth and heaven. Because there exists only a frontal view, but with a three-dimensional form, *All Souls Day* reveals a sculptural form as a relief.

The work defines a celebration of prayer for those deceased Roman Catholics who suffer in purgatory—a spiritual residence for those not yet worthy of Heaven. Prayer is essential for the elevation of souls into Heaven. All Saints Day precedes All Souls Day, and as a celebration of thanksgiving serves to remind the viewer of one's own eternal salvation.

The lower deck of her construction displays three human skulls whose spirits remain in purgatory. To acknowledge the presence of the invisible spirits, the artist exhibits three human skeletons within the upper enclosure. Between the skulls are complete bodily skeletons lying in repose.

The oval habitat also includes several diagonals sprouting upward in a manner similar to the Renaissance version of the ascension of Christ into Heaven.

All Souls Day is an example of additive sculpture. Familiar objects are attached to an earlier established working plan. Rather than work on a two-dimensional surface, Rodríguez builds upward and positions objects in appropriate locations.

Rodríguez's contemporary installation is absent of any Christian symbols. Thus, the title becomes an essential aid to understanding and appreciating the work. The entire installation is encased with closing doors like a miniature church closing its doors after the service of Holy Mass.

Because of the personal nature of Rodríguez's work, it is open to speculation and misinterpretation. Yet, the title alone defines it as a sacred and hallowed notion.

Rodríguez's installation *Tribute to My Grandmother* resembles an altar. This 1982 rendition has three connecting structures. The edging of the altar piece is lined with a series of heart shapes. Enclosed within each shape is a star. Draped behind the altar piece is a lace design resembling a mosaic. The complex composition resting upon the upper section of the altar piece includes several nostalgic objects. A photo of the artist's grandmother is the focal point but is flanked by various memorabilia.

The shape of the human heart, complete with major arteries, is positioned on both the right and left sides. Disjointed arms hang from upper segments of a hinged door. A dove of peace cowers in a corner of the installation. An antique sewing

ALL SOULS DAY by Patricia Rodríguez.
Courtesy of the artist.

TRIBUTE TO MY GRANDMOTHER by Patricia Rodríguez. 1982.
Courtesy of the artist.

machine occupies the center of the altar table. A half-visible male figure is seen in front of the grandmother, partially hidden by an enclosure.

Rodríguez's installations are combinations of several media — painting, sculpture, collage, and montage, in addition to intuitive responses by the artist. There exists a spiritual climate associated with Rodríguez's installations — a sense of the eternity promised by the Divine.

The process of installations is either intuitive or intellectual. A basic form is conceived — usually resembling an altar or shrine — and the finished product is the result of objects instinctively added. Frequently, an additional image demands another to offset or balance the composition. It is conceivable that Rodríguez deliberately adds objects indiscriminately, forcing the addition of other ingredients to unify the composition. Of course, the additional images make for a more complex work, thus demanding a more thorough examination by the viewer.

A Tribute to My Grandmother is a total expression. One may question the addition of more objects or the subtraction of others. Time also affects the evaluation of the work because of the artist's disposition. The work of art never changes unless dictated by the artist.

Man's Theater is a sculptural relief of overlapping planes set to a formal arrangement. On the lower stage is a male dancer flanked by two beautiful female dancers. Four planes or tiers constitute the composition. The immediate foreground backdrop is a smoothly finished panel spiked with a melodious pattern resembling musical stanzas. The foreground is abruptly halted with the placement of a soft cotton fabric, forming a sharp contrast between foreground and the middle ground.

The upper deck or second stage displays two caballeros, again formally balanced. It appears as if caution was practiced in terms of positioning the images. The rigid construction shows no signs of intuitive responses; it is as if the artist had followed a rigid plan.

Although deeply personal, Rodríguez's work is extremely objective. One is not emotionally aroused because of her objective approach; instead, one scans for intellectual insights. The intellectual approach includes the meaning of various images and how they apply to the artist's intent. The three-dimensional elements are connected by a consistent rhythmic pattern, so that the three-dimensional structure blends with the two-dimensional background.

The 1980 installation *Self-Portrait* is a personal and highly speculative work. It is a method of preserving the past. There is a deliberate attempt to balance the composition. Particular symbols are outstanding — heart shapes pierced with nails, skeletal figures, house keys — and one can only ascribe literal meanings based on one's own experience.

Each image may have a spiritual significance: The pierced hearts remind one of the Sacred Heart of Jesus; the skeletal figures are a reminder of the spirit leaving the body; and the house keys may represent the keys to the kingdom of Heaven.

In the 1995 edition of *Notable Hispanic American Women*, Rodríguez is quoted as saying: "I have always believed that my works are a vehicle where spiritual messages are expressed. Each construction has its own self consciousness that is a personal, spiritual and social-feminine statement."

MAN'S THEATER by Patricia Rodríguez.
Courtesy of the artist.

The antique bureau pictured in *Self-Portrait* is adorned with a preplanned composition. Where identical objects do not balance the expression, objects similar in shape and composition are used to avoid an unbalanced expression. Formal balance is obvious in the bureau drawer section. Each bureau drawer has a life that survives alone. The beauty of *Self-Portrait* is that future memories may be added and others may give way to more pertinent and important experiences.

In another nostalgic installation, Patricia Rodríguez recalls past experiences in *Memories of My Home*. A 1990 rendition, it consists of six separate compartments, each of which houses the artist's fondest memories. The ceramic sculpture combines with wooden framed compartments that house particularly cherished memorabilia.

One may question the motive for *Memories of My Home*. In the lower geometric shape is a cage-like construction, and contained within are partially hidden objects. Rising atop the rectangular three-dimensional form is a vertical ceramic housing shaped like a church steeple, again reflecting the spirituality of Rodríguez's approach. The formally balanced installation parallels the objective philosophical outlook of the artist. Textural qualities contrast sharply with the smooth finish of the wood construction that resides within the larger ceramic construction.

A biographical sketch defines Rodríguez's *Portrait of Esteran Villa*, a Sacramento artist friend. Images of hearts and keys flourish and surround an oversized head of the artist made of ceramic material. The head is surrounded by a series of heart shapes to the right and left, while the bottom of the installation has six equidistant keys. A flower pattern accompanies the series of heart images atop the rectangular shape that houses the ceramic head of her friend. Rodríguez places paint brushes and a power paint machine that is a major part of the installation.

The portrait has more to do with symbolic images than a physical likeness of the sitter. The same could be said of *Self-Portrait*. If one were to classify the artist's style, it may well be surrealism, even though the artist might disagree.

In *Notable Hispanic American Women*, Rodríguez summarizes her philosophy of art: "Art plays an important role in the Hispanic community. It serves as the embodiment of our history and cultural values that should be transmitted to our children in order to give them self-esteem and the courage to succeed professionally. I regularly see Chicano artists teaching children and teenagers, working with handicapped people and senior citizens, and in doing so bringing our Hispanic heritage to life."

Rodríguez uses personal images, memories of the past as a recollection of time never to return. Her strong Catholic faith causes her to shape her installations like shrines or altars. She indirectly creates a sense of the crucifixion of Christ with the pierced hearts that are evident in many of her works. By so doing she avoids the extreme agony of torturing the human body. Although it is not always an obvious symbol, it is nonetheless a personal tribute to one's Creator.

Opposite: *SELF-PORTRAIT by Patricia Rodríguez. 1980.*
Courtesy of the artist.

Career Highlights

Born in Marfa, Texas, in 1944.

EDUCATION
B.F.A. degree from the San Francisco Art Institute; M.A. degree in painting from Sacramento State University; the California Community College Instructor Credential; ESL/Civics, Arts, Humanities Certificate of Authorization for Service.

SOLO EXHIBITIONS
Sonoma State University, Sonoma, California, 1990; Manuelitas Gallery, San Francisco, California, 1987; LaPosada Gallery, Sacramento, California, 1986; Mission Cultural Center, San Francisco, California, 1980.

GROUP EXHIBITIONS
Northern New Mexico Community College, Española, New Mexico, 1995; Womens' Center Gallery, University of California, Santa Barbara, California, 1994; The Fine Arts Center Museum, Chicago, Illinois, 1993; Red Mesa Art Center, Gallup, New Mexico, 1993; Channing Peake Gallery, Santa Barbara, California, 1992; The Moss Gallery, San Francisco, California, 1992; El Paso Museum of Art, El Paso, Texas, 1992; Kimberley Gallery, Washington, D.C., 1992; The Mexican Gallery, San Francisco, California, 1992; Porter College, University of California, Santa Cruz, California, 1990; Atlanta College of Art, Atlanta, Georgia, 1990; U.C.L.A., Los Angeles, California, 1990; LaPena Cultural Center, Berkeley, California, 1991; Berkeley Art Center, Berkeley, California, 1991; Mission Cultural Center, San Francisco, California, 1989; Merced Art Gallery, Merced, California, 1989; Arizona State University Art Museum, Phoenix, Arizona, 1988; The Mexican Museum, San Francisco, California, 1988; San Francisco Arts Commission Gallery, San Francisco, California, 1987; San Jose Museum of Art, San Jose, California, 1987; Intar Gallery, New York, New York, 1986; Whittier College, Whittier, California, 1986; New York's Museum of Contemporary Hispanic Art Traveling Show, 1986; The Mexican Museum, San Francisco, California, 1985; University of Santa Clara, Santa Clara, Caliornia, 1984; University of Texas, Austin, Texas, 1984; Cayman Gallery, New York, New York, 1983; Eastern Michigan University, Ypsilanti, Michigan, 1983; Lehigh University, Bethlehem, Pennsylvania, 1982; Humboldt State University, Arcata, California, 1981; De Anza College, Cupertino, California, 1981; The Chicago Public Library Cultural Center, Chicago, Illinois, 1978; Corpus Christi State University, Corpus Christi, Texas, 1978; University of California, Berkeley, California, 1977; Mills College, Oakland, California, 1976; Chabot College, Hayward, California, 1975; Galería de la Raza, San Francisco, California, 1974.

PUBLIC COLLECTIONS
Mexican Museum, San Francisco, California; Hayward State University; Galería de la Raza, San Francisco, California; LaPosada Gallery, Sacramento, California; The Arts Council of the Museum of Modern Art, New York, New York; University of California, Berkeley, California (slide archive).

Opposite: *MEMORIES OF MY HOME by Patricia Rodríguez. 1990. Courtesy of the artist.*

Theresa Rosado

Born in St. Louis, Missouri, in 1965, Theresa Rosado is blessed with artistic talent. Unlike some other Latin American women artists, she has no formal art training, but acquired a degree in anthropology from Michigan State University. By doing extensive research on Latin American art and visiting galleries and museums, she has developed a keen sense of the culture. Self taught, her work focuses on realism and varying degrees of surrealism.

Her 1994 painting *Flying Girl* presents a surreal idea within a realistic environment. Remove the flying girl and the painting becomes realistic. Aside from the mansion that occupies half of the working surface, the habitat is flowing with flowering plant life. A single yellow bird is perched upon the flowered foreground while the girl floats aimlessly overhead.

All visible sides of the building are represented with a trio of identical windows, reminding one of the altar triptychs of the Italian Renaissance. There is a degree of primitivism in the side of the building. Visual recession does not occur, as the windows and side of the building remain constant instead of appearing smaller as they recede. The basic element of childhood coincides with the methods of the self-taught artist. This similarity is common and considered at times a charming and delightful characteristic.

Because surrealism deals with personal and intimate associations and circumstances, it is difficult to interpret various symbols that only the artist understands. In addition, unknown factors frequently are expressed that are not accounted for by the artist.

Prayer of a Sun Woman is a 1994 painting of a mutant creature of plant and human life. It is pure fantasy and reflects a charm and elegance if one were to accept it as such. The human elements have given way to the plant and bird life.

Accepting *Prayer of a Sun Woman* as a delightful fantasy rather than a profound intellectual expression should be rewarding to the viewer. The positioning of birds surrounding the sunflower woman form a circular composition, which reinforces the subject matter.

The artist again has divided the canvas into equal parts foreground and background. The sun woman, as a subjective focal point, overlaps the two sections to form a unique oneness. Even the sky has clouds shaped like sunflowers. Hands are defined with huge sunflower leaves, and the head is a large sunflower blossom. Placed upon her abdomen is the patriotic flag of Puerto Rico, commemorating her cultural heritage.

FLYING GIRL by Theresa Rosado. 1991. Acrylic on wood. 14 × 22 in.
Courtesy of the artist.

The composition is simple, with the subject matter occupying much of the working surface while overlapping both foreground and background. In spite of the complex overlapping of images, there is little confusion. Images are carefully positioned to enhance the initial subject. Background and foreground possess elements that not only activate negative areas but add to the fantastic portrayal.

Five Mysteries or More was executed in 1994. Like her other works, this painting is open to speculation and misinterpretation. Deeply personal images related to her life are incorporated into a fascinating composition. The appropriate placement of several humans of different races and nationalities form the circular composition. Each of the female nudes appears in a garden of Eden, each seemingly devouring a piece of fruit and leisurely enjoying the colorful landscape.

An eerie human species raises its head above the flowering background as a bluish substance emits from its mouth. The same fluid substance acts as a river flowing downward and swaying to the forefront of the painting. Three figures are content to bathe their feet in the river-like stream of bluish pigment.

The weird head that seems to demand the focal point emerges from a landscape of flowers and plant life, while the fully clothed figure occupies the lower frontal plane. She is flanked by the two flags that represent her ancestral and native countries.

PRAYER OF A *SUNWOMAN* by Theresa Rosado. 1994. Acrylic on wood. 24 × 30 in.
Courtesy of the artist.

*FIVE MYSTERIES OR MORE by Theresa Rosado. 1994. Acrylic on wood. 13½ × 26½ in.
Courtesy of the artist.*

Rosado's title presents a speculative game of five mysteries or more. Even though the game itself is one of imagination, the search leads to the enticing experience of abstract art. Misinterpretations do not necessarily mar visual or emotional acceptance. Although the intent of the artist is important, other factors create appreciation and acceptance because of the intimate and personal nature of the artist's intentions.

On Prom Night I Danced with My Grandmother is a dream of sorts to which the artist alludes to fulfill a fantasy. The 1993 rendition pictures a dancing, barefoot young woman strumming a guitar. Accompanying the musical entertainment is the woman's counterpart, who is dancing upon a concrete wall while playing a musical instrument.

The painting is divided into two equal horizontal segments connected only by the gesture of the male image and the upward glance of the guitar player. The upper segment features two bodiless figures arranged between carefully placed decorative pineapple images. The brilliant blue background represents a sky peppered with countless blotches of red pigment.

The viewer is treated to an audience of two. The woman guitarist could be playing for either her male counterpart or the weird creature housed in a tomb-like igloo. Rosado's dwarfed human figure could be a remnant of her grandmother or a character concocted to create a surreal environment. Because of the uncertainty of Rosado's intent, from a spectator's viewpoint, the search for logical meaning becomes an exciting adventure.

On Prom Night has all the charm and mystery of the Latin American culture. Theresa Rosado has united two individual expressions into a single work of art. The positioning of the three human figures while forming a triangular composition within the rectangular shape creates oneness.

The 1994 portrayal *A Mouthful* pictures a Puerto Rican café advertising traditional Puerto Rican meals and American favorites. Positioned adjacent to the eatery is a shrine featuring the Blessed Virgin Mary. Behind the shrine are a beach and ocean shore filled with colorful umbrellas pitched into the sandy beach.

The forefront focuses on a group of female figures whose mouths are plugged with food while a lone woman stands outside the shrine balking at entry and holding a lit candle. Inside the chapel adjacent to the Blessed Mother is a snake coiling around a tree. The snake is symbolic of evil, which the Blessed Mother, as pictured in other paintings, crushes under her feet.

Rosado's images seem to be a series of memories that need not be logically linked, but that do form a composition of worth. Several notions are included as if on a whim of the artist.

There is an attempt to join the two cultures that have influenced Rosado's art. The café in which a couple dines lacks visual perspective. But again, it matters little since the artist is more concerned with inclusion rather than visual accuracy.

Rosado's inclusion of seemingly illogical images seems a trademark of her works. In the painting *We Drove All Night*, the presence of a huge "domino" appears in the background of the painting. Ten dots on the domino suggest a symbolic time element. A bright orange convertible with a young couple leisurely sitting in the

ON PROM NIGHT I DANCED WITH MY GRANDMOTHER
by Theresa Rosado. 1993. Acrylic on canvas. 12 × 22 in.
Courtesy of the artist.

front seat is parked alongside an outdoor eatery. Although the car, eatery and the domino are realistically rendered, it is the circumstances and disconnections that create the surrealism.

Theresa Rosado's paintings seem to be remnants of dreams, memories of the past or hopes for the future. They are enticing, charming and provocative and serve her Latin American heritage well.

Career Highlights

Born in St. Louis, Missouri, in 1965 of Puerto Rican ancestry.

Solo Exhibitions
General Motors Institute, Flint, Michigan, 1996; Casa de Unidad, Detroit, Michigan, 1995; Lansing Art Gallery, Lansing, Michigan, 1995.

Group Exhibitions
Flint Fine Art Gallery, Flint, Michigan, 1995; Michigan State University, East Lansing, Michigan, 1995; Kresge Art Center, Michigan State University, East Lansing, Michigan, 1995; Kellogg Center, East Lansing, Michigan, 1995; Krasl Art Center, St. Joseph, Michigan, 1994; Michigan Heritage & Folklore Gallery, Grand Rapids, Michigan, 1993; Northern Michigan University, Marquette, Michigan, 1992; Scarab Gallery, Detroit, Michigan, 1992; Ella Sharp Museum, Jackson, Michigan, 1991.

Soledad Salame

A 1995 exhibition brochure of the Art Museum of the Americas stated: "[Soledad] Salame's internal landscapes cause the viewer to assume a contemplative attitude. The extraordinary power they exude and their subtle visibility make them internal havens where solitude is a source of happiness. They enter the dimension of human poetry. They then take on a new symbolic meaning closely connected to the inner self. The external landscape and the internal landscape become personal elegies of human existential concerns."

In her painting *Interior 1*, Soledad Salame invents a hauntingly eerie adventure. Stairways leading to nowhere, hallways capturing the essence of infinity, and rooms which appear limitless create a sense of the unknown and unpredictable. *Interior 1* is a spatial creation of several instinctive areas of activity that collide and blend simultaneously. This apparent harmony stems from the inclusion of a translucent coloring process, which diminishes the original color and thus creates a haze, resulting in a dreamy reality.

A sense of reality precedes surreality, and the viewer is left to resolve or disavow his own credo. The blurry atmosphere of the interior creates a sense of floating in air or swimming in an endless voyage. It reflects a diminishment of the past and an uncertainty of the future.

Divided into three related geometric shapes, each with its own environment, *Interior 1* is an assemblage of the past, a dream world to become a real world. It does indeed invoke a personal and intimate reaction.

There is a concern for unity, a blend of the outside and inside world. Salame's version of the interior is a spiritual adventure. Her style of painting is abstract expressionism. However, realism underlies the abstract appearance, as if one were erasing the past in order to reconstruct the future in terms of a spiritual reawakening. The web-like transparent covering of color reasserts the positive elements of the painting. Executed in 1994, *Interior 1* is a work totally lacking in the Latin American culture and reflecting an international flavor.

A second painting, *Fragments of a Journey*, was executed in 1993. It is an extension of *Interior 1* in which fragments of the artist's nostalgic journey are made visible, but again in somewhat illusive imagery. The outside and inside worlds are both evident, along with the presence of mortal and divine creations.

The viewer is confronted with a view of a balcony, a second-story approach to the inner world of the artist. Rectangular shaped windows occupy the entire right

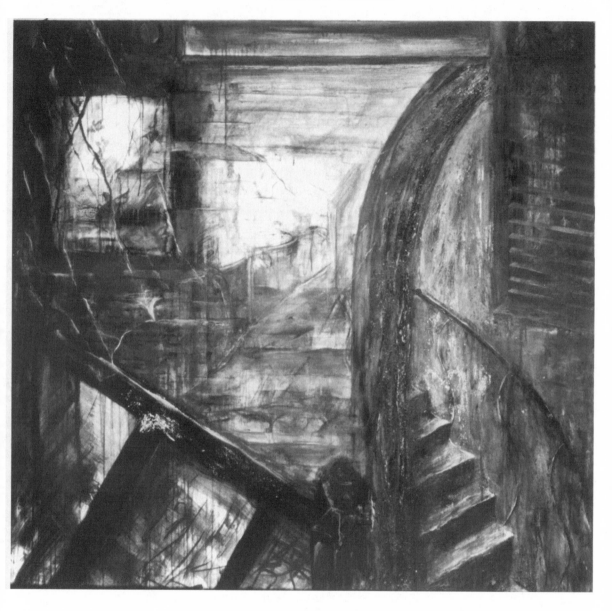

INTERIOR 1 by Soledad Salame. 53 × 55½ in. Mixed media on paper.
Courtesy of the artist.

segment of the painting, each with different contents. A horizontal railing joins a
diagonal railing of attached foliage, symbolizing nature's outside world.

The abstract nature of *Fragments of a Journey* affords the viewer a wide range
of speculation. Since the artist is free to meander during the painting process, the
viewer is likewise free to interpret and understand. Yet, there is never a guarantee
of comprehension and acceptance. In fact, emotional and spiritual reactions differ
with each individual.

Soledad Salame's journey into art is a self-centered one. Born in Santiago,

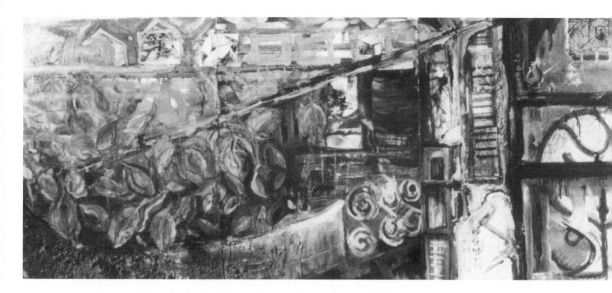

*FRAGMENTS OF A JOURNEY by Soledad Salame. Mixed media on paper. 36½ × 74 in.
Courtesy of the artist.*

Chile, in 1954, she became engrossed in the experimentation of moods rather than ideas. Color and visual images became stimuli for nostalgic and spiritual journeys into eternity. Her painting became an experiment as life had become an adventure into the unknown. Discovery became her goal.

Soledad Salame's artistry lies in her ability to make the commonplace exciting. She seeks the unknown and presents the unpredictable. In a *Baltimore Sun* review, of October 15, 1990, critic Ernest F. Imhoff wrote regarding her scenery for the Baltimore Opera Company's production of *Carmen*: "Rather than offering sets showing routine streets, tavern and mountains, artist Salame gave the audience a kaleidoscopic feast of reds, yellows, browns and blues in paintings and sculptures capturing at different depths, windows or city lights or precipices or buildings. Salame sent the viewer's imagination roaming as the Bizet melodies splashed over them."

Salame's installations, sculptures and paintings are equally emotional and unpredictable. The most ordinary objective images become mysterious and objects of affection. The painting *City of Secrets*, a 1995 production, is a display of bits and pieces that arrives at a remarkable conclusion. Aside from various compositions constituting the whole, there exists a secretive mystery within each variation. Architectural structures are shaped by diagonal, vertical and horizontal overlapping lines. Abstract compositions are formed as shapes, lines and colors interpenetrate to create a vast forest of astonishing images.

City of Secrets reflects the uprooted, the decayed, the newly erected and degrees of decadence. Yet, beauty emerges from all areas of the canvas. Visual perspective is created by textural details rather than colors. In fact, dark colors which normally recede advance, and light colors which normally advance recede. This unusual use of light and dark make for compelling expressions of human thoughts and emotions.

Soledad Salame may be considered an abstract expressionist because of the

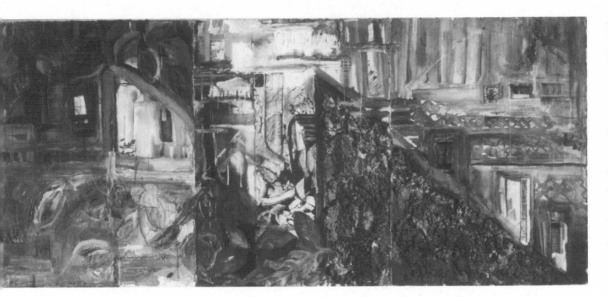

*CITY OF SECRETS by Soledad Salame. Mixed media. Oil on canvas. 6½ × 74 in.
Courtesy of the artist.*

various suggestive elements that are presented in her paintings. The intuitive forces identified with the process frequently alter the initial thrust upon canvas. Much of Salame's process is both objectively calculated and subjectively expressed.

According to John Dorsey, art critic for the *Baltimore Sun*: "The romance, the mystery, the decadence of the city — all these are captured in Soledad Salame's fine mixed media works on paper at Gomez Gallery. She has a sense of the centuries of layered life that inhabit our buildings, of the tales that doors and stairs and windows might tell if they could. Looking at fragmented images put together out of bits and pieces of buildings, we feel that we can almost grasp a story line — and would if we could just sort all this stuff out and put it together the right way. But it is not to be able to — it's better to keep seeking than to find."

Open Gate is such a painting. Considered more of a collage than a painting or mixed media, the relief formed by various natural elements and several styles of painting creates various rectangular compositions within a substantially larger rectangular shape. Salame, with each geometric shape, presents a mysterious search for the truth. Enhanced by equally nostalgic imagery within adjacent rectangular shapes, her work is a coordinated orchestration of past memories. The title itself is open invitation to participation.

In her painting *Trees,* Salame intermingles her nostalgic structural images with nature to form an intriguing compatibility between the creation by man and the creation of the divine. The composition is again structured into rectangular shapes, which are intercepted only by the tree branches that interweave with the inner workings of the building sites.

There is an architectural scheme witnessed in *Trees.* Images soar upward. There are remnants of rooftops, doors and windows, which, when coupled with swirling tree branches offers a mysterious combination of instinctive responses.

Because of the lack of visual perspective and the interplay of geometric shapes with the linear movement of the branches, Salame allows for a free interpretation of her work. Because of its abstract expressionist nature, hidden images and meanings lie dormant. The viewer is left to seek and discover the artist's meaning. Seldom do accurate interpretations occur, and it is the process of discovery that delights the viewer, more so than a correct identification. A spiritual resolve is frequently the course one follows. However, as trees reach heavenward, leaves are shed and one suddenly witnesses naked branches, suggesting the Crucifixion at Calvary.

Trees is open to personal speculation; whether such interpretations meet the artist's intent matters little. The essential need of abstract expressionism is to seek and find meaning. Soledad Salame has indeed entered the mainstream of American art. One is reminded of Hobson Pittman's nostalgic paintings of the 1940s. Salame's works, however, are more dramatic than romantic and less obvious then Pittman's charming and poetic interiors.

Seemingly disorganized at first glance, further scrutiny uncovers a complex, carefully conceived composition. Her abstract expressionist creations are intuitive. Any errant application of pigment is instinctively erased or altered to better the composition. Changes are not readily recognized as appropriate. In fact, frequently, unsatisfactory works eventually prove to be satisfying to the artist long after completion of the painting. Soledad Salame's paintings of mixed media are visually and emotionally strong examples of a poetic — both charming and mystical — approach. Her stamp of approval and her contribution to American art has been acknowledged through her various showings in galleries and museums throughout the United States.

TREES by Soledad Salame. 1995.
Mixed media on paper. 66 × 27 in.
Courtesy of the artist.

SOLEDAD SALAME

Career Highlights

Born in Santiago, Chile, in 1954; created the set designs for the Baltimore Opera's production of *Carmen*, 1990; settled in New York City in 1988.

EDUCATION
B.A. degree in science and humanities in 1972; studied graphic design at the Design Institute in Caracas; studied paper making at the Design Institute in Caracas.

SOLO EXHIBITIONS
Galería Minatauro, Caracas, Venezuela, 1995; Gomez Gallery, Baltimore, Maryland, 1994; Brown Design Associates, Richmond, Virginia, 1992; Zenith Gallery, Washington, D.C., 1990; City University, New York, New York, 1980; Wells College Aurora, New York, 1980.

SELECTED GROUP EXHIBITIONS
Milwaukee Museum of Art, Milwaukee, Wisconsin, 1995; Art Museum of the Americas, Washington, D.C., 1994; Maryland Arts Space, Baltimore, Maryland, 1993; Zenith Gallery, Washington, D.C., 1992; Marta Morante Gallery, New York, New York, 1992; Housatonic Museum of Art, Bridgeport, Connecticut, 1992; Maryland Art Space, Baltimore, Maryland, 1991; Zenith Gallery, Washington, D.C., 1989; Museum of Contemporary Hispanic Art, New York, New York, 1988; Arlington Arts Center, Arlington, Virginia, 1987; Gallery Row, Washington, D.C., 1986; Meridan House International, Washington, D.C., 1986; National Gallery, Caracas, Venezuela, 1982; United Graphic Artists, Santa Fe de Bogatá, Colombia, 1980.

Fanny Sanin

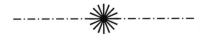

John Russell, in the February 19, 1982, issue of the *New York Times*, said of Fanny Sanin: "The idiom of Fanny Sanin's paintings is one that has a long and honorable history in nonrepresentational art. It is an art of echo and balance, in which rectangles of uninfected color call out to one another on either side of a vertical core. That central core has elements of overlap, and even of death on occasion, but the tall thin panels on either side of it do not intrude upon one another, opting instead for a world of ordered calm."

Although calmness may lead to stagnation or monotony, Sanin has avoided such pitfalls by carefully experimenting with variations of color before pursuing a final approach. Sanin's nonobjective style refers to the absence of recognizable images. Geometric shapes thus refer not to natural images but to a mood or atmospheric condition. Sanin's paintings are described as spiritual or emotional works that play on the heart and soul of humanity. The intensity, or lack, of color determines the degree of emotional or spiritual reaction by the receiver of the work. The shapes themselves also influence the degree of reaction, and the actual positioning of the various nonobjective shapes become a determining factor.

Fanny Sanin's paintings of the sixties are more intense and dramatic than hers of the seventies. The pigment scattered across the canvas reminds one of the feverish approach of a Hans Hofmann or deKooning. Such works as *Oil No. 3, 1966* and *Oil No. 1, 1967* are superb examples of the intuitive juices at work. In *Oil No. 3, 1966*, Sanin carefully considers every segment of canvas and instinctively applies color to appropriate areas. Transparent washes and heavy applications of pigment combine to form dramatic contrasts. The disjointed and seemingly chaotic shapes unite in a dramatic fashion. The intensity underlying each segment seems ready to explode. A tug-of-war exists between colors, creating an ever-present tension. The bright color occupying the central core is intuitively overladen with transparent colors to more pleasantly match adjacent areas. The appropriately positioned blacks adjacent to the once brilliant yellows sustain the focus within the central area of the painting.

The background is a muted, neutral color which recedes in proper fashion and is introduced within the positive elements of the painting. In spite of extreme contrasting colors, the total composition becomes a oneness, a totally complete composition.

Far more restless than *Oil No. 3, 1966* is *Oil No. 1, 1967*. Anxiety is witnessed throughout. A dark diagonal swoop pierces the left side of the canvas and settles in

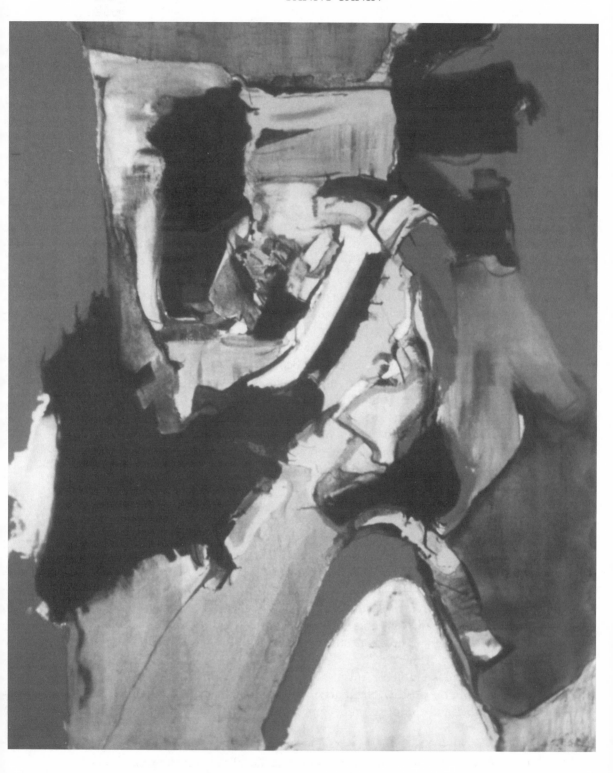

OIL NO. 3, 1966 by Fanny Sanin. 1966. Oil on canvas. 59 × 49 in.
Courtesy of the artist.

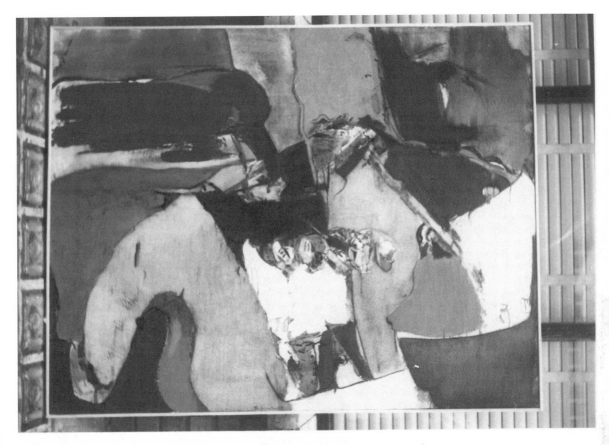

OIL NO. 2, 1965 by Fanny Sanin. 1965. Oil on canvas.
Courtesy of the artist.

a central location. Jagged edges occur throughout the composition, activating already active areas. There is the suggestion of an environment in the use of transparent pigments, while the positive aspects are rendered with thickly applied color. The distribution of color, because of impulsive brushstrokes, remains unpredictable. Balance can occur only after the artist has first created an imbalance within the composition. It is this process of deliberate imbalance in order to balance that intrigues the viewer.

Such paintings as *Oil No. 3, 1966* and *Oil No. 1, 1967* relate to abstract expressionism, but her later works relate more to nonobjectivism as practiced by Josef Albers and Piet Mondrian. *Acrylic No. 2, 1986* totally eliminates the instinctive process in its precise manipulation of color.

John Russell, in a *New York Times* article, questioned her approach but was pleased with the results: "There is the inner life of color, to begin with, and then the rectangles can be made to form up in new ways. Color in painting of this kind has mostly been high and clear, but Fanny Sanin has, on the contrary, her own gamut of hooded in-between hues. Something of resonance is lost in that way, and this is not an idiom that thrives upon mystery, but the results are distinctly her own. As for the management of the forms, it has sometimes a look

ACRYLIC NO. 2, 1986 by Fanny Sanin. Acrylic on canvas. 1986.
Courtesy of the artist.

of overcomplication; but when everything slips into place — as in *Acrylic No. 2, 1980*—
in ways that have not been done before, then the result is really very agreeable."

So perfect is the unity of *Acrylic No. 2, 1986* that to remove a single color and
substitute another would be to destroy the painting. Whether intended or not, a
spiritual atmosphere is created by the series of crosses that occupy the painting. The

dramatic color tones spiked with glints of the Resurrection suggest both the Crucifixion and the Resurrection. The painting being an abstract, one is never sure of proper identification.

A series of overlapping and interpenetration of rectangular shapes create a formal balance. All colors are toned down to avoid a sudden advancement or recession of a single color. The lightest color — which would normally advance to the forefront — rests instead on a recessive plane. Its recessive position is caused by adjacent colored shapes. What appears to be a monumental altarpiece is in essence an abstract nonobjective painting.

Acrylic No. 1, 1974 is an exquisite visual example of a formal balance created by a series of imbalances. Adjacent to a vertical panel are panels similar except for the slight alteration of a single panel. Yet, in viewing the whole, the slight deviation goes unnoticed.

Contrary to Josef Albers' theory of the recession and advancement of color, Sanin's positioning of white creates recession of that color rather than advancement. *Acrylic No. 1, 1974* may be interpreted as an urban downtown, a trio of phone booths, a series of open and shut windows, or an exciting maze of rectangular vertical shapes of contrasting colors. The colors are superbly constructed and arranged into a pleasant composition. Any objective meaning stems from color and shape rather than technique.

A more complex composition is rendered in Sanin's *Acrylic No. 3, 1974*, in which the upper and lower areas of the painting are identical except for a slight offset. In addition, Sanin has once again contradicted Albers' theory of recessive colors by placing pale yellow around the color black. Both colors retain their positions on the frontal plane, neither advancing or receding. The unusual combination is banked by various combinations of pastel colors to offset the obvious contrast of dark and light.

A series of crosses again focus on religious themes. However, the pleasantry of color is more reminiscent of the rebirth than the death. Nonetheless, the notion of the Crucifixion comes into play, more symbolic and intellectual than objective.

In Sanin's *Acrylic No. 7, 1993*, pure colors are purposely avoided in order to experiment with a full palette and all its possibilities. The color yellow is paled and red is grayed, while the area surrounding the gray reds is umber. The three rectangular shapes suggest the tips of the three crosses at Calvary; the middle shape is reserved for Christ. The three shapes also symbolize a crown of thorns. Frequently the artist is subconsciously unaccountable for her brushwork. What is nothing more than a recording of shapes often results in a subconscious record of a profound notion. The dark umber serves as a background and the three sharpened thorns symbolize the color of the victim's hair as well as the color of the cross. The abstract nature of Sanin's work is open to debate.

The question of nationality sometimes arises in the case of international artists. In the United States Fanny Sanin is considered an American artist. She has lived in the United States since 1971 and has recorded an amazing exhibition listing. In addition to over 16 one-woman shows at the time of this writing, she has participated in more than 70 group showings.

ACRYLIC NO. 7, 1993 by Fanny Sanin. Acrylic on canvas. 1993.
Courtesy of the artist.

Although the meaning of *Oil No. 12, 1965* will probably differ for each individual viewer, it matters little to the artist because the thrill experienced from a successful intuitive response to an abstract idea supersedes any outside interest. Sanin's switch from abstract expressionist emotionalism to intellectual objectivity is strictly a personal choice. Her intuitive paintings arouse one's emotions. One is immediately affected by them, and after an initial response one is drawn to the intellectual aspect.

On the other hand, what appears to be haphazard or accidental meandering of color is consciously and objectively considered and applied as integral segments of the whole. Lines or shapes of color suddenly halted or interrupted change muted areas into existing geometric shapes, some resembling reality and others revealing the unknown.

Fanny Sanin's abstracts of the expressionist movement such as *Oil No. 12, 1965* are emotionally strong and structured to foster exciting viewing. Sanin continues to experiment with new ways of expressing her Latin American heritage as it relates to the mainstream of American art.

Career Highlights

Born in Bogatá, Colombia, in 1938.

EDUCATION
B.F.A degree, University of the Andes, Bogatá, 1960; graduate studies in printmaking and art history, University of Illinois; Chelsea School of Art and Central School of Art, London; resident of New York since 1971.

SOLO EXHIBITIONS
Garces Velasquez Gallery, Bogotá, 1994; Inter-American Art Gallery, Miami-Dade Community College, Miami, 1991; Greater Lafayette Museum of Art, Lafayette, Indiana, 1990; Museum of Modern Art, Bogotá, 1987; Chamber of Commerce, Colombia, 1986; Schiller-Wapner Gallery, New York, 1986; Juan Martin Gallery, Mexico City, 1984; Phoenix Gallery, New York, 1982; Phoenix Gallery, New York, 1980; Museum of Modern Art, Mexico City, 1979; University of Illinois, Urbana, Illinois, 1978; Long Island University, New York, 1978; Phoenix Gallery, New York, 1977; Pan American Union Gallery, Washington, D.C., 1969; AIA Gallery, London, 1968; Museum of Fine Arts, Caracas, 1967; Lake House Gallery, National University, Mexico City, 1965; Modern Art Gallery, Monterrey, Mexico, 1964.

SELECTED GROUP EXHIBITIONS
National Museum of Women in the Arts, Washington, D.C., 1996; Milwaukee Art Museum, Milwaukee, Wisconsin, 1995; Bloomfield College, Bloomfield, New Jer-

sey, 1995; El Museo del Barrio, New York, New York, 1995; Inter-American Development Bank Cultural Center, Washington, D.C., 1994; Brazilian American Cultural Institute, Washington, D.C., 1994; Museum of Art of the Americas, Washington, D.C., 1993; Cavin Morris Gallery, New York, 1993; Artspace, New Haven, Connecticut, 1992; Housatonic Museum of Art, Bridgeport, Connecticut, 1992; Art Museum of the Americas, Washington, D.C., 1992; Colombian Consulate Art Gallery, Washington, D.C., 1992; Center Art Gallery, Bucknell University, Lewistown, Pennsylvania, 1992; Andrea Marquit Fine Arts, Boston, Massachusetts, 1990; Humphreys Gallery, New York, 1990; Long Island University, New York, 1990; Women Caucus for the Arts, New York, 1990; Westminster Gallery, Bloomfield College, Bloomfield, New Jersey, 1989; Lafayette Museum of Art, Lafayette, Indiana, 1989; Lafayette Museum of Art, Lafayette, Indiana, 1987; Interamerican Development Bank, Washington, D.C., 1987; New Orleans Museum of Art, New Orleans, 1986; New England Center for Contemporary Art, Brooklyn, Connecticut, 1986; Jersey City Museum, 1986; Hyde Park Art Center, Chicago, Illinois, 1986; Yeshiva University, New York, New York, 1986; Museum of Contemporary Hispanic Art, New York, New York, 1985; Art Consult International Gallery, Boston, Massachusetts, 1985; Cayman Gallery, New York, New York, 1984; Hofstra University, Hempstead, New York, 1983; Colombian Center, New

York, New York, 1983; School of Fine Arts, Paris, France, 1983; Kouros Gallery, Center for Interamerican Relations, New York, 1982; Henry Street Settlement, New York, 1981; Castle Gallery, College of New Rochelle, New York, 1981; Rutherford Barnes Collection, Denver, 1981; Rutgers University, New Jersey, 1979; Randolph Macon Womens' College, Lynchburg, Virginia, 1977; Chatham College, Pittsburgh, Pennsylvania, 1976; S.U.N.Y., Binghamton, New York, 1976; Cork Gallery, Lincoln Center, New York, 1976; Fairleigh Dickinson University, New Jersey, 1975; Brooklyn Museum, New York, 1975; Gruenebaum Gallery, New York, 1975; C.W. Post College, Long Island University, New York, 1972; Columbia University, New York, 1972.

COLLECTIONS
ARCO Collection, Colorado; Congressional Hispanic Caucus Institute, Washington, D.C.; Everson Museum of Art, Syracuse, New York; Greater Lafayette Museum of Art, Indiana; Minnesota Museum of Art, St. Paul, Minnesota; Museum of Art of the Americas, Washington, D.C.; Museum of Modern Art, Mexico City; Museum of Modern Art, New York; National Museum of Women in the Arts, Washington, D.C.; New Orleans Museum of Art, Louisiana; Puerto Rico Institute of Culture, San Juan.

Bibiana Suárez

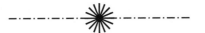

An accomplished painter, Bibiana Suárez was born in 1960 in Mayagüez, Puerto Rico. Her ability to swing from the subjective to the objective without losing the intimacy of her subject matter is crucial to her work.

Sue Taylor, curator of prints and drawings at the Milwaukee Art Center, in a 1993 exhibition catalogue of Bibiana Suárez's work, commented: "In her large and powerful pastel drawings, Bibiana Suárez has sought to give form to the political and psychological issues haunting an artist of two cultures. In past works, motifs such as sugar cane fields, palm trees, sea urchins and the geographic outline of Puerto Rico itself pointed to Suárez's origins in a distant island paradise but themes of uprootedness, isolation and alienation added an edge of pain to what otherwise may have been only wistful memories of a childhood home."

In her painting *In Search of an Island*, Suárez utilizes a single aspect of nature and positions it onto a vast environment similar to a Ben Shahn painting. One is also reminded of Loren MacIver's intimate, unusual paintings of the commonplace that evolve into charming memories of yesteryear.

In her painting *Rio de Agua Viva*, which measures 84 by 61 inches, Suárez places a single aspect of nature — an island with a single palm tree — onto a broad environment. The brilliant red background is accompanied only by a subtle weaving of lines identified as a giant jellyfish dangerously surrounding the island. The island in the painting represents Puerto Rico, which Suárez claims as being invisible and dispensable in that it is ignored by the United States.

The success of the painting relies on the appropriate positioning of the single aspect of nature, as well as the interest developed in the vast environment. Suárez succeeds on both counts. The limited palette aids in the maintenance of subjectivity of the work. The theme of the exhibition in which this painting appeared was titled "In Search of an Island," which is a perfect outlet for one who is immersed in two cultures.

Similar in composition is *Manilo Que Huye Valla*. Suárez adds a second aspect of nature, which not only aids in compositional balance but creates a tension between the two separate aspects. Not only are the two aspects essential, but the distance separating them is equally important. The tension heightens as the two approach each other. Suárez chooses the appropriate distance to create tension within an area that could easily become "dead" territory. The space between is precisely at a combustible position, and yet it is uniquely controlled to avoid an explosion.

Not only does Suárez introduce a compositional technique seldom used in

MANILO QUE HUYE VALLA by Bibiana Suárez. 1993. Pastel on paper. 60 × 50 in.
Courtesy of the artist.

contemporary art, she uses the bird image to symbolize a fallen nation. *Manilo Que Huye Valla (Fleeing the Arena)* portrays a humiliated victim succumbing to a stronger rival. Puerto Rico has always lived in the shadow of the United States. The two participants in *Manilo Que Huye Valla* symbolize Puerto Rico in the lower corner of the drawing and the United States in the upper corner.

An example of the intensity increasing as two aspects of nature approach each other is the 1993 pastel drawing *De Pico a Pico (Beak to Beak)*. The two birds confronting each other symbolize rival countries — the victim and the victor. Puerto Rico has constantly struggled for economic security and democratic freedom. The stripped bird of Puerto Rico and the healthy fat bird of the United States are subjective subject matter. There are both anticipation and frustration. Yet, in spite of the nation's hardships and struggles, Puerto Rico remains determined to fulfill its destiny and realize its dream.

The two birds appear to be taunting each other. The American bird, attired

in full plumage, stands firm against the Puerto Rican bird, which is stripped of all attire. Yet, in spite of continuous setbacks, the courageous bird continues to face the conqueror.

An equally subjective portrayal is *Traqueo (Training)*, a 1993 rendition that pictures the game cock preparing for the next event. Suárez uses the complete working surface to portray her subject matter. She creates a three-dimensional effect with the cell-like webbing surrounding the bird. There is an enormous urge to free the caged-in bird for the attack. The background and foreground are rendered in similar tones of brown, unifying the subject matter with its habitat. To avoid monotony on the frontal plane, Suárez overlaps the cage-like fencing of both front and rear sides creating a shadowy effect.

As an example of Suárez's versatility, one need look no further than her 1992 portrait *La Blanquita (The White One)*, which justifies her switch to a less symbolic picture. Although the white one is deemed more powerful than the native Puerto Rican, the 1991 portrait *What Color Was Your Grandmother?* is given equal exposure. Nonetheless, the two portraits address ethnic discrimination. Both portraits are subjectively rendered and are reminiscent of the close-up views of contemporary artist Chuck Close.

Juan Sanchez, professor of art at Hunter College, in a 1991 exhibition catalogue of Bibiana Suárez's work titled *In Search of an Island,* remarked: "On the surface, Suárez's work may not seem ideological, but on further examination it becomes evident that she can be a polemist. The work takes the form of perceptual thinking and imaging. By absorbing contradictions, Suárez's art frames a difficult and painful reality that is personally reflective. From a hopeful vantage point, it illuminates the cultural, social and political friction of Suárez's spiritual, human, female and Puerto Rican state of mind."

Suárez herself has summed up her approach: "My island is a metaphorical sense of place … not in Puerto Rico, not in Chicago, but my own island … charged with the memories of the other, but enriched by the experience of being distanced from it."

The distance of which she speaks is witnessed in much of her work. The ability to activate a vast area of nothingness to initially isolate an image and later bring focus to it is a tribute to the artist. The proper placement of the image is also essential in maintaining compositional balance.

In the case of two images occupying the same environment, the space separating the two presents a dramatic act of anticipation. The tension intensifies as one envisions the confrontation becoming a reality. Although such an event never occurs, the possibility of occurrence makes for a tug-of-war struggle.

It is interesting to note that the objective process of texturizing the environment results in a sense of subjective reality. The notion of isolation in order to integrate is a common procedure. However, it only works when the environment has the appropriate texture and color and is executed in a manner of detailed dexterity.

Bibiana Suárez utilizes in her work four methods of maintaining subjective sensibilities while proceeding with objective execution. Such treatment calls for the utilization of the working surface in which negative space is totally eliminated. Suárez succeeds in bringing about a oneness in her work, and in spite of her cultural symbolism, she maintains a contemporary look and blend of two cultures.

DE PICO A PICO (BEAK TO BEAK) by Bibiana Suárez. 1993. Pastel/charcoal on paper. 74 × 84 in.
Courtesy of the artist.

Career Highlights

Born in 1960 in Mayagüez, Puerto Rico.

EDUCATION
University of Puerto Rico, Mayagüez, Puerto Rico, 1980; B.F.A. degree from the Art Institute of Chicago, 1984; M.F.A. degree from the Art Institute of Chicago, 1989.

SOLO EXHIBITIONS
Sazama Gallery, Chicago, Illinois, 1993; Dade Community College, Miami, Florida,

1991; Sazama Gallery, Chicago, Illinois, 1991; Arts Student League, San Juan, Puerto Rico, 1985.

GROUP EXHIBITIONS
Painted Bride Art Center, Philadelphia, Pennsylvania, 1995; Condeso/Lawler Gallery, New York, New York, 1995; Kohler Art Center, Sheboygan, Wisconsin, 1994; Rutgers Art Center, New Brunswick, New Jersey, 1994; State of Illinois Art Gallery (traveling

TRAQUEO (TRAINING) by Bibiana Suárez. 1993. Pastel/charcoal on paper. 60 × 50 in. Courtesy of the artist.

exhibit), 1993; Betty Rymer Gallery, 1992; Arkansas Art Center, Little Rock, Arkansas, 1992; The Cultural Center, Chicago, Illinois, 1991; Columbia College, Chicago, Illinois, 1990; Jan Cicero Gallery, Chicago, Illinois, 1990; Central Washington University, Ellensburg, Washington, 1990; Springfield Museum of Art, Springfield, Illinois, 1989; Mexican Fine Arts Center Museum, Chicago, Illinois, 1988; Museum of Modern Art, Mexico City, Mexico, 1988; Mexican Cultural Institute, San Antonio, Texas, 1988; Beacon Street Gallery, Chicago, Illinois, 1987; College of Lake County, Chicago, Illinois, 1987; Noyes Cultural Art Center, Evanston, Illinois, 1987.

Opposite: *LA BLANQUITA (THE WHITE ONE)*
by Bibiana Suárez. Pastel on paper. 1992. 80 × 54 in.
Courtesy of the artist.

Linda Vallejo

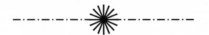

Linda Vallejo's titles suggest a strong attachment to surrealism. Her paintings focus on past dreams, memories and premonitions, although subject matter consists basically of matters of reality. Two 1994 renditions of *The Spirit of Our Ancestors* differ only slightly in each background. One witnesses in each the theory of interpenetration of human forms created by a series of vertical clouds. Cloud-like formations resembling human bodies appear to move forward and backward, creating abstract forms that delight the visual senses.

The smaller, 14 by 10 inch painting shows dream-like images of mankind, in itself a worthy and complete expression. The spirit of the ancestors in the overlapping, smaller linear figure sustains the lower portion of the painting.

It is questionable whether the single figure should occupy such a formidable location or whether the composition actually demands its presence. Aside from its location, two distinctly different styles combat each other. *The Spirit of Our Ancestors* is a strong and complete work without the inclusion of the linear spirit. The word "spirit" denotes a ghostlike image, and if a style similar to that used throughout the painting was used to depict the image of the spirit, the painting would appear more compatible with the viewer. In subtracting the image of the spirit from the painting, one would then assume that the spirit dwells within the series of overlapping and interpenetrating human forms in the background.

A similar analysis applies to the second version of *The Spirit of Our Ancestors*. The painting, a mere 20 by 27 inches, though larger than the first, is a thoroughly exciting spiritual image. However, because of its style, it appears as an afterthought, an image separate from the whole, applied onto an already completed work. Positioned higher on the frontal plane, it would appear more compatible. In both paintings the image of the spirit is transparent except for the outline of the figurative form, aiding in its incorporation of the whole.

Linda Vallejo's paintings are a part of the mainstream of American art. Her subject matter relates to an international theme, and her compositional approach is a personal one. The mood is essentially melodramatic with a combination of grays, blues and greens. Both paintings lack visual perspective because the entire expression occupies the frontal plane. The vertical images are viewed horizontally instead of from foreground to background.

Dusk, a painting executed in 1993, is developed into three horizontal planes. The surreal aspect is evident in the upper area of the sky. The middle plane reveals

THE SPIRIT OF *OUR ANCESTORS by Linda Vallejo. 1994. 20 × 27 in. Acrylic on canvas.*
Courtesy of the artist.

DUSK by Linda Vallejo. 1993. 22 × 30 in. Gouache on paper.
Courtesy of the artist.

the intensity of the dusk, while the lower plane depicts the mountainous terrain. The sky displays the dream of a face identified only by features and not shape.

Viewing two eyes, a nose and mouth, the viewer is invited to assume the volume of the space that the face would occupy. The invisibility of the face makes for an eerie nightmarish image. The image resides above the golden dusk and into the dramatic blue atmosphere and appears to be the eye of a storm about to erupt.

Linda Vallejo introduces parts of the earthly foreground into the sky to maintain a distribution of color throughout the painting. It also contributes to a unified composition.

Evil and Innocence, a 1994 production, is a universal theme, and Linda Vallejo's version is a personal approach. The theme has several variations under various titles and could range in styles from realism to abstract to pop to abstract expressionism and surrealism.

Since Vallejo is motivated by dreams and premonitions, one would assume

*EVIL AND INNOCENCE by Linda Vallejo. 1994. 22 × 30 in. Gouache on paper.
Courtesy of the artist.*

her portrayals to be surreal. The lower torso of the innocent female is excluded from the nonrealistic composition. The theme itself, however, remains unchanged and serves as warning to those outsiders who may fall victim to such gross hunger and lust. The virginity of womanhood is the focal point of attention, surrounded by the lust of man. The male figures are grotesque and ugly. The image of the would-be victim remains mute and defenseless.

A dual technical approach is used to express evil and innocence. The latter is painted in a surrealistic style, while the former leans toward the abstract expressionist school of thought.

The greedy males appear as beasts with dagger-like teeth and terrifying claws for fingernails. There is nothing glamorous about Vallejo's work, but it does alert one to the evils of this world. It is the audience who must contain their evil desires, which, of course, reign under the guise of pleasure.

Vallejo offers a frontal plane in which the two extreme emotions occupy space adjacent to each other. Both emotions are composed separately as foreground and background, and as opposing emotions, the conflict succeeds only in theory. Compositionally, the two emotions integrate into a single unit.

Another surrealistic approach used by Linda Vallejo is the disjointed and disconnected parts of the human body. In her 1993 gouache painting *Dreams and Memories*, Vallejo has human images floating in space. There is no anchoring of ideas. The artist positions a pair of human eyes in the center of the painting, suggesting a possibly invisible head form. It is common for dreams to be painted in a surreal manner, acknowledging only particular items and excluding others. *Dreams and Memories* is a recording of such a dream. Not only are the anatomical parts severed from each other, but the element of nature is introduced in the form of a beautiful flower.

In a letter to the author, Linda Vallejo offers several personal remarks regarding her philosophy and purpose in life:

> The nature of my artwork revolves around my duo-experience as a woman and Chicano living the contemporary lifestyle of the twentieth century and studying the ancient indigenous traditions of Mexico and the Americas. I have worked to discover woman in her modern and ancient place as a source of strength, love and integrity. I believe that all women are a part of the earth and can be inspired by relationships with and through nature.
>
> My art images are dedicated to the image of women understood in the Chicano-Indigena cultural and spiritual concept. It is my belief that an artist must integrate their life's experience into a consolidated whole in order to produce an art image true to themselves and the message that they are to share with their audience. As a Chicano, I now participate in many indigenous ceremonial events throughout California and the Southwest.
>
> I often use the image of the full face, with a background of trees, water, fire, and wind to exemplify the most precious aspects of serenity and love within woman. The eyes became the vehicle of these

DREAMS AND *MEMORIES by Linda Vallejo. 1993. 22 × 30 in. Gouache on paper.*
Courtesy of the artist.

aspects of woman, coupled with the purity of the classical nude form. I have also completed a large series of woman's images surrounding pain and loss. I have selected the symbol of dismemberment to describe feelings of loss and loneliness, which so many women experience through the death of loved ones, dreams and hope. It is my firm belief that the woman is the symbol of the earth, and that each woman can learn directly from the earth the aspects of loyalty, integrity, honor, generosity and courage.

Career Highlights

EDUCATION
B.F.A., Whittier College, California, 1973; M.F.A., California State University, Long Beach, California, 1978.

SELECTED SOLO EXHIBITIONS
Galería las Americas, Los Angeles, California, 1994; Galería Nueva, Los Angeles, California, 1992; Galería Nueva, Los Angeles, California, 1990; Palos Verdes Art Center, Palos Verdes, California, 1989; Roark, Los Angeles, California, 1989; Galería Posada, Sacramento, California, 1988; System M Gallery, Long Beach, California, 1988; Whittier College, California, 1983.

SELECTED GROUP EXHIBITIONS
Mt. San Antonia College, Walnut, California, 1995; The Bronx Museum, New York, New York, 1995; Museum of Modern Art, New York, New York, 1994; San Antonio Museum, San Antonio, Texas, 1993; Museo Chicano, Phoenix, Arizona, 1992; Denver Art Museum, Denver, Colorado, 1992; San Francisco Museum of Modern Art, San Francisco, California, 1991; Tucson Museum of Art, Tucson, Arizona, 1991; Fresno Art Museum, Fresno, California, 1991; Wright Gallery, U.C.L.A., Los Angeles, California, 1990; County Museum of Art, Los Angeles, California, 1989; Golden West College, Westminister, California, 1989; Fresno Metropolitan Art Museum, Fresno, California, 1988; Hippodrome Gallery, Long Beach, California, 1988; Los Angeles Municipal Art Gallery, Los Angeles, California, 1988; Brockman Gallery, Los Angeles, California, 1987; Museum of Science and Industry, Los Angeles, California, 1986; Irvine Fine Arts Center, Irvine, California, 1985; Santa Ana College, Santa Ana, California, 1984; University of California, Santa Cruz, California, 1982; Los Angeles City College, Los Angeles, California, 1981; Amerika Haus, Berlin, Germany, 1979; Malone Art Gallery, Loyola Marymount University, Louisiana, 1978.

AWARDS
Brody Arts Fellowship, California Community Foundation; California Arts Council, artist-in-residence, 1978–1981; Distinguished Recognition, National Association of Chicano Studies; Outstanding Young Woman of America, 1983.

Kathy Vargas

Born in 1950 in San Antonio, Texas, Kathy Vargas earned her bachelor's and master's degrees from the University of Texas. Her work focuses on the anatomy of death and the aftermath of everlasting life. Through the manipulation of life's common images her works explore and discover the inevitability of sacrifice and death. Vargas copes with the unpredictability of life by allowing nature's symbols to become the reality of life. The human spirit absorbs the progress, and the result is a contemplative work of art. Her religious interest stems from the shrines that dot the Mexican American landscape. In her work, life and death become a oneness: One is born to die, and one dies in order to live. Because of her natural faith in Catholicism, there is a duality in her work, an interpenetration of life and death.

Because of her rigid belief in the Catholic faith, her grandmother's tales of ghosts, and her father's stories of pre–Columbian past, Vargas grew intrigued with Mexico's Aztec religion and the concept of duality, in which opposites become essential to a work of art.

Vargas relates the dualities of her life to the spiritual and the religious. In her work *Oracion: Valentine's Day/Day of the Dead*, life and death interweave and coexist. Diana Emery Hulik, in an issue (vol. 6, no. 1) of *Latin American Art*, said: "Death and life intermingle in this piece. The pink skeleton and the miraculous tokens are the color of life as are the pink, yellow and blue flowers that surround them. Yet everything here is detached from life sources: the flowers are not in the ground, the hand is without flesh and substance, the hearts are not in the body. A skeletal hand appears to deal the asymmetrical cards of fate and loses. The image is one of uprootedness, and symbolizes mourning.

"The tokened hearts having failed to heal the deceased, now heals the hearts of his friends through their grief and through the making of this art."

In *Oración: Valentine's Day/Day of the Dead*, Vargas uses the duality of dark and light to create shadows that emanate light and images that fade into light. The lobster image is in reality a skeleton of a human hand that introduces a sense of detached life. The elongated fingers hold miraculous tokens that serve as future elements of life. Geometrically shaped heart images remain detached from other elements but in a compatible environment. The somewhat disjointed hand seems to suggest time periods. *Oración: Valentine's Day/Day of the Dead* has a soft-spoken appearance with nuances of lightweight textures not unlike those witnessed in aquatint etchings. A mystic quality absorbs the surface and leaves a relatively stilled feeling. The composition is a calculated style of manipulation not for its own sake but to secure a

ORACIÓN: VALENTINE'S DAY/DAY OF THE *DEAD by Kathy Vargas. 1990. Mixed media. 24 × 20 in. Courtesy of the artist.*

spiritual and religious overtone. One is reminded of the hand of Christ after being released from the Cross. The heart shaped images, tokens of desired miracles, are nestled near the outstretched fingers of the deceased but remaining unattached.

Another version in the *Oración: Valentine's Day/Day of the Dead* series realistically portrays death in the form of two skeletal heads. To sustain her belief in the duality of existence, an overabundant supply of teeth — indicating the presence of life — reside in each of the skeletal heads. Vargas' use of collage materials to drape over or interpenetrate the surface of her art serve as an environment for the skeleton heads. Directly above the two skeletal heads is a rather sinister background that reminds one of Christ's passion. There is indeed the duality of life and death. One is not sure which prevails, for in this work life exists beyond the grave.

The juxtaposing of collage materials upon the working surface becomes a complex calculation of life and death images. The oval shaped eyes hovering over the ghastly skeletal heads appear as darkened clouds within an already eerie sky. The value of hand coloring is the opportunity to intensify or decrease in intensity those portions of the composition that would enhance the work of art.

The textural glow of the skeletal heads embraces the eerie appearance. The suggested invisibility adds to the spooky and mysterious display of death. Vargas' concerns for the process of life and death concur with those of Octavio Paz, who wrote in *The Labyrinth of Solitude: Life and Thought in Mexico,* "Life extended into death, and vice versa. Death was not the natural end of life, but one phase of an infinite cycle. Life, death and resurrection were stages of a cosmic process that repeated itself continuously. Life had no other function than to flow into death, its opposite and complement; and death, in turn, was not an end in itself; man fed the insatiable hunger of life with his death."

Vargas' magical imagery centers on topics of death and mourning; the loss of loved ones and consolation; and the exchange of dogmatic, fierce gods for the more merciful and gentler Christ figure. Vargas' figures seem to emerge from death or retire to death in a gradual and peaceful fashion.

Symbolism plays an important role in Vargas' art. For example, miracle tokens in the shape of hearts represent the extremes of birth and death, and, in a universal sense, maternal love and love of Christ.

Vargas executes several works of art on a single theme. A third work in the 1990 series *Oracioón: Valentine's Day/Day of the Dead* displays what appears to be a necklace anchored by a heart shaped religious token and hung around a rib cage. It signifies a prayer for the deceased and hope for a possible miracle.

The entire subject matter is surrounded by border designs that aid the viewer in focusing on the subject itself. The borders are lined with arrows pointing outward, suggesting a continuation of the theme beyond the boundaries of the working surface. The actual process of composition is either conceived and arranged before developing the final picture, or the process is advanced during the processing of the film, thus allowing for a more intuitive final result.

Aside an invitation to view life beyond the limitations of art, Vargas presents a three-dimensional sense of space onto a two-dimensional surface. By adjusting symbolic images into layers of collage materials, Vargas lends a sense of the immediate

SITES AND ACCOMPANYING PRAYERS NO. 9 by Kathy Vargas. 1992. 20 × 16 in. Mixed media.
Courtesy of the artist.

to the frontal plane. The intensity of the portrayal relies totally on the subjectivity of the work itself.

Also in the 1990 series, *Sites and Accompanying Prayers No. 9* displays sites of death and prayers are for friends who have died. *Sites and Accompanying Prayers No. 9* is a partial diptych memorializing a friend who died after an agonizing, painful illness. It is a masterpiece of symbolism. The nails symbolize human pain; the heart shaped image represents hope for miracles. The combination of nails and the cloth arranged in the form of a crucifix parallels the man's Christ-like suffering.

Sites and Accompanying Prayers No. 9 comprises a series of interpenetrating images that combine to make an intensely intuitive statement regarding life and death. The unraveling of the cloth shaped like a cross denotes the disintegration of Christ's message. The transparent nature of the work allows for each image to function separately while at the same time blending to enact the oneness that Vargas is reflecting in her work. The decomposing of the shredded cross suggests a lack of care and concern for life. The flame that embraces a segment of the shredded cross reminds one of the Sacred Heart of Jesus.

Kathy Vargas' series *Cuerpo de Milagros* are magnificent works dealing with life and death. Her belief in duality is exhibited in the duality of simplicity and complexity. The subject matter — a detailed view of the inner structure of the human body — consumes the entire frontal plane. What appears to be a rib cage occupies the top segment of the work. Appearing directly below and competing for attention is a miracle-seeking heart shape. The upper portion identifies with simplicity while the lower segment may be viewed as complex; this duality makes for an unusual composition.

The heart as the focus of attention is well-earned since it is the organ of life and death. The upper area sustains a simple inner structure whose outer dimensions create a complex environment. The lower area sustains an element of complexity within the inner structure, while the lower area creates a simple environment. The beauty of Vargas' work is that it is open for interpretation, and yet her adherence to the notion of life and death assists in that interpretation.

In another print in the same series is pictured a bird, perhaps an owl, that faces the viewer. Within the owl's stomach is a second creature resembling a female African head. There are several ways to interpret the nature of this creature. One initially notices the owl perched on a tree branch. A second glance reveals a creature within a creature. In either case Vargas utilizes the entire working surface to relate her message.

Much of Vargas' work is developed in a series. Several interpretations carry the same theme. Although each image precedes another more expansive work, each also may be an end result, a completed art experience.

"A" Series No. 10 features a broken heart, which can be interpreted either as lifeless or loveless. Yet, one must concede that Vargas' serious attitude relates more to the physical being rather than the amorous feeling. *"A" Series No. 10* is a heart shaped token seeking a miracle. In this case, Vargas withholds any identifiable figure to be considered in a transaction of divine intercession. Again, the artist uses a series of overlapping montage papers. Vargas' compositional overlapping creates some areas of three-dimensional interpenetration. The heart image is encased into a rectangular shape and surrounded by spacious blues and greens that create an eerie and mysterious

CUERPO DE *MILAGROS by Kathy Vargas. 1995. Mixed media. 24 × 20 in.*
Courtesy of the artist.

"A" SERIES NO. 10 by Kathy Vargas. 1992. Mixed media. 24 × 20 in.
Courtesy of the artist.

mood. The heart shape is not anchored but appears to float in space. Any movement is blocked by a wall of pointed knife-shapes resembling war on the front lines.

A second image in this series is "A" Series No. 8. A thorny barricade imprisons a miracle token. Yet, the open sky behind the heart allows for freedom. Various interpretations are available as one witnesses the four essential complementary planes. The heart shape appears suspended between life and death; that is, the heart is injured and is fighting for survival. Furthermore, the thorny branches that form the jail cell point toward the arrival of death. The verticals and horizontals are varied enough to afford ample space for the miraculous token. The message of Kathy Vargas: The existence between life and death is living.

Career Highlights

Born in San Antonio, Texas; in 1950; lectured throughout the United States and Mexico, 1987–1995; currently lives in San Antonio, Texas.

EDUCATION
B.F.A. degree from University of Texas at San Antonio, 1981; M.F.A. degree from the University of Texas at San Antonio, 1984.

SOLO EXHIBITIONS
Lynn Goode Gallery, Houston, Texas, 1994; Galveston Art Center, Galveston, Texas, 1993; Galería Posada, Sacramento, California, 1993; Jansen-Perez Gallery, San Antonio, Texas, 1992; University of Texas, El Paso, Texas, 1991; Louisiana State University, Shreveport, Louisiana, 1991; Frances Wolfson Art Gallery, Miami, Florida, 1990; Pinnacle Gallery, Dallas, Texas, 1989; Universität Erlangen–Nernberg, West Germany, 1988; San Angelo Museum of Fine Art, San Angelo, Texas, 1988; Women's Center, University of California, Santa Barbara, California, 1985; Guadalupe Cultural Arts Center, San Antonio, Texas, 1985; Galería Sala Uno, Rome, Italy, 1984; Galería Juan Martin, Mexico, 1984; Amerika Haus, Stuttgart, Germany, 1984; Charlton Gallery, San Antonio, Texas, 1984.

GROUP EXHIBITIONS
CEPA Gallery, Buffalo, New York, 1995; The Center for Hispanic Arts, Corpus Christi, Texas, 1994; Museum of Fine Arts, Houston, Texas, 1993; El Paso Art Museum, El Paso, Texas, 1992; Our Lady of the Lake University, San Antonio, Texas, 1992; The Mexican Museum, San Francisco, California, 1992; Atenco Municipal de Cultura, Guadlajara, Spain, 1992; Center on Contemporary Art, Seattle, Washington, 1992; Union Art Gallery, Madison, Wisconsin, 1991; San Francisco Museum of Modern Art, San Francisco, California, 1991; University of Colorado, Boulder, Colorado, 1990; Denver Art Museum, Denver, Colorado, 1990; Tucson Museum of Art, Tucson, Arizona, 1990; National Museum of American Art, Washington, D.C., 1990; Bronx Museum, Bronx, New York, 1990; O'Kane Gallery, University of Houston, Houston, Texas, 1989; San Antonio Museum of Art, San Antonio, Texas, 1988; Tyler Art Museum, Tyler, Texas, 1988; Millicent Rogers Museum, Taos, New Mexico, 1988; Aspen Art Museum, Aspen, Colorado, 1987; Rockport Art Center, Rockport, Texas, 1987; Blue Star Art Space, San Antonio Texas, 1986; Cameron University, Lawton, Oklahoma, 1985; San Antonio Museum of Art, San Antonio, Texas, 1984.

SELECTED COLLECTIONS
Casa de las Americas, Havana, Cuba; Center for Chicano Studies, University of California, Santa Barbara; Hill Country Arts Foundation, Ingram, Texas; Lucy Lippard, New York, New York; Mexican Museum, San Francisco, California; Museum of Fine Arts, Houston, Texas; San Antonio Museum of Art, San Antonio, Texas; Southwestern Bell Telephone, Houston, Texas; Texas Lutheran College, Sequin, Texas; University of Colorado, Boulder, Colorado; Women's Center, University of California, Santa Barbara.

Bernadette Vigil

Born in Santa Fe, New Mexico, in 1955, Bernadette Vigil excels in both painting and fresco murals and has had the honor of working with master muralist Diego Rivera. Her paintings and murals are of equal provocation.

In a statement to the author, the artist expands her belief by saying: "I believe and know life is the greatest blessing. I respect and love everything that is in this dream and know that it transforms every moment. What I place in these images called murals and paintings are a mirror of the visions in my heart."

In her fresco mural *The Oneness of Dance*, Vigil illustrates a dream of unity among all nations. The azure blue environment is occupied by stars, planets and a crescent moon. A Spartan creature spreads across the background with each of its large tentacles anchoring an individual dancer. The artist depicts the dance as a universal language, a form of communication understandable by all nations of the earth.

Elaborately conceived, it is rendered in realistic style, each dancer attired in native costume — Native American, Latin American and Asian American. Although the work is formally balanced, one is not aware of its formality, perhaps because each individual dancer is positioned in an individual pose. Each has its own distinct style although anchored by similar baselines.

Bernadette Vigil's oil paintings are less complex but more dramatic, due partly to their theme and simplicity of composition. In her painting *Funeral with Shadow of Clouds*, Vigil utilizes secondary images to compose and communicate a religious event. The burial pit is stood over by three mourners, whose shadows are cast to unite with the deceased victim. The entire background is the brown earth interrupted only by the mourners and their shadows.

Vigil chooses a time in which shadows consume a vast segment of the earth's surface. However, she has managed to subordinate the shadow images to serve a compositional and, more importantly, a dramatic and emotional need. The artist creates a contemplative piece, not only because of its religious overtones but because it is a worthy painting. The viewer is brought into the painting as a witness within the crowd. One senses the drama and the satisfaction the artist feels in expressing her spiritual emotions on a permanent work of art.

Funeral with Shadow of Clouds has childlike connections. The top view of an event is a common occurrence in children's paintings. Although Bernadette Vigil utilizes the top view approach, she alters it to satisfy compositional needs, especially in the foreground in which several figurative forms prevail. Vigil has the mourners standing, kneeling, singing and praying while some women of the

THE ONENESS OF DANCE by Bernadette Vigil. Fresco mural. 1994. 9 × 20 ft.
Courtesy of the artist.

bereaved wear hats as was customary during the 1930s and '40s. Even the top view of a crucifix near the edge of the painting suggests a funeral mass has been celebrated. *Funeral with Shadow of Clouds* transcends a gloomy outlook, focusing on the earthly happening rather than the joy of eternal life in Heaven.

One of Vigil's favorite themes is the angel. One such painting, *Nacimiento del Ángel (Birth of the Angel)*, was executed in 1993. Using circular shapes similar to planets, Vigil crams within each circular sphere a stage of the birth. It is interesting to note that the birth transpires in the heavenly skies. The spheres advance and recede in space to communicate the three-dimensional effect of distance.

The main subject stands elegantly in the forefront, attired in full fledged wings and halo. White clothing is wrapped around her body. Her fingers are spread apart as if preparing for an ascension into Heaven. Bernadette Vigil uses a logical environment for her subject. The darkness is sprinkled with stars while the angel's body or spirit floats with ease.

While her paintings are simple compositions, dealing with space is not often as simple. Negative space must complement the subject matter and never detract or confuse the positive aspects. Vigil is usually careful to accommodate the working

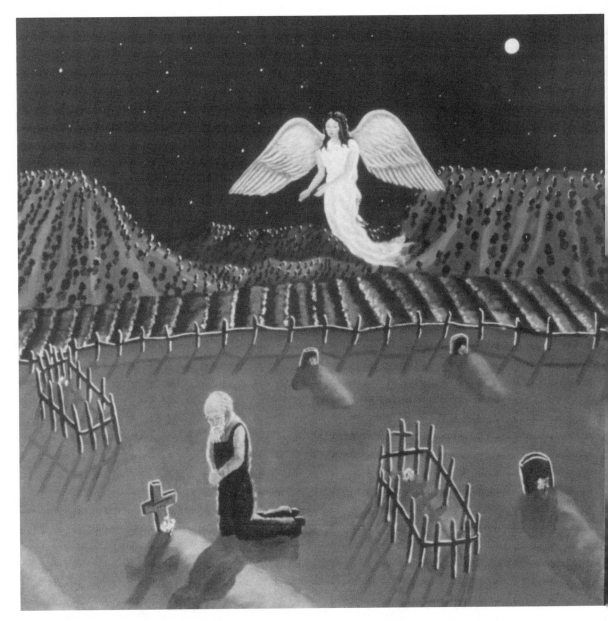

DID I EVER TELL YOU I LOVE YOU? by Bernadette Vigil. Oil on canvas. 1992. 32 × 32 in.
Courtesy of the artist.

surface so that negative space is minimized. However, in the case of *Nacimiento del Ángel*, she subordinates the negative space as the environment in which the positive aspect resides.

The theme of angels concerns the afterlife, and Bernadette Vigil succeeds in promoting her dream of everlasting life. The theme may be a myth to some viewers, but to Vigil, it is a real phenomenon to which one must adhere.

Another angelic theme is witnessed in *Did I Ever Tell You I Love You?*, a 1992 rendition. The painting features two major subjects: a mourner and an angel hovering overhead. The scene is a sparse cemetery in which only six gravesites are

ANGÉLICO SONIDO by Bernadette Vigil. Oil on canvas. 1993. 24 × 36 in.
Courtesy of the artist.

displayed. An elderly gentleman kneels closely to his deceased spouse's grave while an angel reigns overhead.

The composition is divided into three horizontal planes, each harboring its own subject matter. An elderly, bearded, widower kneels humbly on the bright red foreground. Amid other residents are the victims underground who have no mourners. Two gravesites are lined with protective fencing.

The angel appears above the lone mourner creating a three-dimensional visual perspective. The distance between the mourner and the angel creates a sense of wonder. One questions the meaning of the angel's appearance; each viewer may answer quite different from any other. Anxiety and anticipation intensifies as the angel approaches the prayerful figure.

The total composition is quite silent despite the bright hues in the foreground and middle plane. The azure sky has a lone full moon in the far distance. Vigil's portrayals are real, with a hint of the surreal in the images of the angels.

Distinctly different from other angelic renditions is the painting *Angélico Sonido*. The subjective view of two male figures accompanied by an angel playing the lute is an intimate portrait. Vigil's use of color is similar to that of early Renaissance painter Fra Angelico.

The trio of figures form a triangular composition within a rectangular format.

NUNCA by Bernadette Vigil. Oil on canvas. 1992. 30 × 36 in.
Courtesy of the artist.

While one señor plays his guitar, the other sings. Since the angel lacks a physical body, her spiritual presence is essential.

Viewing this subjective painting, one is treated to an intimate visual religious event. Even though each figure is in sharp contrast to the others, Vigil accentuates the contours to bring into sharper focus each aspect of the painting.

The angel acts as a motivator between man and his creator. The identifying mark of an angel is the pair of wings. Without them, a figure floating in air would be a phenomenon difficult to explain. Thus, the combination of the human and the spiritual translates into the real and the surreal.

The presence of an angel is frequently accompanied by a human image to illustrate the angel's spiritual guidance to the human. In Vigil's painting *Nunca* an angel is engaged in an act of blessing, acting as a protective force toward a human whose body is being warmed by a glowing fire. The angel's gesture coincides with that of

the human figure. Visual anticipation exists between both the human element and the fire itself and the angel and the human. The closeness of the three translates into a oneness, a perfect blend of the human and the spirit.

Career Highlights

Born in Santa Fe, New Mexico, in 1955.

EDUCATION
B.A., College of Santa Fe, New Mexico, 1980; Fresco Bueno, College of Santa Fe, New Mexico, 1985; studied under muralist Diego Rivera.

SOLO EXHIBITIONS
Milagros Contemporary Art Gallery, San Antonio, Texas, 1993; Owings-Dewey Gallery, Santa Fe, New Mexico, 1991; Millicent Rogers Museum, Taos, New Mexico, 1990; Jan Cicero Gallery, Chicago, Illinois, 1990; Owings-Dewey Fine Art, Santa Fe, New Mexico, 1989; The New Hacienda Museum, Cieneguilla, New Mexico, 1987; Southwest Spanish Craftsman Gallery, Santa Fe, New Mexico, 1986; Mayor's Gallery, Santa Fe, New Mexico, 1982.

GROUP EXHIBITIONS
Roswell Museum & Art Center, Roswell, New Mexico, 1994; Museum of Fine Arts, Santa Fe, New Mexico, 1994; Albuquerque Museum, Albuquerque, New Mexico, 1993; Eiteljorg Museum, Indianapolis, Indiana, 1992; Headly Whitney Museum, Lexington, Kentucky, 1992; Plains Art Museum, Moorehead, Minnesota, 1992; Millicent Rogers Museum, Taos, New Mexico, 1991; Ethnographic Museum, Warsaw, Poland, 1991; Guadalupe Cultural Arts Center, San Antonio, Texas, 1991; Chicago Art Expo, Chicago, Illinois, 1990; Jan Cicero Gallery, Chicago, Illinois, 1990; Bottger Mansion Gallery, Albuquerque, New Mexico, 1989; Albuquerque Convention Center, Albuquerque, New Mexico, 1988; Governor's Gallery, Santa Fe, New Mexico, 1988; Museum of Fine Arts, Santa Fe, New Mexico, 1987; St. John's College Art Gallery, Santa Fe, New Mexico, 1987; The Harwood Foundation Museum, Taos, New Mexico, 1986; Santuario de Guadalupe, Santa Fe, New Mexico, 1986; Willow Gallery, Santa Fe, New Mexico, 1985; Museo del Barrio, Austin, Texas, 1984; Skylark Studios, Portland, Oregon, 1984; Canyon Road Gallery, Santa Fe, New Mexico, 1984; New Mexico Highlands University, Las Vegas, New Mexico, 1983; College of Santa Fe, New Mexico, 1980; Museum of Fine Arts, Santa Fe, New Mexico, 1979; Armory for the Arts, Santa Fe, New Mexico, 1978.

Concluding Remarks

Latin American countries are steeped in religion, and, in particular, the Catholic faith. A preoccupation with life and death is not uncommon. Nature's delights are pleasantries that are free to enjoy. Devout ties to their faith have led many Latin Americans to depict saintly images, especially the Blessed Virgin and the image of Christ. Women have patterned their lives after the Blessed Mother and have had patron saints intercede for earthly favors.

The dead are revered and are continued cause for prayers and masses. On occasion, the Latin American artist places herself in the image of the Blessed Virgin in the person of the Lady of Guadalupe. Because death is the last step before Heaven, the souls of the deceased are fervently remembered in prayers and novenas.

A split often occurs between the mainstream artist and those who cling to ancestral subject matter; others have little concern for either approach. Some Latin Americans living in the United States promote their cultural heritage, while others intimately weave their personal beliefs and fantasies into their styles of painting.

Shrines, chapels and sanctuaries are essential installations of the three-dimensional artist. The world outside of Catholicism may find it difficult to accept these works. Nonetheless, such works are essential for the viewer to understand the position of the Latin American artist in the mainstream of American art. Often, what appears to be gruesome in anatomical terms is actually sacred and devoted attempts to convey life after death.

Latin American women artists address concerns of uniting their two cultures. Their native roots are deeply imbedded into their personalities, and to introduce their art to an American audience is seldom easy. The strong desire to gain international attention is offset by the loyalty to one's own cultural heritage. Yet, Latin Americans—through their unusual mixed media, installations and technical proficiency—have bridged the gap between their native tongue and a strange new one. The beauty of art is that one need not speak or write two languages; one needs only to paint, sculpt, carve or build.

Bibliography

Ades, Dawn. *Art in Latin America, the Modern Era, 1820–1980*. New Haven, Connecticut: Yale University Press, 1989.

Alegria, Ricardo. *The Art Heritage of Puerto Rico: Pre-Columbian to Present*. New York: Metropolitan Museum of Art, 1974.

Alloway, Lawrence. *Realism and Latin American Painting: The 70's*. New York: Center for Inter-American Relations, 1980.

Amaral, Aracy, and Paulo Herkenhoff. *Ultra Modern: The Art of Contemporary Brazil*. Washington, D.C.: The National Museum of Women in the Arts, 1993.

Baddeley, Oriana, and Valerie Fraser. *Drawing the Line: Art and Cultural Identity in Contemporary Latin America*. London and New York: Verso, 1989.

Baker, Sally. *Art of the Americas: The Argentine Project*. Hudson, New York: Baker, 1992.

Baranik, Rudolf. "Report from Havana: Cuba Conversation." *Art in America* 75, No. 3 (March 1987): 21–29.

Barnitz, Jacqueline, Florencia Bazzano Nelson, and Janis Bergman Carton. *Latin American Artists in New York Since 1970*. Austin, Texas: University of Texas Press, 1987.

Barraza, Santa. *Santa Barraza: An Autobiography*. College Station: Texas A & M University Press, 1997.

Beardsley, John, and Jane Livingston. *Hispanic Art in the United States: Thirty Contemporary Painters and Sculptors*. Houston, Texas: Museum of Fine Arts. New York: Abbeville, 1987.

Bercht, Fatima. *Contemporary Art from Chile*. New York: Americas Society, 1991.

Billeter, Erika. *Images of Mexico: The Contribution of Mexico to 20th Century Art*. Dallas: Dallas Museum of Art, 1987.

Blanc, Giulio. *Into the Mainstream: Ten Latin American Artists Working in New York*. Jersey City, New Jersey: Jersey City Museum, 1986.

Brest, Jorge Romero. *New Art of Argentina*. Minneapolis, Minnesota: Walker Art Center, 1964.

Brett, Guy. *Transcontinental: Nine Latin American Artists*. London and New York: Verso, 1990.

Cancel, Luis. *The Latin American Spirit: Art and Artists in the United States, 1920–1970*. New York: Bronx Museum of the Arts and Harry N. Abrams, 1988.

Carlozzi, Annette and Gay Block. *50 Texas Artists*. San Francisco: Chronicle, 1986.

Caso, Alfonso. *Twenty Centuries of Mexican Art*. New York: The Museum of Modern Art, 1940.

Castedo, Leopoldo. *A History of Latin American Art and Architecture*. New York: Frederick Praeger, 1969.

Castleman, Riva. *Latin American Prints from the Museum of Modern Art*. New York: Center for Inter-American Relations, 1974.

Catlin, Stanton, and Terence Grieder. *Art of Latin America Since Independence*. New Haven, Connecticut: Yale University Press, 1966.

Charlot, Jean. *Mexican Art and the Academy of San Carlos: 1785–1915*. Austin, Texas: University of Texas Press, 1962.

Chase, Gilbert. *Contemporary Art in Latin America*. New York: Free Press. London: Collier-Macmillan, 1970.

Christ, Ronald. "Modern Art in Latin America: Art and Nation Through Individual Discovery." *Arts Canada*. December 1979/January 1980, pp. 47–55.

Damian, Carol. "Cuba-U.S.A." *Arts Nexus* (Bogatá) (January 1992): 92–96.

Day, Holliday, and Hollister Sturgis. *Art of the Fantastic: Latin America, 1920–1987*. Indianapolis, Indiana: Indianapolis Museum of Art, 1987.

Debroise, Oliver, Elizabeth Sussman, and Matthew Teitelbaum. *The Bleeding Heart*. Seattle, Washington: University of Washington Press, 1991.

Duncan, Barbara. *Latin American Paintings and Drawings from the Collection of John and Barbara Duncan*. New York: Center for Inter-American Relations, 1970.

Edwards, Emily. *Painted Walls of Mexico from Prehistoric Times Until Today*. Austin, Texas: University of Texas Press, 1966.

Fernadez, Justino. *A Guide to Mexican Art from its Beginning to the Present*. Chicago, Illinois: University of Chicago Press, 1969.

Franco, Jean. *The Modern Culture of Latin America: Society and the Artist*. Harmondsworth, England: Penguin, 1970.

Fusco, Coco. *Signs of Transition: 80's Art from Cuba*. New York: Museum of Contemporary Hispanic Art, 1988.

Goldman, Shifra. *Contemporary Mexican Painting in a Time of Change*. Austin, Texas: University of Texas Press, 1981.

_____. "How Latin American Artists in the United States View Art, Politics and Ethnicity in a Supposedly Muticultural World." *Third Text* (London) (autumn/winter 1991): 189–192.

_____. *Latin American Art*. Chicago, Illinois: University of Chicago Press, 1995.

Griswold del Castillo, Richard, Teresa McKenna, and Yvonne Yarbro Bejarano. *Chicano Art: Resistance and Affirmation: 1965–1985*. Los Angeles, California: University of California Press, 1990.

Helm, MacKinley. *Modern Mexican Painters*. New York: Dover, 1974.

Hurlburt, Laurence. *The Mexican Muralists in the United States*. Albuquerque, New Mexico: University of New Mexico Press, 1989.

Kirstein, Lincoln. *The Latin American Collection of the Museum of Modern Art*. New York: Museum of Modern Art, 1943.

Lemos, Carlos, Roberto Jose, Teixera Leite, and Pedro Manuel Gismonti. *The Art of Brazil*. New York: Harper & Row, 1983.

Lippard, Lucy. "Made in the U.S.A.: Art from Cuba." *Art in America* 74, no. 4 (April 1986): 27–35.

_____. *Mixed Blessings: New Art in a Multicultural America*. New York: Pantheon, 1990.

Merewether, Charles. *Made in Havana: Contemporary Art from Cuba*. New South Wales, Australia: Sydney Art Gallery of New South Wales, 1988.

_____. "The Phantasm of Origins: New York and the Art of Latin America." *Art and Text* (Melbourne) (September-November, 1988): 52–67.

Merida, Carlos. *Modern Mexican Artists*. Mexico City: Frances Toor Studios, 1937.

Messer, Thomas, and Cornell Capa. *The Emergent Decade: Latin American Painters and Painting in the 1960's*. Ithaca, New York: Cornell University Press, 1966.

Moraga, Cherrie and Ana Castillo. *Este Puente, Mi Espaldo*. San Francisco, California: ISM Research, 1988.

Norwood, Vera and Janice Monk. *The Desert Is No Lady: Southwestern Landscapes in Women's Writing and Painting*. New Haven, Connecticut: Yale University Press, 1988.

Pacheco, Marcelo. "An Approach to Social Realism in Argentine Art 1875–1945." *Journal of Decorative and Propaganda Arts*, no. 18 (1992): 123–54.

Quirarte, Jacinto. *A History and Appreciation of Chicano Art*. San Antonio, Texas: Research Center for the Arts and Humanities, 1984.

Ramirez, Barl Carmen. *Puerto Rican Painting: Between Past and Present*. Princeton, New Jersey: Squibb Gallery, 1987.

Ramirez, Mari Carmen. *The School of the South and Its Legacy*. Austin, Texas: University of Texas Press, 1992.

Rasmussen, Waldo. *Latin American Artists of the 20th Century*. New York: Museum of Modern Art and Harry N. Abrams.

Raven, A., et al. *Feminist Art Criticism: An Anthology*. Ann Arbor, Michigan: UMI Research, 1988.

Reed, Alma. *The Mexican Muralists*. New York: Crown, 1960.

Richard, Nelly. "Margins and Institutions: Art in Chile Since 1973." *Art and Text* (Melbourne). May/June 1986 (special issue).

Rodriguez, Antonio. *A History of Mexican Mural Painting*. London: Thames and Hudson, 1969.

Stellweg, Carla. *Uncommon Ground: 23 Latin American Artists*. New Paltz, Washington: State University of Washington Press, 1991.

Sturges, Hollister. *New Art from Puerto Rico*. Springfield, Massachusetts: Museum of Fine Arts, 1990.

Torruella, Leval, Susana Goldman, and Shifra M. Goldman. "Latin American Art and the Search for Identity." *Latin American Art* (Scottsdale) (spring 1989): 41–42.

Weiss, Rachel. *Being America: Essays on Art, Literature and Identity from Latin America*. New York: White Pine Press, 1988.

Zuver, Marc. *Cuba-U.S.A.: The First Generation*. Washington, D.C.: Fondo del Sol Visual Arts Center, 1991.

Index